the under 40

Financial Planning guide

cornelius p. mccarthy

From
Graduation
to Your
First House

Merritt Publishing
A Division of The Merritt Company
Santa Monica, California

The Under 40 Financial Planning Guide
From Graduation to Your First House

First edition, 1996
Copyright © 1996 by Cornelius P. McCarthy

For a list of other publications or for more information from Merritt Publishing, please call (800) 638-7597. Outside the United States and in Alaska and Hawaii, please call (310) 450-7234.

Library of Congress Catalogue Number: 96-075088

Cornelius P. McCarthy
The Under 40 Financial Planning Guide
From Graduation to Your First House
Includes index.
Pages: 398

ISBN: 1-56343-134-3
Printed in the United States of America.

Acknowledgments

This book is dedicated to my wife Gail and my son Conor, who inspired me to start and finish the work.

I'd like to thank all of the people who worked on this book with me, or gave me (and you) the benefit of their expertise, including my publisher and editor Jim Walsh at Merritt who was beside me (often with a pint of Guiness) from concept to finish (all the bad jokes are his and the good ones are mine) and Megan Thorpe who had to read my handwriting and fix my grammar and did the real work; Sean Doyle, who introduced me to the Internet (and the 20th century) and Margeret Simonian who helped me get my thoughts clear and on disk; Pat Severo at Merrill Lynch and Tom Quick at Quick & Reilly for opposing views on the brokerage business; David Stack, Esq., whom I intend to ask to write my will as soon as I get around to it; my mother-in-law Phyllis for helping out on the will chapter and my wife Gail for her help on balancing the checkbook section (which she actually does while I'm busy writing books and getting all the glory); James Kenefick, renowned financial scholar, for the options section; Megan Kelly (my sister) for her help on the insurance and real estate sections, and my other sisters Eileen, Kelly, Nora and Molly; and my parents Lynn and C. Pat "Chubby" McCarthy, whose questions and answers represent the core of what you are about to read.

Thank you all.

CPM
Los Angeles, May 1996

THE UNDER 40 FINANCIAL PLANNING GUIDE

The Under 40 Financial Planning Guide

Table of Contents

Introduction ... 1

Part One: Finding Your Hidden Money
Chapter 1: Budgets...The Devil's in the Details 7
Chapter 2: Visa Bill as Rorschach Test—Your Spending
 Patterns ... 17
Chapter 3: A Place to Live and a Way to Get to Work 25
Chapter 4: Containing the Cost of Consumables 39

Part Two: Taming Your Tax Burden
Chapter 5: Tax—Not Just a Good Idea: It's the Law 55
Chapter 6: Filing Instructions ... 67
Chapter 7: 1040 Chess...Strategies for Managing Your
 Tax Burden ... 81

Part Three: Credit and Debt
Chapter 8: Bank Accounts...the Ruin of Many a Poor Boy 93
Chapter 9: Credit Cards Don't Kill People's Finances,
 People Do .. 111
Chapter 10: Student Loans and Other Early Debt 127
Chapter 11: Taking Control of Your TRW 137
Chapter 12: Escape from Debt Hell .. 145

Part Four: The Second Biggest Purchase
Chapter 13: The Mechanics of Buying a Car 153
Chapter 14: Borrowing the Money for a Car Can Be a
 Good Discipline ... 167
Chapter 15: Leasing a Car Can Mean More Bang for
 Your Buck ... 173
Chapter 16: Used Cars—Some Bargains and a Lot of
 Rip-offs ... 179

Part Five: Covering Your Assets
Chapter 17: What to Insure...and What Not to Insure 187
Chapter 18: Life and Limb ... 195
Chapter 19: Insuring Your Moveable Feast 211

Part Six: Playing at the Wall Street Casino
Chapter 20: The Basic Concepts of Investing 219
Chapter 21: Matching Your Investments to Your Goals 235
Chapter 22: Stocks, Bonds and Mutual Funds 249
Chapter 23: Choosing a Broker ... 297
Chapter 24: The End-Game Approach to Retirement
 Planning .. 307

Part Seven: Plans for When You're Gone
Chapter 25: Wills—The Plain Pine Box of Estate Planning 323
Chapter 26: Preparing Your Will ... 337

Part Eight: Buying That White Picket Fence
Chapter 27: Working the Real Estate Market 345
Chapter 28: Your Down Payment and the Really Big Loan 353

Conclusion ... 387

Index .. 391

Introduction

A friend of mine claims that, when it comes to money, success is a matter of temperament—there are savers and there are spenders. Period. It's tempting, especially when you're young, to buy into this kind of fatalistic mentality. But I think that's a mistake. The great secret of financial success is that it's not luck, magic or art.

What it is is detail work and attention to small points. It's being careful and critical—and being able to separate your financial decisions from your ego.

The plan for this book started several years ago, when I wanted to figure out how to take advantage of what little money I made. The problem was that all of the self-help books for investing and managing money assumed that I had tens of thousands of dollars laying around the house. In the meantime, I always felt like I was about $80 short at the end of each month—even after I got a raise or bonus.

I was living paycheck to paycheck, and most everybody I knew was in the same spot. So I started doing research, reading up on the conventional wisdom of how to save a little money...and how to spend the little I had more intelligently. I also talked to people—sometimes interviewing them formally in an office setting, sometimes talking informally over beers.

This book tries to take things like saving money, making investments, buying a car, insurance and even a home, and make them simple enough for anyone to understand. Since I didn't know anything when I started this process, I think it makes sense to start with the basics and then add some of the more tricky stuff as we go along. There are sections throughout each chapter that explain terms that you may not recognize.

I can be of help because I'm pretty much like you—or what you'll be like in a few years. I'm a reasonably intelligent person who's not yet 40 and has had to manage my own finances since I was 18. I've made a few mistakes along the way—but I've come through the process pretty well. While I'm not making millions of dollars a year in real estate scams or selling junk through classified ads, I've got a job I like and live a pretty comfortable life.

What I saw several years ago is still true today. Many of the financial planning books you'll see are either ponderous textbooks or are written for older readers concerned with retirement and estate planning. Even the computer on-line forums that sell punk attitude about money skew toward people in their forties. That's a strange place to focus.

The twenties and thirties are the years when many important financial choices are made, such as buying a first home, selecting life insurance or taking advantage of a 401(k) plan. Yet most people have little understanding of the important issues involved in making these choices.

Most people have formed their savings and investment habits by the time they reach 40—their peak earning years. And the earnings in those years need to be peak: If you save $20 a week—or about $1000 a year—from the time you're 40 and invest it at a 10 percent rate of return, you'll have about $110,000 when you reach 65. If you start saving the same $20 per week at age 20, you would have about $820,000 at age 65. Starting early, even if you start small, is the best way to accumulate wealth.

And I'll say one important thing now, so I get it off of my chest and don't spend the whole book ranting about it: If you're in your twenties or thirties in the 1990s, you can't count on Social Security or any other government system to take care of you. There may be something left in these programs when you're 65...or 70...but it's not going to be enough to let you live any kind of life you'd want to live. The plain truth is you're going to have to plan for yourself. And—given the way government benefits programs generally work—that's probably for the best, anyway.

This book won't turn you into a financial wizard, but it should be enough to get you started. Think of it as a traveler's guide for getting through your reckless youth in decent financial shape. It's a reference book for people who want to start managing their money, even though they don't yet have any. It sets a framework. But don't stop here. There are numerous magazines and books that can provide you with more detailed information on all of the topics I cover.

My conclusions aren't earth-shattering, but they should give just about everyone a hopeful message and a place to start.

Most of all, I hope this book gives you enough information to make your own financial decisions with confidence. You don't need to have a lot of money to make good money decisions. In fact, it's better in some ways if you don't have a lot of money at first—being broke makes your margin for error smaller. You have to make smarter decisions. And that's what this book is about.

Part One:

Finding Your Hidden Money

Chapter One

Budgets...the Devil's in the Details

Introduction

Most of us have, at one time or another, lived from paycheck to paycheck—and lots of us still do. This may seem normal to people who've recently entered the work force, but it shouldn't be shrugged off casually.

Not having any money in reserve is a bad habit to start. And, like many bad habits, it can influence lots of other decisions that you have to make later on.

The best solution for preventing this bad habit—or breaking it, if you're already there—is adopt the discipline of making and living within a budget.

I hope that my argument for living under a budget is more than the lecture you've heard from parents and teachers a thousand times before. Budgeting is the only scientific tool any of us has for taking control of our finances. Working people do it. So do millionaires—

especially ones with the dreaded liquidity problems. Just ask Donald Trump. Even corporations do it. And these guys budget for more than just the thrill of filling in blanks on a sheet of paper. They do it because the process itself can be helpful in figuring out how we live and spend our money.

It's tempting to say, "I can't afford to save money now, but I'm definitely going to start saving as soon as I'm making more money." You may be surprised to learn that you could be comfortably living within your means and still have enough to put money aside for the things you want.

Even if you just save a few dollars a month, using a system for analyzing your finances gives you the perspective to make informed decisions. If trouble—or better times—come along at some point in the future, you'll be able to adjust your spending accordingly. This helps make bad times not so bad and good times last longer.

More than anything else, the discipline of a budget gives you a feeling of control over some part of your life. If you hate not having enough money to pay your bills, or buy a new car or even a house, you have to start finding your hidden money right now.

The Magic of Compounding

Another reason to start saving money as soon as possible is so that you can take advantage of "compounding," which is probably the single most important financial tool you can use. Compounding means that the money you save earns interest, and then the interest earns interest. It's just like putting two rabbits in a room and coming back to find that they've multiplied to 20. The longer you're out of the room, the more rabbits you get.

Money works the same way—if you put it in the right place and give it time, it will multiply.

For instance, if you save $20 a week, or about $1,000 a year, in a big piggy bank from the time you were 40 until you reached 65, you would save about $25,000. If you invested that money at a 10 per-

cent rate of return, you would have about $110,000 when you reach 65. The difference is compounding—when you invest your money, every dollar is working full time for you.

If you start investing the same $20 per week in the same piggy bank at age 20, you would "save" about $45,000 by age 65. That means you will put away an extra $20,000 by starting early. But, if you invest that money at a 10 percent return, you will have over $820,000 by the time you reach 65. By simply investing an extra $20,000, you will accumulate an extra $710,000. By the time you're 68, you'd be a millionaire.

(And don't start with the smirky remark that $1 million will barely buy a hamburger and fries when you're 65. Over the long haul, the money you earn will more than compensate for inflation.)

You might be thinking, "I can't even make ends meet, so forget about saving $20 per week." Not to worry. Compounding even works if you can't afford to put away $20 a week. If you put only $5 away every week from age 20 until you reach 30, and then increase to $20, you'd still retire with about $500,000.

While the amount you choose to save is important, getting started early is crucial.

Don't get depressed if you're already 30 and you haven't gotten started yet. In order to reach the same $820,000, you will have to save a bit over $50 a week. And this book is dedicated to showing you how to make up for lost time.

The key to financial success in a capitalist system is being one of the people who's got cash. Having a little cash is a lot better than having none.

Simple Math—Make More or Spend Less

If you don't have enough money to pay all of your bills at the end of each month, or if you want to save more, there are only two ways to fix your problem—make more or spend less. Lots of people have the

ability to take on some overtime, or work an extra shift. Some of you may even have a talent or hobby that can make you money during weekends or evenings. If you can increase your earnings without ruining your home life, that's a solid way to improve you financial performance.

Unfortunately, most of us are working as hard as we can and don't have the time to take on a second job. Whether you can increase your earnings or not, improving your spending is a sure way to improve your financial health. Almost everyone can cut enough out of their monthly budget to make ends meet, without reducing their quality of life.

In order to discover your hidden wealth, you have to find the answer to one of life's greatest mysteries— "where does all of my money go."

This takes a bit of work, but it's the first step toward financial freedom.

Every financial book that's ever been written tells you to do a budget, so why should this one be any different? After all, a budget is the only true way to see where your money is going. If you finish your budget and think that you are spending your money in exactly the way you wanted, you may be the first person in history who feels that way. For the rest of us, a budget is usually a bit of a shock.

If you ask most people to write down how much they make every month, and then list what they spend their money on, most can only come within 20 percent of the total. Clearly, they have no clue where their money has gone.

I worked with a guy who always complained that he could never save a dime (we were both making the same pitiful salary). Yet almost every day he'd spend nearly $3 on a Double Mocha Java Latte Frappe at the local coffee bar. He didn't realize that he was spending almost $15 a week on coffee, and that he had to earn almost $1,000 a year to have enough money, after taxes, to feed his coffee habit. By drinking the disgusting—but free—coffee in our office, and reducing his trips to the coffee bar down to once a week, he would have been able to save about $800.

The point is that even small expenditures can add up, if you have enough of them. Making a budget is about as exciting as watching paint dry, but it's the only good way to find the leaks in your financial boat.

Doing Your Homework

A proper budget should be an estimate of what you will spend in the next year, based on your actual expenses in the past. In order to estimate your actual expenditures properly you will need to do a little work.

Look at Your Records. Dig out your checkbook and your last three months of credit card statements. Some of your expenses, such as clothing, gifts, etc., come in big chunks rather than equal monthly amounts. In order to get a better grip on where you have been spending, a quick review of your checking account and credit card receipts should help you to figure what you spend on these items. Your pay stubs from work will be helpful in estimating the amounts that you pay for taxes and other payroll deductions.

Construct a Paper Trail. For at least one month, get a receipt for every amount over $1 that you spend. Save the receipts until the end of the month, and then allocate a couple of hours to tally the results and enter them onto your list. Don't cheat on this one—the little expenses add up and they're the hardest ones to find. (I do this exercise one month a year—usually in January. It helps me get into the mindset for keeping resolutions.)

Track Variable Expenses. For things that vary from month to month, like your phone bill, try to use the average over several months. For things that can get much more expensive during certain times of the year, like the heating bill in winter or expenditures on gifts and travel during holiday months, or for one time costs like a vacation, estimate the amount you will spend over the next year and divide by twelve. Add this amount to the appropriate category. If you expect certain large expenditures, such as a new couch or a set of tires, you have to reflect these in your list.

Compile Your Estimate of Expenses

Fill in all the categories of expenses in the chart below. If you have an unusual expense that isn't in the list, simply add a new category. For instance, for women, bridesmaid dresses and shoes can represent a category all by itself.

Where the Money Goes

	Estimate of Amount for One Month
Taxes	
Federal	$ _____
State	_____
Fica	_____
401(k) Plan Contribution	_____
Other payroll deductions	_____
Housing	
Rent	_____
Mortgage	_____
Property taxes	_____
Cable television	_____
Electricity	_____
Water	_____
Gas	_____
Garbage	_____
Furniture	_____
Curtains, linens, etc.	_____
Appliances	_____
Repairs	_____
Cleaning	_____
Other	_____
Phone	_____

Credit card payments _____

Student Loan
 Bank fees _____
 Other _____

Transportation
 Car payment
 Gas _____
 Maintenance and repairs _____
 Registration
 Parking and tolls _____
 Subway, bus, taxi _____
 Tickets _____
 Car wash _____
 Other _____

Nourishment
 Food—groceries
 Food—take out/delivery _____
 Cigarettes _____

Clothing
 Work clothes
 Play clothes _____
 Shoes _____
 Accessories _____

Appearance
 Gym
 Makeup _____
 Hair and nails _____
 Shoe shine _____
 Dry cleaning and laundry _____

Health
 Doctor
 Dentist _____

Drugs _____

Glasses and contacts _____

Other _____

Insurance

Health _____

Life _____

Disability _____

Renter/homeowner _____

Auto _____

Other _____

Children

School _____

Day care _____

Toys _____

Supplies _____

Other _____

Support of others

Church and charity _____

Accounting and tax return _____

Pets _____

Gifts _____

Postage _____

Other _____

Total Expenses $ _____

Reviewing your list

Once you have completed the list, come up with a grand total of your total monthly expenses. Fill in the chart below to get your profit or loss for each month.

Gross Monthly Income	$ _____
Less Total Expenses	$ _____
Potential Savings or Shortfall	$ _____

If you have potential savings at the end of the month, congratulations—you can skip ahead to the section on buying houses and investing money. But, you should still go through the next three chapters to see whether you can squeeze a little more from your monthly budget.

If you have a shortfall, don't worry, because you are about to use the information you prepared to begin to find your hidden money and change your loss to a profit.

This part of the book is just the beginning of finding your hidden money, and deals with most of the smaller items. I almost hate to tell you some of these savings, because some of them may seem obvious—or just petty. But I want to point out enough of them so that you can find a way to be a tightwad in your own special way. I guarantee that at least some of these tips will save you money.

The big ticket items, such as taxes, insurance, buying a home or a car, are too detailed to describe quickly, so these and other topics have their own chapters.

Keeping Records

While we're talking about budgeting, this is also a good time to talk about records. Keeping good records doesn't take much time, and it

helps you keep track of your life. It's also helpful for tax time. Just buy (or borrow from work) about 20 to 30 folders, and save a few shoeboxes. Each bank account, credit card, student loan, investment account or other periodic report gets a folder. Put the new bill or account statement in the front, and keep them in date order. (I keep bank statements for seven years, bills for three or four months, and brokerage or investment statements and loan documents forever.)

Put your checks in numerical order, so the highest number is on the top. (I keep each year's old checks in a shoebox. It's a surprisingly good filing system.) You will need the banking and account statements and records to prepare your taxes, and in case of an audit.

Also, keep a separate folder marked "tax-receipts—199_" for each year, so you can have an easier time doing your taxes. (After your taxes are done, keep a copy in a file marked "tax return —199_.")

Nothing I've mentioned in this chapter is really that difficult. It's just tedious. But spending some time doing tedious work now is better than turning 50 and realizing you're going to have to spend your old age asking pissed-off relatives for hand-outs.

Chapter Two

Visa Bill as Rorschach Test—Your Spending Patterns

Introduction

Most of us have at least a few bad spending habits. This holds especially true for people whose spending experience has been focused on things like records and rollerblades. In many cases, a lack of experience with daily costs of living leads to a certain level of volatility—which means running out of money before your next paycheck.

Bad spending habits don't make us terrible people, but they can cause us to worry about money more than we have to.

The first step in solving this problem is identifying it. Once you understand what your bad spending habits are, you can respond to them. You can prioritize expenses, trim where you can, and eventually take control of your financial health.

What follows is a review of some of the worst—but most common—spending habits that screw up people's early careers. Check your own habits against these patterns. If you see similarities, pay close atten-

tion to the solutions that appear in this chapter—and throughout the rest of this book.

Buying on Credit

Buying on credit is probably the worst habit you can have. If you do have it, you shouldn't feel alone. American consumers have more short-term, unsecured debt than any other group on the face—or in the history—of the planet.

People who avoid buying things on credit (whether through credit cards or installment plans) are sometimes looked on by everyone else as cranks or eccentrics—hard cases who aren't willing to play by the conventional financial rules. Some may be just that, but there's a lot to be said for avoiding the temptation of revolving consumer debt.

Borrowing money to buy things that lose value over time means you lose twice—once in the interest costs of borrowing the money and twice in the lost value (*depreciation* is the accountant's term) of the thing you've bought.

Of course, credit—used carefully—can be a sensible way of buying big ticket items over a comfortable period of time. But buying on credit can bury you under a mountain of obligation. Consumer debt is designed to lull the consumer—namely, you—into a false sense of financial security. That's why Circuit City, Bloomingdales and Nordstrom are happy to issue store credit cards.

Credit cards are the worst form of debt. Because they are readily available, they encourage you to use them to stretch your spending beyond your limit. Then, they charge you 18, 19 or even more than 20 percent interest so that you can't ever make enough to pay them back.

The only way to break this habit is to restrict yourself from buying anything on credit except your education, your car or your house. Anything else you buy should be paid off when you get the credit card bill. The only exception to this rule is an emergency. If you have an emergency—and I don't mean that you absolutely have to buy a

new stereo—buy on credit and then devote your financial resources to paying off your credit as quickly as possible.

When I was in school, I drove an old Lincoln Continental—very big, very black, and very cool. It was the perfect car for hauling a dozen people to a U.Va. party—but it drank gas and was constantly breaking down. Somehow, I managed to get an AMOCO gas card and a Sears credit card to support my retro automotive habit. Between these two cards, I managed to charge over $3,000 in gasoline, tires, batteries and repairs in less than a year—on a car that had only cost me $2,000 in the first place. It was so easy to charge the expenses....

Let me repeat that for emphasis: $3,000 in maintenance and repairs of an asset that was worth less than $2,000. For anyone still wondering, that's terrible money management.

Even though I was working, I was constantly late on the card payments. Sears eventually cut me off and I've never gotten back in their good graces.[1] The gorilla at my local AMOCO station actually confiscated the gas card—forcing me to borrow money from my date to pay for the gas I had just pumped.

Not too much later, a rich lawyer smashed into the Lincoln while it was parked in front of my house. This lucky accident provided me with the cash to pay off my outstanding debts.

But there was a not-so-lucky side to the story. Even though I paid back what I owed, my first experience with credit card debt left bad marks on my credit rating for years to come.

Media mogul Rupert Murdoch once said the most important thing in business—far more important than visionary perspective or negotiating prowess—was paying your creditors on time. Murdoch was talking about high finance, but I think the same rule applies to ordinary life.

The best plan is not to have any consumer debt. If that's not possible, here's a rule of thumb to follow: The interest payment on your con-

[1] Discount department stores are notoriously tough about credit. I know quite a few people who have six-figure jobs, big houses and various shades of gold and platinum in their wallets—and can't get a Sears or J.C. Penney card because they paid bills late when they were in college.

sumer debt (again, this doesn't include student loans, etc.) shouldn't be any higher than 5 percent of your monthly take-home pay. If you're making $30,000 a year, this means a minimum payment on your credit cards of about $80 a month. If you're carrying more than that, you're probably spending too much.

If you are already bogged down in a debt quagmire, try consolidating your existing loans or credit cards into a single loan with a lower interest rate. If you're really in a cash crunch, you may want to take more aggressive actions. Specific defensive measures are described in excruciating detail in Part Three of this book.

Keeping Up with the Joneses

Thanks to a natural competitive instinct and billions of dollars spent every year by advertising geniuses, we have been brainwashed into judging ourselves by whether we have the same material goods as our friends.

This is the familiar rat race of consumption—more money to support a fancier lifestyle which then requires even more money. And that word "lifestyle" doesn't only mean buying BMWs and beach houses. It can apply to just about anything—the amount of time we spend on the Internet, the number of times we see our favorite band in concert, the food we eat, booze we drink or the clothes we wear. It's amazing how this impulse remains consistent across generational lines—from the Baby Boom to Generation X, to kids barely old enough to watch Barney.

The average human lives for over 70 years, so the human rat race can be a very long haul. Like most races, the runner who sets an early pace rarely wins.

Avoid keeping up with the Joneses today, and you can pass them by tomorrow.

You may be seeing this already: For many people, volatile spending habits right out of school translate into a cash crunch three to five

years later. For most of these many, this is a time to pay down credit cards and learn a lesson about living with revolving debt. For others, this is the first of many cycles of financial binging and purging.

Indeed, some people get into money problems that are like an eating disorder—a life-consuming cycle that's very hard to break. The best strategy for avoiding this problem is to avoid the first cycle of spending.

Sigmund Freud said that a sign of adulthood is the ability to delay gratification. Be an adult. Wait until you've got the cash to satisfy your jones for a leather jacket or mountain bike. That will keep you out of the rat race and keeping up with Madison Avenue Joneses.

Buying for Status

Status is the reason that Ralph Lauren can sell a $10 polo shirt for $85. Like buying on credit, though, looking for status in disposable goods is a bad idea.

It makes sense to pay for quality in things that you expect to have for a long time, but don't be fooled by fancy labels. They sometimes are masking questionable value. The more expensive the purchase, the more important this rule is.

Here's a more specific example: The Isuzu Rodeo and the Honda Passport are both made by Isuzu, and are nearly identical in everything but their name. The Honda costs about $2,000 more, and it sells like hot cakes. People are willing to pay $2,000 for the Honda label. Go figure.

Philosophically, true status is probably better defined as the ability to do the things you want when you want to do them. Financially, this means liquidity and flexibility more than hard-asset investment.

You might insist that what you really want to do at this stage in your life is drive a Honda Passport. Then, I'll shift from philosophy to physics.

The physical law of entropy says all things eventually break down. If you don't have a lot of money, remember the law of entropy. Don't put the money you've got into things.

You might argue that Hondas (even the ones made by Isuzu) are made so well that they defy entropy. I know several people who've been driving Accords for years and swear this kind of thing. At that point, I'll refer you to Part Four of this book and wish you happy trails.

Buying without Goals

Despite the single-mindedness you just showed, many people get out into the work force and suddenly feel they have to spend money because they're making money. This is kind of the flip side of the debt problem—and a variation of the status issue.

Just because you can afford a new Honda Passport doesn't mean you should buy one.

If you're doing well enough that you feel you should be spending more, you may want to rethink your personal and financial goals. In an economy that laughs at old notions of career stability, no one is doing too well if their main source of income is a salary.

Most people are fairly average financially—that is, they don't make that much more or that much less money than other people their age. It's just that some people are better at using their money to reach their goals.

By having financial goals, you may decide that you'll take a pass on the Passport and save up enough money to buy a house, or start a new business. A little planning can prevent you from overspending on things you don't need.

Making Choices with Your Money

All of the things you choose to do with your money are inter-related: If you save a dollar, you don't get to spend that dollar; if you spend

your dollar on food you can't use it for clothes, etc. The key is to make conscious decisions to allocate your money to the places that will make you the most happy now and later. Only you can know what's best for you.

Let me give you an example of what I mean. Marcia, Jan and Cindy each has maxed out her only credit card with a balance of $100 at an interest rate of 19 percent per year. Each of the three young professionals got a year-end bonus of $100 after withholding.

Marcia put her $100 bonus in a savings account at her local bank, earning interest at the rate of three percent per year. She knows that savings accounts are insured by the FDIC, so it's virtually impossible for her to lose her money. At the end of the year, she will have earned $3. However, she'll still have the $100 balance on her credit card, and she would have paid $19 of interest during the year. That means her "net interest" would be the $3 she earned on her savings account less the $19 she paid on her credit card, or a loss of $16. But she would have access to the $100 in her savings account during the year, and that made her feel good.

Jan took her $100 bonus and paid off her credit card. She didn't earn any interest, but she didn't pay any either, so her net interest was $0. She could use her credit card for up to $100 if she needed it.

Cindy spent all the money on a bottle of Dom Perignon to celebrate the New Year with some friends. They had a blast. She didn't pay off her credit card, so she paid $19 of interest.

Here's a chart of how each of them did at the end of the year:

	Debt	Savings	Interest	Other Issues
Marcia	$100	$100	Paid $16	Had access to $100
Jan	$0	$0	None	Had access to $100
Cindy	$100	$0	Paid $19	Had a blast

Each person made financial decisions in order to reach certain goals. Marcia didn't do a very good job compared to Jan: Marcia lost money after paying interest on her credit card, Jan spent nothing on interest and still had access to the $100 if she needed it. Jan knows a key rule of investing—always pay off expensive credit cards first. Cindy also did well, because she used her money to enjoy herself. There's nothing wrong with rewarding yourself—as long as you realize it usually costs money. In Cindy's case, it cost $100 for the champagne and $19 for the interest on a loan she could have paid off. (What's worse, Cindy might have been able to buy that bottle of champagne for $70 if she'd gone to a discount liquor store.)

The point is that I don't want to instruct you on when you should save your money, and when you should spend it on something you need or even something that you want. The specific things that make you want to spend money aren't as important as the patterns that emerge over time. What you need to ask yourself is: "How do I spend my money? And is there anything I can change that will help get more for my dollar?"

Summary

At this point, you may want to take another look at the expense worksheet from the previous chapter. Consider how the expenses you normally incur impact other things you could do with your money. Also consider whether any of the expenses you listed require credit card financing or other costly terms—the expenses could be hitting you on multiple levels.

Throughout this book, you'll find tools for analyzing your spending priorities. A warning, though: The purpose of this book is to help you be smart with your money, regardless of what you choose to do with it. It will give you advice and guidelines so that once you decide where to allocate your spending, you can get the most bang for your buck— but it won't tell you specifically how to spend your money.

Despite my ranting about that hypothetical Honda Passport, my instincts are too libertarian to allow me to lecture. What you do with your money is your own business. Just make sure you understand the short-term and long-term impacts of the spending decisions you make.

Chapter Three

A Place to Live and a Way to Get to Work

Introduction

You're going to have some basic, inescapable costs once you're out of school and venturing into the work world. Most people spend a few years experimenting with different combinations of job and living arrangements. This gives you the chance to find out which set-up works best for you and usually provides—whether you intend it to or not—humorous and horrifying cocktail party stories for the rest of your life.

Strategically, your best bet is to keep these costs to a minimum and keep your options open and commitments as limited as possible in the first few years. This applies to many things—including where you live and how you get around.

With the possible exception of taxes, housing is usually your single biggest expense—so it makes sense to do a lot of looking before you choose a place to live. The following chart gives you an idea of the maximum that you should be spending on shelter.

Yearly Take Home Pay	Monthly Rent
Under $15,000	45 percent
$15-25,000	40 percent
$25-50,000	35 percent
Over $50,000	30 percent

If at all possible, you should try to come in lower than these numbers. In some cities—like New York or San Francisco, where the cost of living is high and you may not need a car—you may have to exceed these guidelines. But there are always ways to minimize your housing costs.

Apartment Sharing

The most obvious way to save money on rent is to share an apartment or house. Keep in mind that if you are the only person on the lease, you may get stuck with the contractual obligation if your roommates bail out. The best way to avoid this problem is to have a clear understanding among your roommates about how much they will pay, how long they will stay, and any other responsibilities of the lease.

I suggest getting this in writing—not because you don't trust your roomies—but because reducing your thoughts to paper is the easiest way to make sure that everyone understands and remembers the agreement.

Also, insist that everyone pay a share of the deposit—its the only fair way to protect the person who signs the lease. If you don't have enough for a deposit, some landlords will allow you to pay your deposit over several months. This is also an ideal use for graduation gifts and other cash windfalls that come your way.

Another important issue in roommate arrangements: the utilities. In my experience, more friendships have ended and acquaintances gone

from cordial to nuclear because of phone, gas, cable or electric bills. The best way to handle bills is to let your roommates get the things in their names and pay your share on time. The next best solution is to get separate services—and bills—for big-ticket items like the phone.

If you're the person with the utilities in your name, try to package the gas, sewage and electric bills with the rent the others pay each month. If you have collective bills for phone and cable service, itemize the expenses, copy the paperwork and make sure everyone gets copies as soon as possible.

Don't hesitate to stop service or limit access if roommates don't pay. It's far worse to let them go for a couple of months and then try to collect bigger amounts later. If someone can't pay you smaller bills on a regular basis, there's no reason to think they'll be able to pay you larger ones in a crunch.

Sublets

Another option is to sublet an apartment from someone who will not be using their place for an extended period. Sublets are usually furnished, so you can save substantial money on furniture. Also, you are usually dealing with an individual rather than a professional landlord or an apartment management company, so you may be able to get better terms.

The downside is you may have to move from one sublet to another, since they are often short-term arrangements.

Sublets are usually more plentiful in larger cities, or near college campuses.

Living at Home

This is probably only acceptable to you (and your family) for a relatively short while, but it is a good way to put together some savings before entering the "real world" they told you about at graduation. (Or to regroup after a less-than-spectacular first effort.)

I suggest paying some amount of phantom rent into a savings account, which can become the bedrock for your financial empire. Your family may suggest that you pay some real rent as well.

There's strong temptation to make a bunch of jokes about the cliche of people getting out of college or grad school and moving back in with their parents—but it's really not a laughing matter. If there's any reasonable way you can afford to live on your own when you get out of school, take it. Living with the people who raised you is dangerous because it's so safe.

In my experience, people who move back in with their families end up making decisions that work against their own financial interests. They mouth off to bosses they don't like and get fired. They buy cars (or boats, or animals) they couldn't otherwise afford. They put money or time into activities that don't pay—or even lose money.

Your situation may be exceptional. Your circumstances may be so dire you have no choice. But living on your own is a good discipline—just like watching your consumer debt load. Be it ever so squalid, there's no place like your own home.

And, in most cases, your family will respect you more if you're self-sufficient.

Changing Your Arrangement

If you already have an apartment and you're having trouble making ends meet, you may want to consider taking on a roommate. This may be inconvenient if you're in a studio apartment, but even a small one bedroom can usually accommodate two people. If your rent is too much to bear, and a roommate is not practical, you are going to have to have a talk with your landlord. I favor a frank conversation in which you explain that you are not going to be able to afford the rent you are currently paying. Most landlords will work with you to come up with a solution. You may want to offer one or more of the following options:

- Ask for a decrease in the rent. A temporary decrease is more

one or more months of rent if you move out and the apartment is temporarily vacant.

- Ask your landlord if there is a less expensive apartment available. You may be able to move into something a bit smaller in your building, or in another building controlled by the landlord, and save some money.

- Explain to your landlord that you are going to have to move out of your apartment. Ask if you can help find a new tenant, provided that your landlord will let you out of your lease.

- Offer to work in exchange for a rent reduction. Most apartments and apartment buildings have hundreds of odd jobs that need to be done—from cleaning the carpets to painting the halls. In many situations, the landlord dreads having to spend the time and money required to do more than just basic maintenance. You may be able to take on a few of these tasks for a break on your rent.

Whatever approach you take, keep in mind that your landlord simply wants to collect rent and deal with the least amount of hassle. Running an apartment building can be endlessly problematic. That's why landlords charge security deposits. And you want to avoid forfeiting your security deposit because you can't come to an agreement with a stressed-out landlord.

Important Tips For Renters

Before you sign a lease, make sure you've read and understand the whole thing. Some landlords will try to slip all kinds of wacko terms and conditions into the document, hoping you'll just skim over them. Pay particular attention to the following items:

- **The amount of rent each month.** Make sure it's the same thing you've agreed to in discussions.

- **The term of the lease.** The best term for a basic apartment lease is usually six months to two years. If you want to stay longer, either ask for an option for more time or agree to convert to a month-to-month agreement.

- **Fees.** Check how much extra you'll owe if you're late on a payment, bounce a rent check, or cause damage to the apartment. Some landlords put onerous terms on these events as an easy way to break a lease.

- **Rules on roommates, pets or children.** Many leases specify whether or not you can have any of these things—most often they prohibit pets. But I do know one guy who asked his girlfriend to move in with him—and almost got evicted because the landlord didn't approve of unmarried couples living together (and this was in California).

- **Any conditions pertaining to your security deposit.** This issue is the single biggest problem in lease deals. Make sure you're clear on how the landlord can make charges against your deposit when you want to move.

Also, inspect the apartment carefully after you've agreed to rent but before you've moved in. Check the following:

- electrical outlets and fixtures for operating status
- appliances, heating or cooling and ventilating systems for operating status
- water pressure and drips or leaks in the bathroom and kitchen
- windows for broken or damaged glass, sticking or jamming and security devices
- doors for cracks, sticking or jamming
- fire or burglar alarms and security systems for operating status
- carpets or wood floors for damage, wear or stains
- floors and walls for cracks, buckling or noticeable damage
- panelling or molding for noticeable damage
- mirrors or other decorative elements in windows, staircases, fixtures or anywhere else

- balconies, decks or patios for usefulness

- any furniture or equipment being stored or offered for use

Before you sign your lease, you have some leverage. Once you've signed the thing, you're just another complaining tenant.

That said, go out of your way to stay on good terms with your landlord. He or she can make your life difficult, and you may need a recommendation from them for your next apartment. Landlords can also report late payments or non-payments of rent to credit reporting agencies.

One couple I know was borderline for being accepted as tenants in a really nice apartment building in New York. What got them in was a letter from their previous landlord saying they were completely hassle-free renters. I swear, this really happened. In New York.

The Human (and Subhuman) Factor

If you think I'm painting too sympathetic a portrayal of landlords, you're getting me wrong. Some landlords are low-life bloodsuckers. But fighting with them doesn't usually help you get what you need. Put any problems you have with your rent situation in writing, date the letter and keep a copy.

If your landlord agrees to change any of the terms of your lease, make sure to write it down in a letter and send it to your landlord. I like to start these letters with "This letter is to confirm that we have agreed to the following: ...," and end them with, "Unless I hear from you, I will assume that these terms are still acceptable to you." Although you are better off getting this letter signed by your landlord, this type of letter should be enough to protect you if your relationship sours.

Most states have laws controlling the rights of tenants. Regardless of what your lease says, these laws control things like how much of a security deposit and prepaid rent your landlord can require, how much they can take out of your deposit for damages, and how quickly they have to return your money after you vacate your apartment. These

laws are usually favorable to tenants, and if they are not followed, the landlord may have to pay you up to three times the amount of the deposit.

Almost every state (and even some cities and/or counties) has a Department of Consumer Affairs, Tenant Rights Department or similar group, that will help you with any problems with your landlord, and answer legal questions about your lease for free.

A friend in Los Angeles recently called to tell me his landlord was making noises about not giving back his deposit when he left his apartment. By calling the appropriate local-government help line, we found out that if he didn't get his deposit or a written bill for damages within 21 days of leaving, he was entitled to his deposit plus $600.

Another help line gave us instructions on how to file a claim in small-claims court for the deposit and the $600. He did this and promptly won the suit. That makes my record Tenants 5 and Landlords 0 as a legal adviser in deposit disputes.

You may be able to get out of your lease if your apartment is not "habitable," which can include leaks in the roof, infestations, heating or appliances that don't work, etc. Make sure you check with the local Consumer Affairs Department to establish your rights. Generally, your next step is to write a letter to the landlord explaining why you are leaving your apartment and keep a copy.

Mortgage

If you have a mortgage, it is likely to be your most expensive and most important payment. If interest rates have come down since you took your mortgage, you may want to consider replacing your mortgage loan with a lower interest rate loan. Part Eight of this book describes in detail how to decide when it makes financial sense to refinance your mortgage. For now, I'll just say that refinancing can save you a great deal of money over time, but may require some up front investment.

Interest on your home loan is tax deductible, and usually carries a much lower interest rate than credit cards or car loans. If your home has appreciated in value, you may want to consider refinancing with a larger loan, and paying off your other debt. Although this may not reduce your mortgage payment, it can reduce your interest costs on other debt. Because of the expenses involved in refinancing, you have to make sure that the savings justify refinancing.

An alternative way to get a lower interest loan using your home as collateral is a home equity loan. These used to be called "second mortgages," but that term has faded from use. Although these carry slightly higher interest than a new mortgage, they are usually more attractive than other consumer debt. Keep in mind that failing to pay your home equity loan is as serious as failing to pay your mortgage.

Interest on home equity loans is usually tax deductible as long as your total amount owed on any lines is less than $100,000—or if you use any amount over that for actual home improvements.

Warning: If you are having problems making your mortgage payment, it is essential that you contact your lender to look for help. Your lender may be amenable to one of the following:

- Interest only payments—but if you have had your mortgage for less than five years, this is not likely to reduce your payment dramatically; or

- Reduction in payments—your lender may be willing to temporarily reduce payments.

If your house is worth more than when you bought it, you will certainly want to consider selling it if your circumstances become extreme.

Property Taxes

Your property taxes are fixed by the tax assessor, based on the purchase price of your home and the value of similar homes in your area. If homes in your area have decreased in value, you may be able to

appeal the valuation on your home.

I recently read a study from a tax-payers' rights group that claimed almost half of all tax assessments have mistakes in them. Even if that number is high, it is true that you should check your assessment against previous ones—and against the original transaction records from the purchase of your house.

If you can get your tax assessor to agree to a lower valuation, you can reduce your property taxes. The best thing to do is get information regarding sales of comparable houses in your area.

If the prices for those sales give you evidence that your home has decreased in value or that your assessment was in error, you may have a strong case for a property tax decrease. Call your local tax assessor to discuss the procedures for appealing your assessment. I did this for a rental property my parents own in Hoboken, New Jersey, and was able to save them more than $900 a year.

Public Transportation

I live in Los Angeles, where the concept of public transportation is far more offensive than anything in a Quentin Tarantino movie. But there's no argument that taking a bus or train will be cheaper for most people than buying, maintaining and insuring a car.

While L.A. is particularly bad about mass transit (the city is building a subway that doesn't connect any major residential enclave with any major work center), other cities go out of their ways to make getting around easy. This is a key reason for young people to live in places like Washington, D.C., Boston, San Francisco, Chicago and—despite all of the jokes about its subways—even New York.

Car Payments

In strictly utilitarian terms, cars are an expensive way to get around. Avoid them for a while, if you can. But, since most people don't heed that advice, here are some points to consider.

If you haven't bought a new car yet, or you're still thinking about taking the plunge, let me offer two pieces of advice:

- First, cars are a phenomenally bad investment—they plummet in value from the first day they leave the sales lot. So, be careful about spending too big a portion of your monthly budget on them. A rule of thumb: Never borrow money to buy a car you love. If you have strong automotive passions, wait until you have cash to indulge them. Love is a bad thing to buy on installment.

- Second, never trade in a car you still owe money on for a more expensive one. Even if you're rocketing higher through your career, finish the terms of any deal—lease or purchase— that you enter. The things are designed to wallop you if you don't finish. (If you must have a new car every other year, explore using short-term leases.)

If you already bought a leased a car beyond your budget, it's probably too late to do much about it. If you own the car, you may want to consider keeping it after you've paid off the debt, to get one or more years of debt free operation.[1]

Gas, Maintenance and Repairs

Pump your own gas. Unless your owner's manual tells you otherwise, use regular unleaded. If you're not driving a luxury or sports car, you probably won't be able to tell the difference, and you'll save 15 percent off the price of premium.

Join the local chapter of the American Automobile Association (AAA) or other auto club. This is one of the best automotive deals you can make. Especially if you drive an older car, the towing service the AAA offers is absolutely critical—even if it can sometimes take a while when you call. This is also handy if you need a jump-start, run out of gas or lock your keys in the car. Auto clubs provide dozens of services that can help you out of automotive jams.

[1] For more on cars, see Part Four: The Second Biggest Purchase.

Rule number one for automotive maintenance and repairs: Always get a written estimate of exactly what work is going to be done and what it's going to cost. Estimate forms are standard to the auto repair business—you should ask for one when you bring your car in for work.

If you're not sure what's wrong and the repair shop is going to try to locate the problem, get a written estimate of what it will cost to find out what's wrong. Also: Make sure the shop doesn't start making a repair until you've been told what the problem is and what it will cost to fix.

A car dealer is the most expensive place to get your car repaired. I have a family friend who owns an auto dealership and he told me—after a few drinks—that he makes more money repairing a Toyota Camry than he makes selling one. (And a Camry is a relatively reliable car.)

This is one reason why specialty shops that do nothing but lube and oil changes have grown so quickly. Use those places whenever you can—and at least once every 5,000 miles. Oil changes at these places usually satisfy the warranty requirements for a new car and will keep an older car running longer.

In general, it's a good idea to use national chains for oil changes, brake jobs, mufflers and transmission work. They are usually much cheaper, know what their doing, and for the repairs, offer long-term warranties.

For other types of work, try to find a trustworthy local shop that can do your auto repairs on a budget, preferably one that is an expert in your model car. Ask people you trust—friends, neighbors, co-workers—if they have a mechanic they trust. If you can't get a recommendation, look up auto mechanics or repair shops in the phone book and make some calls. Explain your problem and say you'd like an estimate. If the car's still running, make a few appointments and drive by a few shops—make sure to bring something to read. If the shop can't check the car and give you an estimate of what's wrong and what it will cost within an hour or two, go to the next one.

If the car's not running, you're going to have to be more patient. If you have an AAA membership, you can schedule to have the car towed to a repair shop. Again, make sure to tell the shop not to do any work until they give you an estimate that you approve.

Some repair shops may offer to tow your car to their place. Some even offer to do this for free—if you get the work done there. If you take someone up on this offer, be prepared to be charged for the tow if you decide not to do the repairs there.

Don't tell anyone what you're prepared to spend until the people at the shop tell you what's wrong and what they think it will cost to fix. If you don't like the estimate they give you, negotiate. Give them an amount you can spend and ask whether they can get the car running again for that price. Also ask if the shop can use reconditioned parts—or even used parts—and still have your car running safely.

If you're patient—and if you look for a mechanic before your car stops running—you can usually find reasonable local repair shops. I found that by taking my second-hand Saab to a local guy (actually two Swedes named Sven and Lars—again, I'm not kidding), I could save about 40 percent on major repairs and tune ups. I drove that car until it had more than 120,000 miles on the odometer.

That was an effective automotive expense.

Chapter Four

Containing the Cost of Consumables

Introduction

Once you've figured out where to live, your biggest questions are going to be what things are necessary—or nearly necessary—to maintain the kind of life you want to lead. Living at home with your family or in a dorm at school can hide a lot of expenses that come crashing into your checkbook every month when you're out in the real world.

Many of these costs go toward consumables—things you use once or a few times and then can't or don't use again. Some people consider this kind of spending a waste of money. And they're sometimes right. Consumables are definitely a place you want to minimize expenditures. In this chapter, we'll consider how.

Long Distance Telephone Service

If you're still using AT&T, MCI or Sprint for long distance, you're probably paying too much. Although these provide excellent service, they are premium priced services. By switching to an alternative long

distance carrier, you can save up to 40 percent on your long distance phone service. Although these services are not quite as efficient as using one of the major carriers for things like international long distance, they offer competitive service at attractive rates.

Also, because of increased competition among long distance phone companies, you can take advantage of incentives offered by the major and second-tier long distance companies by switching between carriers several times a year.

At various times, I have been offered checks for $50, free calls home on major holidays and $50 of free long distance calling, just for switching long distance carriers. By switching once, you increase the likelihood that you will be offered these incentives. Switching a couple of times a year can provide you with a lot of free calls, although your new carrier may require you to stay with them for a minimum of time to receive these bonuses.

The following charts provide a comparison of rates and the phone numbers for some of the larger alternative carriers. Keep in mind that these rates change fairly often, so you have to make some phone calls to find out who is cheapest.

THE BIG THREE

Rate Per Minute

	Day	Evening	Late & Weekend	Billing Increments	Discount Plans and Monthly Fees
AT&T 800-222-0300	.24-.34	.14-.23	.12-.17	60 seconds	25 percent discount when monthly bill is $10—$49; 30 percent when bill is more than $50
MCI 800-444-3333	.22-.24	.14	.11-.13	60 seconds	25 percent off when monthly bill exceeds $10, 50 percent off calls to Friends & Family circle
SPRINT 800-746-3767	.24-.34	.14-.23	.12-.17	60 seconds	Sprint Sense flat rates: 7 a.m.-7 p.m.,.22; 7 p.m.—7 a.m. and weekends.10

BARGAIN ALTERNATIVES

Rate Per Minute

	Day	Evening	Late & Weekend	Billing Increments	Discount Plans and Monthly Fees
ALLNET 800-631-4000	.22	.10	.10	6 seconds	None
LCI 800-524-4685	.19	.14	.12	6 seconds	Free calls on holidays like Mother's Day, Valentine's Day, etc.
LDDS WORLDCOM 800-275-0100	.20	.10	.12.5	6 seconds	None
TELEGROUP 800-338-0225	.13	.13	.13	6 seconds	$5 fee if bill is less than $50
UNIDIAL 800-895-7474	.12.9	.12.9	.12.9	60 seconds	$3 monthly fee

Another way to save on long distance is by sending e-mail over your computer. Several software companies have come up with a way to make long-distance phone calls over the Internet. Some require that both parties purchase the software to be able to converse. Another newcomer has started using similar software to allow everyone to use the Internet for long distance without requiring you to have this software. Essentially, you call a local number that gets you into their system. They hook into the Internet and exit to local lines near the party you are calling. This system is only available in parts of New Jersey, but it is likely to spawn competitors.

Another inexpensive way to communicate long distance is a quaint method of communication known as writing a letter. For 32 cents, you can talk as long as you want to anywhere in the country, and everybody loves to get mail.

Local Telephone Service

Local phone companies typically sign you up for a basic package that allows unlimited local calls. Most offer a discounted rate, that comes with a limit to the amount of free local calls you can make. You should compare this rate to your current rate bill to see if it will save you money. Depending on your earnings, you may qualify for Universal Lifeline or comparable service which is specially provided to low income households. Particularly if you're just starting out, you might be able to get this rate which is often half of the normal monthly charge. Call your local phone company or check the front section of your white pages for details.

Cable Television

Cable television usually comes in a wide variety of options, and the cable company charges you extra for everything. You may be able to save money by canceling some of your services, such as the remote control rental (many television remote controls can also be programmed to work the cable box—check your owner's manual), or the monthly cable guide (often more expensive than a magazine subscription).

If you are having real financial difficulty, or if you want to get to know your friends or family better, you may want to cancel cable television altogether.

Another thought: With video cassette recorders selling for less than $100, you can buy one of these and avoid cable. You can rent or tape programs you like to watch and recoup the money you would have spent on cable bills in a couple of months. When you rent videos, pick a place that has an all night return slot, otherwise, you'll wind up with several videos and all of the late charges you can accrue.

A growing number of public libraries also stock videos—which you can check out for free. New releases can be tough to find at the library; but if you like classics, you may find more that you like at the library than some video rental stores.

Electricity, Water, Gas and Garbage

Many municipalities have discounted utilities services for low income families. Check to see if these programs are available, and get a list of qualifications by calling your local utility. This is particularly true if you are renting by yourself.

Furniture

The best places to find cheap furniture are in thrift stores and yard sales. If you are handy with refinishing, you can usually find some decent pieces at dirt cheap prices, just because someone painted them an ugly color. Look for pieces that are solid, and need a minimum of repair. Also, check you local newspaper for auctions—when companies go bankrupt or move or when hotels remodel, they often sell lots of furniture at really low prices.

Groceries

Shopping at warehouse stores, clipping coupons and buying bulk or generic brands can save you 10 percent or more on your grocery bill. If stores in your area give double credit for coupons, you can save even more. Buy fresh foods and produce once or twice a week in reasonably small portions. Many people buy groceries in bulk for per-pound savings—but end up tossing half or more that they don't eat by the time it goes bad. Better to pay a little more per-pound and use what you buy.

Also, avoid buying brand names when generics will do—in many cases, they are required by law to be the same. Here are some examples of items where this can make a difference:

Aspirin
Acetominophen (Tylenol is one brand)
Bleach
Sugar
Flour
Vitamins & Minerals
Vegetable oil
Nuts
Pasta

Alcohol

If you can't afford to pay the rent, you shouldn't be drinking imported beer. The alcohol industry spends more than almost any other industry to try to convince you that their brand is the best. You wind up paying for all that advertising.

As a longtime bartender, I challenge any of you to identify the brand of vodka in your vodka tonic. Most people can't even identify their regular vodka in a blind taste test. The darker liquors are a bit easier to identify, but expensive liquor is not always better. My grandmother used to keep a Chivas Regal bottle full of Safeway Brand scotch, and she claimed that no one ever mentioned the difference. (That does not mean that no one noticed.)

When it comes to wine, there are plenty of good wines for under $10 a bottle, and plenty of plonk for lots more money. Anyone can choose the $50 bottle, but most people shouldn't be spending their money like that. Try to find and serve one or two inexpensive bottles and you'll really impress your friends. Don't be surprised if they start buying the same bottles.

Cigarettes

They're bad for you. They're also expensive—a pack a day habit costs almost $1,000 a year. So, why don't you cut down? I recommend buying an off brand. They cost a lot less, and they taste different, so you probably won't want to smoke as many. You can even try rolling your own. It's much harder to smoke as many. So you save money, and the tobacco has less additives, so you'll be better off physically. (Also, if you *have* to smoke, rolling your own is very cool.)

Coffee and Bagels

If you're making $20,000 and spending $3.75 for a mocha cappucino coffee drink and a muffin or bagel at the local coffee house every morning before work, you may be dedicating about $1,200 of your gross income to breakfast. Drink your coffee at home or drink the free stuff in the office, and bring a muffin with you. No one cares where you buy your muffins. If you would be traumatized without a caffe latte, spend $40 for a espresso machine and put it in the break

room. Then you can make all the coffee drinks you want on a reasonable budget.

Snacks

One of the most expensive ways to buy food is in small packages at little stores. This is easier to avoid at home. For work, bring some carrot sticks or an apple from home, and keep some gum in your desk. People won't think you're cheap, they'll assume you're on a diet.

Music

Three ways to save on music: tape your friends' music, buy used CDs, and join either the BMG or CDHQ record clubs. These clubs let you have 11 CDs or tapes for the price of 2 (usually you have to buy one, and the shipping and handling costs are equal to the cost of another one), and then you can quit. If you're going to buy 2 CDs anyway, this is an excellent way to get 9 for free. You can find order forms in most music magazines, and lots of others. Avoid the Columbia House and other clubs that make you buy several more CDs over a period of time. You'll never satisfy their needs, and the bill collectors for those clubs are even tougher than student loan officers.

Sports Events and Concerts

Unless the game is sold out or a playoff game, show up a few minutes after the game starts and see if you can score tickets off of a scalper. Once the game begins, you can usually get a pretty good deal. Make sure to look at the tickets closely to be sure you're not buying a fake, or a ticket for another night. For concerts, call the ticket office on the day before, or morning of the concert. Because most of the staging is done at the last minute, they often release additional stageside seats at the last minute.

Dining Out

There are about a dozen ways to save money when dining out, but some are more practical than others. You should know a few things

about where restaurants make their money—drinks (both alcoholic and non-alcoholic) and desserts. Appetizers that are priced at about 75 percent of the cost of an entree may not be as profitable, but they can add dramatically to the cost of your meal. If you can keep these to a minimum, you can shave about a third off of the cost of dining out. These are some ways to lower your dinner bill and still have a good time:

- Meet at your place, or hers, his or theirs, and have a cocktail (or two) before you go to dinner—you can save money on drinks, but you'll probably have to clean up before your guests arrive. And possibly after they leave.

- Skip dessert—instead of paying $6 for an overpriced creme brulee, suggest the cafe down the street, stop at a Baskin Robbins, or—if you're a pound or two over your perfect weight—just have coffee.

- Bring your own bottle—although they're a little tough to find, many places will allow you to bring your own bottle of wine, saving you a lot of money compared to the 100 percent premium that most restaurants charge for ordering off of their wine list. Be aware that some of the more fancy restaurants will charge you a "corkage" fee to allow you to bring in your own bottle.

- Eat at less expensive restaurants—a look through a local magazine or newspaper, Zagat guide or other food guide is usually enough to identify bargain restaurants in your area. Remember that a white tablecloth doesn't make the food taste better.

- Go ethnic—everyone knows that pizza or Chinese food are less expensive than "continental cuisine," but you can usually score some cheap food, and a new outlook, eating Indian, Mexican, Russian, Ethiopian or Vietnamese.

Dining Cards

Dining cards are the perfect solution for people who like to be frugal, but love great food. If you spend more than $500 per year dining out,

and like to go to nice restaurants, you can save a fistful of dollars by getting a dining card.

There are several different versions of the concept, but they all have one thing in common—they provide you with discounts for eating at restaurants that accept their card. That means that the key is to make sure that your new dining card is acceptable at restaurants in your area, and that they're places where you want to eat.

Most dining cards cost about $50 per year and give you a discount of 25 percent off the price of your meal, including drinks. These cards can be difficult to use—they're usually designed that way—but if you take the time and make the effort to master the system, you can do well with them.

Transmedia (800-422-5090) is one of the oldest and has an extensive list of restaurants in many cities. In Good Taste (800-444-8872) is another up and coming card, with a pretty good selection of restaurants, depending on the city (it's strongest in New York, Florida, Chicago and Los Angeles). Both of these issue you a credit card with their name on it. You use the credit card and your bill arrives with 25 percent off the top.

Entertainment Club (800-346-3241) works slightly differently—your restaurant directory has coupons in it that specifically describe the deal you will get at each restaurant (one free entree with the purchase of another, etc.).

If you are afraid that whipping out a discount dining card is not going to impress your date, friends or clients, then you should probably join Dining a La Card (800-833-3463). Although this club only gives you a 20 percent discount and you can only get a discount at any specific restaurant one time per month, the service is automatically linked to your American Express, Visa, Mastercard or Discover. You can pay with a "real" credit card and, as the advertising says, "no one will know the difference." At the end of the month, DLC sends you a check for 20 percent of your bill, including tax and tip. (Unlike most cards, which don't rebate tax or tip.)

Another benefit is that you have a receipt on a real credit card for the full amount of your bill, which may come in handy for dealing with expense account matters. Whether you choose to mention the 20 percent rebate to your accounting department is between you and your god.

Athletic Stuff

Most athletic equipment is made to last, and can be bought used at a fraction of its original cost. There are several chains of sporting goods stores that specialize in selling used gear. For big ticket items, like exercise machines and treadmills, you can usually find an ample supply in the classifieds.

Travel

Travel can provide some of the most memorable times of your life, for both good and bad reasons.

Travel agents are paid commissions by the airlines, hotels and rental car companies to help you. They will do a tremendous amount of work for you, and usually know the best way to save money. However, because the size of their commission depends directly on the amount of money you spend, they have a financial incentive to get you to spend more. Make sure that you tell them that you are on a budget, and ask them to get you the best available price. A few travel agents may charge a fee of $10 to $35 per airline ticket, so ask up front if they have service fees.

Getting the Best Bargains

Every seat on an airplane, room in a hotel or berth on a cruise ship that goes empty is money lost to the travel business. About 40 percent of the seats on every airline flies empty. If the airlines could get $25 for each of those empty seats, even after spending $1.45 for each additional rubber chicken, they wouldn't go out of business so often. But if everyone could buy tickets for $25, no one would pay $1,500 for a "full fare" ticket.

The travel industry's problem is your opportunity. The major air-lines, American, Delta, USAir, Northwest, United, TWA and Conti-nental try to solve the problem with a thing called yield manage-ment—the art of selling the same ticket for a wide variety of prices to get the most passengers to pay the most money. For instance a full fare ticket from Los Angeles to New York on United or American costs $1,400. If you can stay over a weekend, and buy your ticket three days, or a week or two weeks in advance, you can buy the same ticket for as little as $350.

If you can't meet the airlines' advance purchase or Saturday stay re-quirements, but you have definite travel plans, you can use a dis-count ticket broker, also called a consolidator.

Discount brokers buy blocks of empty seats from airlines and then sell them to the public. Usually, these tickets are not refundable or changeable—if you don't use them, you have to throw them away. They sometimes require that you buy them a day prior to your trip, and you usually can't get these tickets through a travel agent. Also, you usually have to call the airline directly for seating assignments.

I have used a consolidator called Cheap Tickets (800-377-1000) on several occasions with great results. They have offices in many major cities, or they will mail tickets to you via overnight mail for an addi-tional charge and provide similar services to travel agents.

Besides the major airlines, there are the low fare airlines, such as Southwest, ValueJet, Reno Air, Tower Air and others. (Discount ser-vices being introduced by the major airlines have comparable low fares, but don't operate in all markets.)

Discount airlines generally fly shorter routes and charge everyone the same low fare. They don't serve meals, often don't have assigned seats and usually fly full. Also, because the gate agents and crew are so harried, be prepared to be treated like cattle or worse. (I'm sitting on Southwest Airlines as I write this sentence, and I don't have the time to tell you how bad their service can be.)

All in all, if you're willing to show up at the airport an hour before your flight (or more on holidays) so that you can get a decent seat, you can get some of the best prices available.

You usually have to ask your travel agent specifically to check the fares on Southwest, ValuJet, and some others, because they are not hooked into the same computer reservation systems used by the major airlines. Like Domino's and Pizza Hut, they often run specials, such as allowing a friend to fly with you for free or at a big discount. Make sure to ask your travel agent or reservations agent. Because there are limited seats for these programs, you should always make your reservations in advance.

Vacation Packages

Hotels, cruise ships and tour operators have the same problem—how to fill their empty seats, and still get top dollar from at least some of their customers. At most hotels, if you ask for a discounted rate, you may be able to get a lower rate than the one originally quoted.

Also, there are several groups that buy up space on vacation packages and sell them at a discount for last minute travelers.

Clothes

I wish I could put all of my mother's expertise on this subject into this paragraph, but it could take years to get all of her theories in writing. Suffice it to say that "shopping" should be something you do for fun—and only with cash you've budgeted in advance. You should reserve "buying" for only the things you can afford.

Health Clubs

I did some consulting work for a chain of health clubs, and they told me that almost 60 percent of their members used the club less than five times a year. That means that 60 percent of you have no business joining a health club. If you feel that you must, you can usually get a free month's membership at most clubs to entice you to join. If you don't use it during that month, you shouldn't join. The local branch

of the YMCA is often a less expensive alternative, and so is joining a company or church-sponsored softball, basketball or soccer league.

Gifts

Many people are frugal on their own expenditures but spend lavishly on gifts for others. Unless you're buying someone a jewel encrusted Faberge Egg, they probably won't remember your gift for more than a few weeks. Remember, it really is the thought that counts.

 Web Tip

There is a useful government operated information clearing house in Pueblo, Colorado. But now you don't have to write them, you can go on-line to find guidance on hundreds of topics, including the ever-popular "66 Ways to Save Money." You can even read that pamphlet on-line, and save the $.50 cost of the pamphlet. They're at http://www.gsa.gov/staff/pa/cic.htm.

Part Two:

Taming Your Tax Burden

Chapter Five

Tax—Not Just a Good Idea: It's the Law

Introduction

Will Rogers, the first great American pundit, claimed that the income tax system was our greatest source of lies since the invention of golf. Although a healthy imagination is one tool for minimizing the tax bite you face every year, a reasonable understanding of how the tax system works is the best way to avoid paying through the nose.

Essentially, the federal government, and most states, collect a tax from individuals on the money they earn every year, called an "income tax." They accomplish this by either withholding part of your paycheck, if you work for someone else, or by requiring you to make periodic direct payments, if you're self-employed.

People respond very strongly—and usually negatively—to paying taxes. There are many theories about why this is so. Mine is simple: People work hard for their money, but the government just orders tribute like some kind of Egyptian pharoah and then squanders it on $600 screwdrivers. What's worse: Simply taking a big chunk of your

pay check is not cruel enough for your free-spending Uncle Sam. He feels the need to humble you by making the paperwork, the rules and even the language of the tax system so confusing that even the people at the Internal Revenue Service can't agree on exactly how it works.

Which may explain why they're so unpleasant so often.

Nevertheless, unless you're as fabulously wealthy as Thurston Howell III, taxes are really pretty simple. Just like in sex education class, understanding a few basic terms can help you get a grasp of the situation—with minimal embarrassment.

Graduated Tax

The federal income tax is calculated as a portion of what you earn. That means that the more money you make, the more taxes you pay. The theory behind this is that people who make more money should pay more taxes than people who make less money.

Not surprisingly, almost everyone agrees that we should tax the rich. The problem is that "the rich" usually means "anyone that makes more than I do."

In order to make the rich pay more, the federal tax is *graduated*. A graduated tax system has several different tax rates, and the higher rates apply to people who make more money. For instance, the tax rate for a single taxpayer with earnings of up to $24,000 is 15 percent, and the tax rate for earnings of over $24,000 (and up to about $58,000) is 28 percent. So if Bruce makes $24,000, he has to pay 15 percent, or $3,600, to the federal government. If Demi makes $25,000, she still pays 15 percent, or $3,600, on the first $24,000 she earned, but she has to pay 28 percent, or $280, on the remaining $1,000. Her total tax bill would be $3,880.

	Tax Rates	Earnings	
	15 %	$0-24,000	
	28 %	$24,001-58,150	
	Earning	Tax Rate	Tax
Bruce	$24,000	15 %	$3,600
Demi	24,000	15 %	3,600
	+1,000	28 %	280
	$25,000		$3,880

The benefit of a graduated tax is that it doesn't require you to pay a higher rate on all of your earnings, just on the incremental amount. For instance, Demi only had to pay the higher 28 percent rate on earnings over $24,000. If the tax were not graduated and Demi had to pay 28 percent on all of her earnings, she would have to pay $6,720. That would represent an extra $3,400 in taxes for earning $1,000 more than Bruce. In other words, she'd wind up having less money than Bruce, even though she made more. Fortunately, the tax system doesn't work that way.

Adjustments

There are a number of adjustments that can reduce your taxes. The government allows these in order to encourage people to make certain expenditures, to favor certain types of businesses over others, or for certain other political reasons.

These adjustments include tax deductions, tax exemptions, tax credits and other items we will talk about below. These things make the tax rules difficult to understand, but they are also the rules that will allow you to reduce the amount of taxes you have to pay.

Tax Deductions

One way to pay less taxes is to make less money. Unfortunately, this isn't a very practical solution. The other way is to have deductions. A

deduction allows you to make believe that you didn't make as much money as you actually did. So if you made $21,000 last year, but spent $2,000 of that money on things that are deductible, the IRS will allow you to claim that you only made $19,000—and you only have to pay taxes on that amount.

Deductions are usually expenditures that are related to business, or expenses that are otherwise attractive for the economy or society. For instance, interest on mortgage payments is a deduction, in order to encourage people to invest in houses. Gifts to charity are also deductible.

Tax Exemptions

An exemption is similar to a tax deduction, but it doesn't require you to spend your money in a specific way.

The most common exemption is the one based on the number of dependents you have. Except for people who earn a lot of money, every taxpayer gets to reduce their income by about $2,550 (in 1996) for each dependent including the taxpayer, spouse and children, and this number goes up every year.

Also, there are several types of earnings which are not taxed by the federal government—they are referred to as "tax exempt." For instance, interest earned on tax-exempt municipal bonds is not taxed. Municipal bonds are used by state and local government to borrow money to build highways, schools, hospitals, sports stadiums and other public uses.

In order to encourage people to invest in these projects, the interest paid on these investments is tax-exempt. That means that you don't have to include this in your earnings when you are calculating your taxes.

Because they have tax advantages, municipal bonds usually pay less interest than comparable taxable bonds. That saves money for state and local government.

Other types of earnings that are tax exempt include certain government payments, child support, gifts you receive, insurance proceeds (with certain exceptions) and certain scholarships.

Tax Credits

These are the rarest tax advantage, and they are also the best. A tax credit is a direct reduction to your tax bill. For instance, at a 15 percent tax rate, Bruce has to pay $1,500 on earnings of $10,000. If he qualified for a tax credit of $1,000, that would reduce his taxes to $500. The most common tax credits available to individuals are for money spent on child care, and elderly or disabled care expenses for people who are your dependents.

Alternative Minimum Tax

This is something you won't have to worry about unless you are very wealthy. Essentially, the alternative minimum tax, or "AMT" to you tax geeks, applies to rich people that try to take advantage of too many tax adjustments to reduce their taxes. The AMT requires that no matter how many tax benefits you have, if you make over a certain amount of money, you have to pay taxes of at least 24 percent of your earnings.

Flat Tax

There has been a lot of talk lately about scrapping our current system, and replacing it with a flat tax. A flat tax is the opposite of a graduated tax—under a flat tax, everyone pays the same percentage of their earnings as taxes. A true flat tax also eliminates all tax deductions, exemptions, credits and adjustments. The benefit of the flat tax is that it is easy to calculate. In theory, a flat tax return would only have two lines. In one, you enter the amount of money you made for the year. In the other, you enter the amount that you are paying in taxes, which equals your income multiplied by the flat tax rate. If the flat tax rate was 20 percent, your tax return might look like this:

Form AAAA Flat Tax	
Name: Ken Griffey, Jr.	
Address: Seattle, Washington	
Income:	$8,000,000
Taxes (multiply income by 20 percent):	$1,600,000

However, the flat tax would eliminate the government's ability to favor or punish certain activities or groups of taxpayers through the use of the tax deductions and other adjustments. Because this is such an important source of power for politicians, the odds that a pure flat tax will replace the current system of taxation in the United States are only slightly higher than a Milli Vanilli reunion.

Tax Tables

The tax tables change almost every year, but the 1996 tables below will give you a general idea of recent tax rates. Keep in mind that you are taxed on your income, after you take all the adjustments allowed. If you're single, you can knock off at least an exemption for yourself ($2,550) and a *standard deduction* ($3,900) from your total income.

Taxable Income	Tax
Single	
up to $24,100	15% of every dollar
$24,001 to $58,150	$3,600 + 28% of amount over $24,000
$58,151 to $121,300	$13,162 + 31% of amount over $58,150
$121,301 to $263,750	$32,738.50 + 36% of amount over $121,300
over $263,750	$84,020.50 + 39.6% of amount over $263,750
Heads of Households	
up to $32,150	15% of every dollar
$32,151 to $83,050	$4,822.50 + 28% of amount over $32,150
$83,051 to $134,500	$19,074.50 + 31% of amount over $83,050
$134,501 to $263,750	$35,024 + 36% of amount over $134,500
over $263,750	$81,554 + 39.6% of amount over $263,750
Married Couples Filing Jointly and Surviving Spouses	
up to $40,100	15% of every dollar
$40,101 to $96,900	$6,015 + 28% of amount over $40,100
$96,901 to $147,700	$21,919 + 31% of amount over $96,900
$147,701 to $263,750	$37,667 + 36% of amount over $147,700
over $263,750	$79,445 + 39.6% of amount over $263,750
Married Filing Separately	
up to $20,050	15% of every dollar
$20,051 to $48,450	$3,007.50 + 28% of amount over $20,050
$48,451 to $73,850	$10,959.50 + 31% of amount over $48,450
$73,851 to $131,875	$18,833.50 + 36% of amount over $73,850
over $131,875	$39,722.50 + 39.6% of amount over $131,875

The Magic Number—Your Marginal Tax Rate

Your *marginal tax rate* is the tax rate applied on the last dollar you earned on the last day of the year. Continuing with the fun couple we considered earlier in this chapter, Bruce paid 15 percent on every dollar he earned, including the last dollar he made, so his marginal tax rate is 15 percent. Demi paid 28 percent on the last dollar she made, so her marginal rate is 28 percent. This is also called your *tax bracket*—Demi is in a 28 percent tax bracket.

This number is crucial because it tells you how important it is to save money on taxes. If Bruce could somehow shield $500 of his earnings from being taxed, it would save him 15 percent, or $75, on his tax bill. But if Demi could shield $500, she would save 28 percent, or $140, on her tax bill. Therefore, Demi has a greater incentive to try to reduce her tax bill.

Tax exempt municipal bonds are discussed in greater detail in Part Six of this book, which looks at investments. However, this is a good opportunity to look at the importance of your marginal tax rate. Let's assume that Bruce and Demi were considering where to invest $1,000. Also assume that their choices were to invest in a bond from IBM, that would pay interest of $90 per year, or a tax exempt municipal bond from the New Jersey Turnpike Authority that paid interest of $70 per year.

Bruce is in a 15 percent tax bracket. If he bought the IBM bond, and received $90 in the first year, he would pay 15 percent of that amount (or $13.50) in taxes. So he would get to keep $76.50 ($90 he earned less $13.50 in taxes). If he bought the tax exempt bond, he would earn $70, but he would pay no taxes on that money. Although the tax exempt bond would save money on his taxes, he would earn more by investing in the IBM bond.

Demi is in a 28 percent tax bracket. Therefore, if she invested in the IBM bond, and earned $90, she would pay taxes of 28 percent of that amount, or $25.20. That means her net earnings after paying taxes would be $64.80. If she invested in the New Jersey bond, she would earn $70, and she would pay no taxes on that amount. Therefore,

Demi would make more by investing in the tax free bond. This example illustrates the point that although something is more attractive from a tax savings standpoint, it may not be the best solution for you.

When Is It Income?

For most types of income, such as salary, tips, bonuses, interest, etc. it is income when you receive it. So if you get your paycheck, you have income. However, if you earn a commission in year 1, but don't get the commission check until after January 1, it's income in year 2. If you expect to be in a lower tax bracket in year 2, or expect that you'll have more deductions to shelter your income, you can use this fact to try to move income into an earlier or later year. As we'll discuss later, money that you make on "capital investments" such as houses, stocks, bonds and other items isn't taxable until you sell the investments. If you buy a house for $100,000 and the value of it increases to $125,000, you have made $25,000 without paying taxes. Eventually you will probably sell the house , and then you will owe taxes on your profits. However, the ability to choose the timing of these profits can help you manage your tax liabilities. In some cases, you can avoid taxes forever, as we will discuss below.

Other Tax Terms

To bring this chapter to a close, I'll quickly run through a number of other tax terms and concepts that are useful—although these are not nearly enough to get you a job at H & R Blockhead.

Capital Gains (or Losses) are money you make (or lose) when you sell an investment that you have owned for at least six months. The reason that this definition exists is that the government wants to encourage investment, so it has established a lower tax rate on capital gains. Although the current top tax rate is 39.6 percent, capital gains don't get taxed at over 28 percent. You would keep over ten percent more money.

For example: If you buy a share of stock for $5 and sell it a year later for $11, you have a capital gain of $6. You have to pay taxes on the $6

of capital gain, but you don't have to pay taxes on the remaining $5 because you are merely receiving your original investment back. Theoretically, you paid taxes on that $5 in some prior year.

Capital investments include houses, stocks, bonds, art collectibles, and other investments.

Ordinary Income is the opposite of capital gains, and includes income from salary, bonus, dividends, interest, royalties, tips and numerous other sources.

Adjusted Gross Income, or AGI, is your income, less certain adjustments related to retirement savings and alimony. You calculate this number as part of your tax return, and it is a measurement used to limit certain deductions.

Depreciation is an estimated deduction you can take now for things used in business that wear out.

For example: If you are a stone mason, and you buy a cement mixer, you should be able to use that cement mixer for years. Therefore, the IRS won't allow you to deduct the cost of the cement mixer in the year you buy it. However, the IRS will let you estimate the number of years that the cement mixer can be used, and deduct the cost of the cement mixer over that number of years. If they think a $5,000 cement mixer should last five years, you can deduct $1,000 of depreciation per year for the next five years.

This becomes a big deal for people who are self-employed. It also works well for people who invest in real estate. They can get a deduction based on the depreciation of their investment, which is more than the money they actually spent maintaining the house. In the meantime, the value of the house isn't depreciating, it's actually increasing over the years, and can be sold for a profit. This is one of the few deductions you can get without actually spending money. You can't depreciate your investment in your home—only income producing properties qualify for this tax break.

A warning: The Feds can be strongly opinionated about how they think a thing should be scheduled for depreciation. Many of the most heated battles in tax court are people or companies disagreeing with the IRS about depreciation.

Basis is the amount of money you put into a capital investment, including the purchase price plus subsequent investments. You need to know your basis in order to calculate your profit (or loss) on an investment you've made. When you sell an investment, you only pay taxes on your profit; you don't pay taxes on the return of your investment.

For example: If you buy a house for $80,000, and you spend $12,000 to add a bedroom, your basis is $92,000. If you sell the house sometime later for $100,000, your profit on the investment is $8,000. That's the part of the investment that the government will tax.

Chapter Six

Filing Instructions

Introduction

The Internal Revenue Service is the branch of the government that is in charge of collecting taxes. It divides its collection periods into calendar years. What's more, it tries to collect as much income tax as possible in advance—in the form of deductions from workers' paychecks.

For most people, filing an income tax return is a matter of adjusting the amount owed to the amount that's been paid in advance through these deductions. Through the course of a working life, there are likely to be years in which you owe the IRS money at the end of the year—and years in which the IRS owes you. Whichever is the case, you need to do the paperwork.

The IRS loves paperwork. Aside from collecting taxes, it is responsible for printing and distributing the forms, and workbooks and other information related to calculating your taxes.

You can get IRS publications that explain almost every aspect of the tax code. You can also talk to people at the IRS about questions you have—they will even calculate your taxes for you.

However, you may get better advice from an alternative source of information who is more...aggressive...when dealing in some of the gray areas of the tax code.

This chapter gives you the basics on who has to file, when and how to get the job done—either alone or with the help of a pro.

Forms and Filing Information

No matter how old or young you are, if you make more than $6,400 during a single year if you're single—or $11,550 if you're married and filing jointly as a married couple—you have to file a tax return, which is the document used to calculate what you owe. Even if it turns out that you don't owe any taxes, you still have to file a tax return.

The failure to file a tax return can be a serious problem, although, as a practical matter, you won't get in much trouble if you don't owe any money. This is a common situation for people in their first jobs—where salaries aren't huge and employers deduct money from each paycheck to prepay income tax obligations.

I've known people who work five or six years without filing a tax return because they've actually overpaid their income tax through paycheck deductions—and they're too lazy to collect the difference. This may make you feel like a bohemian non-conformist—but it's a very bad idea.

A mistake in this area can be very expensive. If you don't file a tax return and you owe any money, the IRS will hit you with absolutely unreasonable penalties and interest on the amount of money you owe. I have a friend that made a legitimate mistake on about $800 of taxes (the actual amount of the mistake was even smaller than that). He thought it was too small an amount to be a concern to the Feds. By the time the IRS caught up with him, the penalties and interest were over $2,000.

Even if your tax situation is very basic, and even if the Feds owe you a pittance in return, you should fill out the forms. As we'll see later in more detail, there are simplified IRS returns that only take a few minutes to complete.

Like so much else about financial planning, this is a matter of discipline. Filling out the forms from the beginning will get you in the habit of dealing with the IRS. Later, when your situation becomes a little more complex and using an accountant begins to make sense, you'll at least have some background of understanding of the system.

These are the important phone numbers that you should know about when dealing with the IRS.

- General Number 800-829-1040
- TDD Equipment 800-829-4059
- Forms Only 800-TAX-FORM (829-3676)

When You File

Individuals have to file their taxes by April 15 of the year after the tax year in question. In order to qualify as having filed, you have to get your return to a post office before it closes so you can postmark your letter on that day. (If April 15 falls on a weekend, you get to file by the following Monday.)

If you are sending a check with your return, I suggest using registered mail so that you have proof that you actually mailed your return on time. Even using Federal Express or one of the other overnight delivery services will provide you with evidence that you filed and paid on time.

Extension of Filing

If you aren't going to be able to complete your tax return by April 15, you want to make sure to file a Form 4868. This is my favorite IRS form because it gives you a four month extension (until August 15)

to file your taxes. And, if you need more time, you can file a Form 2688 by August 15, to get a second extension until October 15. Some states give you an automatic extension if you request an extension for federal income taxes. Others require their own forms.

The only problem is that you have to pay an estimate of the taxes you owe by April 15, when you file the Form 4868. As long as your estimate is relatively close, you'll have no trouble, but you will have to pay interest on any additional amounts when you file your return. If you are more than 10 percent off on your estimate, you can be assessed some major penalties when you finally pay your taxes.

Reports of Your Income

The IRS receives information from a variety of people who pay you money during the year, so they usually know how much you make and if you should be filing a return. The following is a list of forms that are used by your employer, bank, brokerage firm, etc. to inform the IRS of the amount of money you made during the year. You should receive copies of these by January 31 of the following year. If you receive a form that has a mistake on your name, address or social security number, mark your copy of the form to indicate the change. If any of the money amounts are wrong, immediately contact the person that sent you the form, inform them of the mistake, and ask for an amended form. If you try to change the form yourself, the IRS will assume that you're lying. The forms used to report your income are listed below:

- **W-2.** This is the form you receive from your employer that tells you how much money you earned. Your employer also provides this information directly to the IRS.

- **Schedule K-1.** This form reports gains or losses from an investment in a partnership.

- **Form 1099.** This is an all purpose form that comes in a number of varieties (for example: 1099 INT for interest, 1099 DIV for dividends, 1099 MISC for miscellaneous income, etc.). This form is used by your bank, brokerage firm and

even some part-time employers to report income from interest, dividends, sales of stock and bonds and retirement income.

Income Not Reported

Certain income is not reported to the IRS by any external source, such as tax exempt income from municipal bonds, or tips, or cash paid to you "under the table." You are supposed to report these amounts to the IRS, and (except for the tax exempt income) pay taxes on them. Naturally, if you don't report this income, you will not have to pay taxes on it. Keep in mind that this is the most serious tax offense you can commit. However, unless you are working at a job that may be closely monitored by your employer, it is very difficult for the IRS to keep track of exactly how much you make in cash. Here are some of the ways that the IRS could estimate how much you make:

- **Bank Records.** If you deposit your cash income into your bank account, there will be a good record of how much you made.

- **Records of Other Taxpayers.** If you provide a service to others for cash, such as bookkeeping for a small business, that business may be claiming the money they paid you as a deduction from their taxes. The IRS may be able to track your income through the records of others.

- **Estimates.** If you work in certain businesses where tipping is the norm, the IRS can make certain assumptions based on the income your co-workers claim, or the volume of business that you handle. I know a guy that runs a car wash, who told me that the IRS looks at his electric and water bills to estimate how many cars he is washing.

If you are clearly spending more than you are claiming you make, this can be an easy tip-off that you are under-reporting. For instance if you buy a Porsche and a $250,000 house on an claimed income of $18,000 per year, you can expect the IRS is going to be suspicious.

Income That is Not Taxable

There are some forms of income on which you don't have to report or pay taxes:

- **Gifts and inheritances.** Because these amounts have usually been taxed when they were earned by the person who gave them to you, the IRS doesn't tax you when you receive them. Keep in mind that if you receive a tip, as part of your job as a bartender, that is not a gift because it's related to work.

- **Insurance Proceeds.** If you wreck your car and get paid by your insurance company, this is a replacement of something you had, and therefore not taxable. The big exception is that disability insurance payments are taxable, but only if your employer pays the premiums. Therefore, make sure to pay your own disability insurance premiums or buy extra disability insurance.

- **Rebates.** If you receive a $5 rebate on software you bought, or $800 on your new Ford, this is treated like a discount and is not taxable income.

The Mother of All Forms—the 1040

This is the name of the most important form that you file with the IRS. Every individual taxpayer has to file a Form 1040 ("ten-forty") of some kind or another. The purpose of the form is to help you calculate the amount of your taxes. The IRS will usually mail you a copy of the 1040, as well as the other most common forms, and a booklet explaining how to complete the forms, to the address on your prior year's tax return. You can also get these forms by calling the IRS, or by visiting your public library and many post offices and banks. Even if you have waited until the last minute and all of these places have run out of tax forms, there is usually a book of all IRS forms at your public library. As with other tax forms, you can copy the forms out of the book and use them.

The Form 1040 comes in three basic levels of difficulty, plus one extra:

- •1040EZ. According to the Feds, Forrest Gump can fill this one out. Put in your name and address, and answer ten questions and you're done. Rules: you must be single, earn less than $50,000 and have a very simple financial picture.

- 1040A. This one is tougher, but the guy who wrote *Forrest Gump* can complete this with only a little work. This form allows you to include income from interest and dividends, and get credit for IRA deductions and child care credits. However, if you have a lot of different deductions, you can't use them on this form, so you may want to consider the big Kahuna—Form 1040. Rules: you must earn less than $50,000.

- 1040. This one is possible for most people, but they may need to consult with the lawyers who negotiated the movie rights for *Forrest Gump*. Keep in mind that if you have any specific questions, the IRS has a help line you can call. If you aren't good with these types of things, you should think about some of the alternatives below, such as a computer tax program or a good accountant or tax adviser. Usually, you have to fill out one or more additional forms that go along with the 1040.

- 1040X. The mistake fixer, this is the form you file if you made mistakes on a prior form. For instance if you completely forgot that you were entitled to an additional exemption because you had a baby during the tax year(like I did), you can file this form to get additional money back. There are time limits for some deductions, so you may have to call the IRS for advice.

TeleFile Your 1040EZ Return

Telefiling is the perfect way for you to avoid the hassle of completing and mailing a tax return. If you are a single filer using the 1040EZ, and you are living at the same address as shown on the label on the tax package the IRS sends out, you can file your taxes by phone. Simply call the TeleFile number provided with your return, and you will be lead through a series of prompts that you can answer by using your telephone keypad. At the end of your call, you will be told the amount of your return, or the amount of taxes you must send to the IRS.

> ### Web Tip
>
> Using the Internal Revenue Service Website can get you downloadable versions of 400 tax forms and other publications. If you know what you want, this can be a quick and easy way to get the forms you need. Use http://www.ustreas.gov to access the IRS website.

Which Form to Use

You want to choose the form that let's you save the most money on your taxes. Use the following checklist to see which of the forms you should use:

Step One. If the answer to any of the following questions is yes, you should probably be using Form 1040, otherwise go to Step Two.

- Do you want to itemize your deductions? (See "Itemizing Your Deductions" below.)
- Did you receive capital gains distributions (for instance from mutual funds)?
- Did you receive income from self-employment or alimony?
- Are you married and your spouse is filing a separate return and itemizing deductions?
- Did you sell any real estate?
- Did you make more than $20 in tips that you didn't report in a single month?

Step Two. If you answer yes to any of the following questions, you should use Form 1040A; if you can answer no to all of the following questions, you should use Form 1040EZ.

- If you are single, did you make more than $50,000?
- If you are married and filing jointly, did you make more than $61,250?

- Are you married and filing separately?

- Did you receive more than $400 in interest?

- Are you claiming an exemption for any dependents?

- Did you put pretax money into an IRA?

Note: If you have any special tax credits, or income from sources other than your job, you probably have to read the directions to Form 1040 to make certain which form is correct for you.

Schedule Time For Schedules

If you choose Form 1040, you can be sure that you will have to fill in at least one or two additional schedules or related forms. These are cross referenced to the 1040, so you can usually tell which ones you will need as you fill out the 1040. In fact, when you get your 1040, it is packaged as part of a booklet that includes the most common schedules you will need and the instructions on how to complete them. Here are some of them:

- Schedule A for itemizing your deductions including mortgage payments, career-related education and development costs, state and other taxes, charitable contributions, health care expenses, moving expenses, casualty and theft losses and job and miscellaneous expenses. Note that if any of these deductions are significant, you probably need another form to provide the IRS with details. (Read the next section for more about "itemizing.")

- Schedule B for listing income from interest and dividends

- Schedule C for people who own their own businesses

- Schedule D for capital gains and losses

- Schedule E for income other than salary and bonus, or things that go on Schedules B, C or D, such as royalty income, rental income, etc.

- Schedule SE for people that are self-employed, to help you with your income tax, and other items such as social security taxes.

Itemizing Your Deductions

If you are using Form 1040, you have the option of using a standard deduction, which is set every year based on your filing status, or itemizing your actual deductions. The standard deductions are listed on the back of both the 1040 and the 1040A (they were $3,900 for a single filer and $6,550 for a married couple filing jointly for 1995).

If your actual deductions are greater than the standard deduction that applies to you, you will be able to shelter more income (and pay less taxes) by itemizing your actual deductions.

Unfortunately, this process is not simple. Depending on how much you make and the kind of deductions you have, there are often limitations on the amount of your deductions that you can actually use. The most common ones: the interest paid on a mortgage, charitable contributions and certain career-related expenses.

However, if you are like most people and make less than $115,000, almost all of your deductions are fully usable. Use the IRS form Schedule A to identify and calculate your deductions and apply the various limitations to certain kinds of deductions. Despite all the legitimate dread that people have about using IRS forms, you don't need to be intimidated by this exercise. Schedule A is fairly easy to follow.

If your itemized deductions are more than the standard deduction applicable to you, you will want to file Form 1040. It's the only form that allows you to itemize deductions.

If you're even considering itemizing deductions, you might want to look into having an accountant check your calculations. In most cities, you should be able to find someone to do this for a couple hundred dollars (for more detail on these costs, keep reading).

State Income Taxes

Most states have state income taxes that you will need to pay if you live or work in that state. Some cities, like New York and Los Angeles, also have local income taxes. They range from nominal to expen-

sive—and sometimes even ridiculous. The City of New York recently tried to collect income taxes from players of the Chicago Bulls who came to Madison Square Garden to play the New York Knicks.

Most of these taxes mirror the federal tax laws, so much that your preparation and tax planning will be applicable to your state taxes as well. One bit of good news: State and local taxes are a deduction on your federal tax return for the year in which you pay them.

However, because state rules are so numerous, you are going to have to check with local authorities or tax pros to find out what your obligations are.

Beat the Code with Your PC or Mac

Unless you are self-employed or have rental-income property, you should be able to do your own taxes on your computer. The two best known names in the electronic tax assistance are Turbo Tax and Mac-In-Tax, with honorable mention for Kiplinger Tax Cut. Although I have only used Turbo Tax, my computer geek friends claim the other two are just as good, and there are plenty of others available. Essentially, the programs lead you through a series of questions and then spit out your complete tax return on forms that are stored on your computer. Some of them, like Tax Cut, include tax tips that can help you save money on taxes.

These programs will also let you look at various alternatives to see what different approaches would do to your tax bill, such as a married couple filing jointly or separately.

Also, once you've used one of these, the next year's software is a less expensive upgrade, and it will allow you to access information from your prior returns.

The great thing is that you probably won't have to make a last-minute dash to the public library to photocopy the forms you forgot to get, because almost all of the forms you will need are on the software. Most of these packages come with software that will complete most state and local tax forms as well.

People Who Do Taxes

If you can't imagine doing your own taxes, fear not—there are plenty of people who will be glad to do them for you:

- **Friends and Family.** Most people know someone who is nice enough (or foolish enough) to do your taxes for you. If you were able to get other people's notes for classes you slept through, you should probably be able to find your own free tax adviser. Although she denies it, I'm pretty sure that the main reason my wife continued to date me (and eventually marry me) was that she had no one else who could do her taxes.

- **Tax Preparers.** From the guy on the corner to the national firms like H&R Block, there are thousands of tax preparers who are happy to do your taxes. Expect to pay about $50 for a simple return and up to several hundred dollars for a more complex return, for instance if you are self employed. Their charges are usually based on a minimum fee, plus additional charges for each form they complete. These people are not always accountants, and are often part-timers, but they usually have a pretty good idea what you need. However, unless you get lucky, don't expect too much creative thinking. Also, the closer to April 15 you get, the busier these operations become and the less likely you are to receive their complete and undivided attention. These preparers are usually well versed on state taxes, and that talent alone is usually worth the price of admission.

- **Enrolled Agents.** If your return requires at least a 1040 with several schedules or additional forms, you may want to use an enrolled agent. Enrolled agents either have to have worked at the IRS for five years or passed a pretty tough IRS exam. They also have to complete periodic tax courses to keep up with the tax laws. They will cost a bit more than a preparer— usually about $80 to $150 per hour, and take about 2-4 hours to complete your return.

- **Accountants**. These are higher up on the tax food chain, and are best suited to complete more complex tax returns. Expect to pay a minimum of $200, and as much as $1,000, depending on the amount of time they spend on your return. You can minimize your costs by preparing and providing detailed records.

What If I Can't Afford to Pay My Taxes?

Don't sweat. You're better off filing your taxes and not paying than avoiding the problem by not filing. That's because the penalty for not filing is 5 percent per month, and the penalty for not paying is about 0.5 percent per month, or about one-tenth as bad.

Also, if you really don't have the cash to pay, you can file Form 9465, one of my personal favorites. This form allows you to request monthly payments and lets you estimate the amount you can afford to pay. As long as you're not too unreasonable (for instance, $1 a month for 167 years), your plan will probably be approved. Once it is, you have to make sure that your payments are on time. If not, the IRS can come to your work and garnish your wages or come to your home and take your stuff. They can't stand being ignored.

Go with Direct Deposit

The IRS will direct deposit your refund—if it owes you one—into your bank account if you fill out Form 8888. Although this won't save you money, it will allow you to get your check about a week earlier. This is a rare chance for you to work the tax system in your favor.

As a tax-hating friend of mine says, every minute that you have your money and the IRS doesn't is a good one.

Chapter Seven

1040 Chess—Strategies for Managing Your Tax Burden

Introduction

The tax system is a maze of rules and regulations. Many of these have no apparent reason. If you know a number of these rules, you can employ a number of simple tax strategies that can reduce your taxes— sometimes dramatically. Not all of them will work for you, but they can help.

Most of these strategies work by lowering your taxable income, or by some other method, and you don't need to itemize to take advantage of most of them.

Shifting Income or Deductions

You sometimes have the ability to accelerate or delay the receipt of income or payment of deductions. If you are expecting a lot of income in a particular year and you expect it may push you to a higher tax bracket, you may be able to move some income to an earlier or later year in order to reduce your tax bill. For instance, you may be

able to ask your employer to pay your year-end bonus after the end of the year. If you are self-employed, don't bill your clients until it's late enough in the year so that they won't pay you until after December 31.

Invest in Tax-Free Municipal Bonds

Tax-free investments, such as municipal bonds or mutual funds that invest in municipal bonds, allow you to earn interest that is tax-free. Tax-free bonds usually pay less interest than comparable taxable corporate bonds. In order to compare them, you'll need to know the tax-free interest rate, the interest rate of a comparable taxable investment and your tax bracket. The formula is:

Taxable Interest × (1 − Your Tax Bracket) = After-Tax Interest

Use this formula to calculate the after-tax interest on a taxable bond. If the after-tax interest from the formula is less than the interest rate on the tax-free bond, you will want to invest in the tax-free bonds. Generally, if you are in the middle tax bracket or higher, tax-free bonds provide you with better after-tax earnings.

Keep in mind that bonds issued by your home state or city may also be free from state and local taxes. These may be referred to as Double Tax-free or Triple Tax-free. For certain larger states, such as California, New York, New Jersey and Florida, there are mutual funds that invest only in bonds which are free of federal and state taxes.

Transfer Money to Your Kids

Although it may not seem to be a way to save money, giving money to your kids can actually reduce your tax bill.

The theory is that your kids are in a lower tax bracket and therefore will pay lower taxes on earnings than you would. For instance, assume that you were able to save $10,000 for your daughter's college education. If you give her that $10,000, and she earns $600 of interest, she will pay no taxes on that interest. If you keep the money for her, and you have a marginal tax rate of 33 percent, you will pay $200 in taxes for the same earnings.

Until your child turns 14, if she (or he) earns more than $1,300 of investment income, the IRS can tax the rest at your rate (under the so-called "Kiddie Tax"). While this is bad news for Macaulay Culkin's generally miserable family, it probably won't affect you until you have moved a large amount of money into your child's account. Even then, you still save taxes on that initial $1,300. Also, if you invest in longer-term investments, such as stocks, you can avoid recognizing income until your child is over 14, and the regular tax rates apply.

After age 14, the benefit of having earnings in your child's name can provide an even greater tax advantage, assuming that they will be making less money than you do.

This is best done through a custodial account at a brokerage firm or mutual fund that will allow you to control the money as your child grows. One last catch: When your child is old enough to control the account(18 in most states), she could spend all the money you saved on a new Jet Ski rather than on the college education you had been planning.

Buy Bonds

U.S. savings bonds offer several tax advantages, and may make sense for you. You buy these bonds at a discount—a $50 bond costs $25—and then cash them in when they reach full face value or *mature*. The interest builds the value of the bond from $25 to $50, but you pay no taxes until you cash in the bond. Even then you pay no state taxes. This is one way to beat the aforementioned—I've always wanted to use that word—Kiddie Tax. Also, if you use the earnings to pay for college education, you may never have to pay taxes.

Let IRA Save You Money

I don't mean your cousin Ira, the accountant; I mean an Individual Retirement Account. If you (and your spouse) aren't covered by a pension plan, like a 401(k), at work, or even if you are, and you earn less than $32,000 on a single return (or $40,000 on a joint return), you can put up to $2,000 into an IRA. The amount you contribute is tax deductible, even if you don't itemize. Once it's in the IRA, you

can invest that money in almost any stock, bond, mutual fund, etc. And both the original contribution and the earnings are tax-free until you remove it from the IRA.[1]

The tax savings is your contribution multipled by your tax bracket. For example: If you contribute $1,000, and you are in a 28 percent tax bracket, you are giving up $720 and the IRS is reducing your tax bill by $280, and helping you save. The downside is that you can't take the money out until you are 59 1/2 without paying a ten percent penalty tax. But hey, you're gonna be old sometime, and that money will be big bucks by then.

You can contribute to an IRA up until the April 15 tax deadline, so be sure to consider a contribution even after the tax year is over.

Flexible Spending Accounts

If your employer offers a flexible spending account, you probably should take advantage of that generosity. A flexible spending plan allows you to put pre-tax money aside for child care expenses or medical related expenses that aren't covered by insurance. A premium conversion plan is a type of flexible spending plan that lets you pay for health, life and disability insurance with pretax dollars.

This is one of the best tax advantages that you can get, and I recommend that everyone take advantage of this benefit.

Here's an example of how a flex plan works. If your health insurance has a deductible of $500, you have to pay the first $500 of medical expenses for you or your family. If you are in a 31 percent tax bracket, that means that you have to earn $724 and then pay taxes of $224, to have enough money to pay the first $500 of medical expenses.

Under a flexible spending account, you could elect to put a little under $10 per week into your account to cover the $500 deductible on your health insurance. When you spend money on child care or medical expenses, you fill out a simple form and your employer reimburses you.

[1] See Chapter 24 for a more detailed description of retirement planning issues.

Participating in a flex plan would save $224 from your tax bill at the end of the year. Also, it doesn't matter if you have to spend that $500 in the first month of the year—you can withdraw as much money as you need at any point during the year as long as you don't withdraw more than you are scheduled to contribute during the entire year.

The money can be spent on almost all child care and medical costs, including glasses and contact lenses, prescription and non-prescription drugs and supplies, deductible and co-pay amounts from your health insurance.

The only hitch is that you have to spend all of the money you put in your flex account before the year end, or you forfeit it. That means that if you contribute $1,000 to your flex plan but only use $850 during the year, you lose the $150. But if you haven't spent enough, you can always buy a new pair of glasses or an extra supply of any prescription drug to try to spend any leftover amount.

I recommend trying to estimate your ongoing medical and child care expenses and putting at least 75 percent of your estimated expenses into the plan.

Cafeteria Plan

A cafeteria plan, sometimes called a full flex plan, gives employees a fixed amount of pretax dollars, in addition to their salary, to allocate as they wish to medical deductibles and insurance premiums. It works much like a flexible spending account.

Deduct Your Health Insurance Premiums

If you are self-employed, you can deduct 30 percent of your family's health care insurance premiums, even if you don't itemize. (You can only deduct the other 70 percent if you itemize and have enough personal medical expenses.)

Open a SEP

Another benefit for the self-employed person is a Simplified Employee Pension, or SEP. A SEP works like an IRA, allowing you a tax deduc-

tion equal to your contribution, and any money you earn is tax-free while your money remains in the SEP. The difference is that you can put in up to 13 percent of your income (capped at $20,000 per year). A SEP is easy to set up at most banks and brokerage firms. You can invest your SEP money in stocks, bonds, mutual funds and other investments.

I recommend using a brokerage firm to get the greatest number of investment options.

Keep in mind that you can open a SEP until the April 15 tax deadline for filing your taxes. If you file for an extension, you will have until August 15 to fund your SEP, but I recommend opening it by April 15 anyway—to guard against any changes in the tax law for that year.

Take a Capital Loss

As we discussed above, capital investments are investments in stocks, bonds, mutual funds, homes, and other similar items. If you make a profit on these investments it's called a "capital gain"; a loss is called a "capital loss."

If you have made a capital investment that is a loser, you can sell the loser and lock in a loss. You can use this capital loss to offset any capital gains. Even if you have little or no capital gains to offset, you can offset up to $3,000 per year of ordinary income.

For example: If you bought stock in Bedrock Rubble and its value has decreased to $2,800 less than you paid for it, you can sell Bedrock Rubble and take a capital loss of $2,800. You can use the $2,800 to offset your taxable ordinary income.

If you still believe that Bedrock Rubble is a good investment, you can buy it back after 30 days. If you buy it back during the 30-day period, the IRS treats you as if you never sold it in the first place. Your risk is that the stock goes up during the 30-day period.

In order to recognize a loss, you have to sell your stock before December 31 of the tax year. Also, you can offset an unlimited amount

of capital gains, but if you have more than $3,000 that can be used to offset ordinary income, you can use the remainder in later years, with the same limitations.

Get a Refund for Overpaying Social Security

Social security requires you to pay 7.65 percent of the first $61,200 you make. If you have two jobs, and your income exceeded that amount, it's likely that you may have paid more than your share. Look at your W-2s from each of your employers to see how much you paid. If the total on your W-2s exceeds $4681.80, use the Payments section of Form 1040 to get a refund.

Maximize Your Dependents

If you just had a baby, make sure that you get your bundle of joy a social security number. Unless your child was born in November or December of the tax year, you will need to have a social security number to get a deduction for the new dependant.

At the other end of the spectrum, as long as your children are eighteen or younger, you can claim them as dependents. Even if your kids are as old as 23, if they are still full-time students, you can still claim them if you're paying for half of their bills. So keep your records. (If you have a kid that old, you're probably over 40—didn't you see the cover?)

This last point may be more important to you from another perspective. If you're 18 to 23 and your parents are declaring you as a dependant, you can't claim yourself as a dependant on your own tax return. This can be a big deal for people who are working while they're still in school.

The simplest solution, if you can afford it, is to keep your income under $6,400 a year while you're under 23 and in school full-time. That way, you don't have to file a tax return at all. If you need to make more money—and you're getting support from your parents—your status as a dependant probably means more to them financially than it does to you. Let them have it.

If you have to file a tax return while you're working and a full-time student, your best strategy is probably the most basic: declare no dependants and file the 1040EZ form at the end of the year.

Only If You Itemize

To round out this discussion of the tax system, I'll make some suggestions about beefing up your itemized deductions. Of course, these suggestions only work if you have enough deductions to itemize. (If you have a state income tax and you own your own home or business, you should probably have enough deductions to justify itemizing.)

Charitable Donations of Property

If you are itemizing deductions, you can easily increase your deduction for charitable contributions and do a good deed at the same time, by donating property to charity. Take all of your old clothes, furniture, books, and other useless personal items to your local Goodwill, Salvation Army, Hospital Thrift Shop or other charitable organization that sells used goods. You can deduct the full value of these goods to reduce your income. Make sure you get a receipt, and ask the charity if they have a sheet to help you to estimate the value of your donations.

If you have $400 worth of clothes that you don't wear anymore, and you are in a 25 percent tax bracket, giving those clothes to charity can generate a reduction of $400 in your taxable income, and a savings of $100 off your tax bill. The catch is that you have to itemize to take advantage of this tax benefit.

I try to do this every year before December 31, as a way of helping the charity, saving money on taxes and clearing out the house for the new year. Bill and Hillary Clinton did this through the 1980s—and they got in some hot water later for padding the value of Bill's old boxer shorts.

I'm going to resist throwing in the obvious punch line here.

Even if you don't pad your shorts, giving your extra stuff to charity will let you avoid a long painful afternoon of sitting in your driveway trying to sell your old stuff in a yard sale.

Charitable Donations of Investments

If you have an investment that has increased in value, you can donate it to charity, avoid paying taxes on the increased value, and get a tax deduction for the full amount of the property deducted.

For example: If you bought stock in Disney for $100, and it has increased to $200 in value, you have a profit of $100. If you are in a 28 percent tax bracket, and you sell that stock, you will receive your original $100, and $100 profit. You will have to pay taxes of $28 on your profit, leaving you with a total of $172. If you simultaneously made a $200 cash donation to your church, you would get a tax refund of $56 ($200 x 28 percent), so after the tax adjustment, your gift would have reduced your take home pay by $144. The combined effect of these two events is to leave you with a net benefit of $28 ($172 less $144).

An alternative is to give the stock to charity. You avoid paying the taxes on your profits, and you get a tax deduction for the $200. Which provides you with a benefit of $56, or an additional $28. From the charities' point of view, they are usually more than happy to receive stock.

Buy a Home

This is discussed in much greater detail in Part Eight. Because you are permitted to deduct most of your mortgage payment, the government in effect pays for a part of your mortgage. For instance, if you are taxed at a rate of 30 percent, and you have a mortgage payment of $2,000, you are actually paying about $1,400 per month, and the IRS is reducing your taxes by $600. In effect, they're subsidizing your mortgage! They'll also let you deduct the real estate taxes you'll pay on your home, and other expenses related to the purchase.

If you are buying a new home, you can even deduct the full amount of "points" you pay to your lender. When you refinance, points are deductible equally over the life of the loan, but if you re-refinance you can deduct any leftover points from a prior loan that you have not yet deducted.

Sell a Home

An additional reason to invest in a home is that you can shelter the profits you earn when you sell your home. As long as you buy another home of equal or greater value within two years, you can shelter all of your profits from the sale of your house. Once you reach 55, you can sell your home, and buy a smaller home (or even no new home at all) and make up to $125,000 of profit with no taxes. This is one of the best deals in the entire tax code!

Home Equity Loans

Because interest on your credit cards or personal loans is no longer deductible, you may want to borrow money on a home equity loan. The interest on these loans is still deductible, as long as you spend the money you borrow on your home. Even if you don't spend the money on your home, you can borrow up to $100,000 for any purpose and still deduct the interest.

Accelerate or Delay Deductions

You may also want to delay or accelerate deductions to either match your variations in income or to avoid minimum or maximum limitations.

Take a Vacation with Your Family

Plan a vacation around a business trip. As long as the main reason for the trip is business, you can deduct the cost of the travel and lodging, and part of food and entertainment costs. (Extra travel costs for your family aren't deductible.)

Part Three:

Credit and Debt

Chapter Eight

Bank Accounts...the Ruin of Many a Poor Boy

Introduction

Although they may provide a wealth of services, banks are where you keep your money for short term uses, basically separated into savings accounts and checking accounts.[1] While the Unabomber and other burnouts living in the outback of Montana may swear off banks, those of us with slightly less extreme lifestyles use these things as tools of daily financial life.

Checking and savings accounts—used appropriately—can be the most basic and cost-effective means of managing your money. The problem comes with that "used appropriately part." Many people, and especially many young people, use these accounts sloppily. In the worst cases, this sloppiness can lead to credit problems—and even legal problems. But, in most cases, it leads to lots of service fees and penalties.

The purpose of this chapter is to show you how to use bank accounts appropriately.

[1] Banks may also provide retirement accounts and longer term investments, but these are discussed in Part Six of this book.

Avoiding bank fees is a key purpose of good financial planning. Put another way: If you're paying lots of fees—now or at any point in the future—that's a sign that there's something wrong in the way you're handling your money. It's an early-warning system for reviewing and correcting your behavior.

Personally, bank fees are one of my pet peeves. I can't stand paying them. They're unnecessary. They're far worse than even taxes—at least taxes are *theoretically* being used for societal good. Bank fees are a victory for the insufferably snooty tellers who sneer at you from behind the bullet-proof glass windows....

The Institutions

There are several different kinds of banks and related institutions. Each has its pluses and minuses.

Kind of Institution	Examples	Pluses	Minuses
Commercial Bank	Citibank, Bank of America, NationsBank	They usually have lots of locations and lots of services. The FDIC insures deposits up to $100,000 in case the bank goes out of business.	They tend to charge higher fees, and the service is impersonal.
Credit Union	Anything that has the words "Credit Union" in its name	Credit unions usually have the lowest fees because they are non-profit. At the end of the year, they may distribute profits to their customers.	Most are not FDIC insured. You don't get your checks back, so your checks come with carbon paper so you can keep a copy.
Brokerage	Merrill Lynch, Paine Webber, Smith Barney	They offer limited check cashing, but offer better options for saving.	Usually require large balances - you probably want to have a bank or credit union for your balances.
Private Bank	J.P. Morgan	They offer the best service, and a wide variety of investment services.	Most require *very* large balances.

Savings Accounts

A savings account is an account where you keep the excess money that you don't need for your monthly bills. Savings accounts generally pay a low rate of interest, but a rate that is higher than your checking account. You usually have to go to your bank or an automated teller machine (ATM) to withdraw money from your savings account.

Passbook Savings

This type of savings account provides you with a little book in which the bank records all of your deposits and withdrawals. This can be difficult if you want to make a deposit or withdrawal and you don't have your passbook with you.

Although these accounts used to be commonplace, most banks have moved to statement accounts.

Statement Savings Accounts

These are savings accounts that send you a monthly statement of the deposits and withdrawals made on your account, as well as the interest you have earned and fees, if any.

Interest on Savings Accounts

All savings accounts pay interest, but if you keep a very small balance, some pay a reduced interest rate or charge you fees that can actually erode your overall account balance. (There they go with the fees again....)

Although savings accounts are almost always federally insured, and therefore nearly risk-free, they earn the lowest interest of almost any investment you can make. Many banks will provide you with free checking if the combined balance in your savings account and checking account meets certain minimums, so you will want to consider keeping at least some money in your savings account.

Most banks will also allow your savings account to act as a back up to your checking account, in case you write checks for more than you have in your checking account. Otherwise, most other investments make more sense.

Calculating Interest

There are three common ways to calculate interest on savings accounts. *Day of deposit to day of withdrawal* is the best, because you earn interest on your money every day it's in the bank. *Average daily balance* calculates interest on the average amount of money during the period, and is nearly identical to day of deposit. *Lowest balance method* calculates interest as if you had your lowest balance for the entire month, and is the least attractive option.

Checking Accounts

Checking accounts are a place to keep the money you will be using all the time. A check is basically an I.O.U. that your bank will pay out of your checking account. Because most checking accounts pay low interest or no interest, you should only keep the maximum amount you need for about two months of living expenses in your checking account. Most banks will let you link your checking account to your savings account so that you can earn better interest in your savings account and still have enough if you write more checks than you have in your checking account.

Overdrafts and Overdraft Protection

If you write a check and it is presented to your bank for payment when there is not enough money in your bank account, your bank will refuse to pay your check. Many merchants will automatically try to cash the check again. Bouncing a check is both embarrassing and expensive—most banks charge fees of $15 to $35 for each check you bounce. Worse still, many merchants will charge you fees of $10 to $25 if you bounce a check written to them. These extra fees add up quickly.

A warning: Bouncing a check is, technically, a form of fraud. It hap-

pens so often, though, that most merchants and finance companies simply redeposit or ask for another form of payment. However, if you refuse to make good on a bad check or bounce several checks to the same company, you may be sued in either civil or criminal court.

In most areas, law enforcement authorities treat bounced checks like drunk driving or other serious, but common, crimes. They will force you to make good on the check and possibly take some form of money-management course to learn how to balance a check book. If you continue to bounce checks after this, you might be prosecuted more seriously and face probation, fines and even jail time.

It's best, of course, to avoid this whole scenario by paying attention—and playing it straight—from the beginning.

Keeping your checking account "balanced" so that you know how much money you have is one way to avoid check problems. Overdraft protection is another.

Overdraft protection is available at most banks. Overdraft protection allows you to borrow money from the bank if you write checks in excess of the amount in your account. You have to apply for overdraft protection in much the same way as you apply for a credit card. Most banks will provide you with overdraft protection if you have a credit card from that bank.

Expect a nominal fee (usually about $3) every time you need to use your overdraft protection, but it's a lot less than the charge for bouncing a check.

Types of Checking Accounts

Regular Checking	You can write unlimited checks, but you don't earn interest on your money. Usually comes with an ATM card.	Monthly fees of about $10, but fees can be waived if you keep minimum balances in checking and/or other accounts.
NOW Accounts	You can write unlimited checks and earn interest on your money.	Usually have fees and require a higher minimum balance in checking and/or other accounts.
Money Market Accounts	You earn higher interest, sometimes even tax free. May have limits to the number of checks you can write. Also may not be federally insured.	Usually have fees of $5 to $10, but fees can be waived if you keep minimum balances in checking and/or other accounts.
Asset Management Accounts	These are through a brokerage firm, and usually have unlimited checking and superior interest.	You will need a higher minimum balance, and pay monthly fees and fees for other investments.

Minimum Balances

Many checking accounts reduce or waive fees if you keep a minimum balance. Some banks will include money you have in your savings account and other accounts when calculating your minimum balance. Meeting the minimum balance requirements can save you money, but you have to compare your savings to what you could earn if you invested that money elsewhere.

Let's say that your bank is offering free checking if you keep a minimum balance of $2,500 in your account. Also assume that the fee you are avoiding is $8 per month, or $96 per year. A benefit of $96 per year on an "investment" of $2,500 is about 2.6 percent ($96 divided by $2,500) per year.

Because your bank isn't actually paying you cash, your benefit is not

taxable. Check to see how you could save by putting your money in a CD or money market fund, and you'll probably find that you are better off investing elsewhere. (Don't forget that you have to deduct the taxes from your interest earned on these investments to get your "true" return.)

Direct Deposit

You can easily elect to have your paycheck deposited directly into your bank account electronically, by providing your employer with a request for direct deposit. Essentially, this provides your employer with permission to transfer funds each pay period. Your employer will need an ABA routing number that will get the money to your bank and your account number, which will get the money into your account.

Most banks will give you a break on your checking fees if you use direct deposit. It saves a lot of paperwork and time.

Check Storage

Because of the expense of handling your checks and sending them to you, many banks suggest that you have the checks stored—either physically or electronically—as images on bank computers or microfilm. If you need a copy of a specific check or checks, the bank will provide them.

Banks that offer this service will reduce your checking fees if you elect check storage. However, as I've mentioned before, I like getting my canceled checks back at the end of each month. I'll even pay an extra $5 or $10 a month—as some banks charge—to get them.

How the Checking System Works

The checking system is organized nationally, with the Federal Reserve System as the backbone. If a check from your bank is deposited into another account at your bank, the money is drawn out of your account immediately. If you live in New York, and your check is deposited into another New York bank, the check is sent to the New

York Federal Reserve Bank, which routes the check to your bank. If there is money in your account, your bank wires the money electronically to the New York Fed, who passes it on electronically to the other bank. This usually takes at least one day. If you send a check to someone in Chicago, and they deposit it in a bank in Chicago, it has to go to the Chicago Fed, and then to the New York Fed, and then to your bank. If your bank account has money, it is then transferred to the New York Fed, the Chicago Fed and then to the bank account in Chicago.

What This Means to You

If you are depositing a check in your account, you may not get to use the money right away. Federal laws require that your money be made available after a maximum amount of time for a variety of checks.

Type of Check	When the Money Is Available
Check from your bank	1 business day
Check from local bank	2 business days
Check from out of town bank	5 business days
Federal, State or Local Government check, U.S. Postal Money Order, U.S. Treasury checks, cashier's or certified checks	1 business day

How to Beat the System

If you write a check from a New York bank to someone in New York, you'd better have enough money in your account to cover the check. But if you are sending a check out of your region, you can usually rely on it taking one or two days in the mail and an additional one or two days for the system before it hits your account.

This means that if you deposit your New York paycheck in your bank

on the thirtieth of the month, you will probably be in time to cover checks you mailed on the twenty-eighth. This is called "playing the float." The danger is that, if you don't get your paycheck into your account on time, the checks you sent start bouncing and you get stuck with overdraft fees.

At $15 to $25 per bounced check, overdraft fees can add up to a $100 bite out of your checking account pretty quickly. And, again, you're getting nothing for this money.

Another way to beat the system is to slow it down. The system works as fast as it does because your checks are imprinted with magnetic ink. The account numbers on the bottom of your check are magnetic, and they are fed through high speed machines that read the checks and send them through the system.

If you rip a small portion of the bottom of the check, enough to take out one or two of those numbers, the check must be processed by hand. This can take two or three extra days. As long as the check arrives on time, this probably won't get you in any trouble with your creditor. But it should delay the time it takes to remove the money from your account.

Don't make it a habit, but this trick can come in handy in emergencies.

Buying Checks

You can save a fair bit of money when the time comes to reorder checks for your account. Most banks will order you an initial set of checks. When you near the end of your supply, you mail the pre-printed card in your checkbook to the check printer and they will send you more checks. However, most banks use an expensive check printer because they aren't the ones paying for the checks. You can get the same quality checks for about half the price by ordering them from an independent printer. They have similar choices of color and design and can be ordered over the phone from several sources including Checks in the Mail (800-733-4443) or Current Inc. (800-426-0822).

Also, buy a checkbook with stubs next to the check, or even duplicate carbons. Although they cost a little more, they make it easier to keep better records of the checks you write, and less likely that you will overdraw your account.

Balancing Your Checkbook Step by Step

Every month, your bank will provide you with a statement for your checking account that reflects the most recent information the bank has recorded on your account. "Balancing" your checkbook means comparing your records to the bank's to make sure that you both agree on the amount of money in your account. This is also a good way to find out if you or the bank made any math errors.

And mistakes do occur. In almost twenty years of writing checks, I've averaged finding one significant (over $100) error by my bank about every five years.

The first step in this exercise is to take the balance shown on your bank statement, and update it by adding all of the checks you have written and withdrawals and deposits you have made that aren't yet reflected in your bank statement. Then, compare this balance to the balance you're showing in your checkbook.

If you're lucky—or good—these amounts should be the same. If they're not, you've got to look for a mistake in your accounting or the bank's. This can be tough, but there's a method to it:

1. Make sure your checkbook register is up to date, i.e., you have recorded and deducted all checks and added in all deposits. From your bank statement, note any interest you have earned or fees that you have been charged. Forgetting to record interest and fees in your checkbook is the most common mistake you can make.

2. Take your cancelled checks and put them into numeric order by check number. In your check register, check off all the numbers of the checks you received with your bank statement: these checks have been paid. Most checkbooks have a spot

for the check marks. I like to use different color pens each month so I can easily see what happened in that month.

3. Next, make a check mark next to each ATM and point of sale (POS) transaction in your checkbook that is reflected in your bank statement. (POS is when supermarkets, gas stations, fast food restaurants, etc., allow you to use your ATM card to deduct directly from your account.)

 It is very helpful to be as detailed as possible on your check register when noting teller machines from different banks and POS transactions from specific merchants, e.g., Exxon. The bank statement will provide this information, and any notes you have in your checkbook will help you to match transactions. Do not be surprised if ATM or POS transaction dates shown on your bank statement are a day or two later than those on your ATM or POS receipts. It sometimes takes a while for the bank to record these charges.

4. Make a check mark next to each deposit reflected in your bank statement—the deposits are usually much less troublesome because there are so few. Included in deposits are any transfers into your checking account from other accounts, e.g., a savings account, and any uses of overdraft protection.

5. Check off fees and interest entries in your checkbook that are reflected in your statement.

6. Now the math:

Step 1. Enter the new or ending balance shown
on the bank statement $ _____

Step 2. **ADD** any deposits listed in your
register or transfers into your account
which are not shown on your statement $ _____

Step 3. **CALCULATE THE SUBTOTAL** $ _____

Step 4. **SUBTRACT** the total outstanding
checks and withdrawals from the
chart below $ _____

ITEMS OUTSTANDING		
NUMBER	AMOUNT	
TOTAL	$	

Step 5. **CALCULATE THE ENDING
BALANCE**
This amount should be the same as
the current balance shown in your
check register $ _____

Trouble Shooting

If you do not come up with the same number, here are some common mistakes to look for:

Problem	Remedy
Suspected addition error on your register.	Double check your math. Also look back several pages in your register to find if there's an old check that hasn't been cashed.
The dollar amount that is off between your register and the bank statement is a round number, e.g., 40, 80, 100.	This is almost always a math error. Check all the math in your register to make sure you haven't made an addition or subtraction mistake.
You think you have a few dollars (under $25) more than the bank says you have.	Make sure you have been entering bank fees and charges in your check register.

Banking Software

If your eyes started to glaze over while reading the preceding information about balancing your checkbook, you're in luck. The computer age has come to banking. There are several brands of banking software that will allow you to computerize your check register. The most popular is Quicken, which is available for Windows, DOS and MAC. Kiplinger's Simple Money (Windows), Microsoft Money (Windows) and Managing Your Money (Windows, DOS and MAC) are other available programs.

Most of these will allow you to categorize your expenses and provide you with summaries of where you are spending your money. Although they require some setup time, once you have the information on your

computer, balancing your checkbook takes less than five minutes.

Most of these programs also allow you to pay your bills on-line, using a service called CheckFree.

If you bank at a larger bank, such as Chase Manhattan, Wells Fargo, Corestates, etc., you can also use the newest versions of Quicken or Microsoft Money for Windows 95 to pay bills electronically, invest in CDs, transfer funds between accounts and get balance and account statements on-line. Some of these banks will even provide the software for free.

Safety Precautions

Never sign a check without filling out the person the check is made out to, or Payee. If you lose this check, someone can fill it out and cash it and you will probably lose your money. If you lose a blank check, and someone forges your signature, the bank is more likely to have to cover the loss.

Checking After Marriage

One of the tough financial issues that newlyweds often face is how to set up their checking account or checking accounts. There's no better metaphor of all the issues of independence and identity that mark the early years of a marriage than where the money flows. A simple compromise is to share a joint checking account, but keep individual savings accounts.

Agree to deposit the majority of your paycheck or paychecks into the joint account, but agree to a small amount that can go into your individual savings accounts. That way you each have access to some "private" money, for gifts and such, without having the headache of multiple checking accounts. You may even be able to link these to the joint checking account, and your ATM cards.

I also recommend that only one of you take responsibility for bill paying and account maintenance. As long as the other spouse promptly shares ATM receipts, you should be able to run a balanced account

without any unpleasant surprises.

Special Kinds of Checks

To bring this chapter to a close, there are several special kinds of checks that you should know about.

Third Party Checks

If someone writes you a check, you can endorse it to someone else by writing on the back "Payable to _____" and endorsing the check. This makes the check "third party." Banks usually take longer to credit these checks to your account.

Post-dated Checks

In some cases, a creditor, supplier or other business entity may ask that you write checks today but date them for some point in the future. The person or group will usually assure you that they won't deposit the check until the later date.

This is never a good idea (and, depending on the circumstances, it can actually be against the law). Most importantly, a future date on the check doesn't mean the check can't be deposited sooner. In some cases, a bank may not accept a post-dated check for deposit—but some will. If the payee on the check forgets, makes a mistake or just decides to be impatient, you can end up with a bounced check.

Any situation in which a person or group asks you for post-dated checks is likely to be trouble. Proceed carefully.

Certified Checks

If someone doesn't know you and wants to be certain your check is good, they may require a certified check. You can write a certified check in any amount up to the balance in your account. To certify a check, you must take a personal check to your bank. For a fee of about $10, the bank will put a special stamp on the check assuring that it will be honored and freeze your account for that amount of

money.

A warning: You cannot stop payment on certified checks. If you elect not to use a check that has been certified, you should take it back to your bank and ask a teller to cancel it, so that the funds can be returned to your account.

Cashier's Checks or Bank Checks

These are checks written on the account of your bank. You provide the bank with the amount of cash and the name of the payee, and it issues the check. The bank will normally charge you a fee for this service—usually less than the fee for a certified check. Some banks will waive this fee if you maintain a certain amount of money in your account.[2]

If you're running late on a payment—or if you've bounced a regular check—many creditors will require that you send money in the form of a bank check. Be careful if you get into this kind of situation. Make sure to get back on time as soon as possible or not to bounce any more checks. If a creditor insists that you make all payments with bank checks, you may be close to some kind of drastic action on the creditor's part.

Like a certified check, you cannot stop payment on a bank check. If you decide not to use a bank check, you should take it back to your bank and ask them to cancel it, so that the funds can be returned to you.

Money Orders

You can get money orders at banks, post offices and even your local 7-Eleven. They usually cost $1.00 to $5.00—and are less expensive

[2] In fact, most banks will waive all kinds of fees if you keep a lot of money with them. In most cases, these waivers come as part of some sort of preferred customer package. But don't wait to be offered these packages. If you're keeping more than $2,500 in any combination of a checking account, savings account or CD, ask a customer service agent at your bank about special deals. Banks have to compete with mutual funds and stock brokerages—which usually offer more interest—for your money. Make them work for it.

at the post office. These are the cheapest way to send money if you don't have a checking account.

You cannot stop payment on a money order. If you decide not to use a money order, you can take it back to the issuer and ask to cancel it, so that the funds can be returned to you.

Traveler's Checks

Traveler's checks are checks issued by large banks or credit card companies that are specially designed for travelers. You can buy these checks in a variety of denominations starting at $10 or $20, and you will pay a fee of about 1 percent.

The checks can be used to pay most merchants that accept credit cards, and many that don't. They can also be cashed at most banks around the world. Each check has two signature lines. One is signed when you purchase the checks, and the other must be signed when you use the check. If they are lost or stolen, they can be canceled and typically replaced within 24 to 48 hours, depending on where you are.

Traveler's checks aren't the best deal in the world—especially with the growing acceptance of credit cards and international ATM networks. Most people who buy traveler's checks don't mind paying the premium for the peace of mind that comes from carrying a form of money that can be replaced.

I have actually had American Express Traveler's Cheques stolen from my hotel room. I was in a major city and went directly to a nearby American Express office—they provided me with replacements on the spot. That experience alone makes me look kindly on the nominal additional expense the things require.

Chapter Nine

Credit Cards Don't Kill Peoples' Finances, People Do

Introduction

A friend of mine tells a story about his grandfather, a prominent small-town businessman in the 1950s and 1960s, who dismissed credit cards as a device that would bankrupt working people not accustomed to managing revolving debt. "If you really have credit, you don't need a piece of plastic to prove it," the old man said. And there is a kernel of truth to this argument.

People's reactions to credit cards can be extreme. Just about everyone knows someone who's managed to load up on credit card debt that they'll be paying off for years. On the other hand, an investment banker I know—who's as rich as anyone under 40 who doesn't play professional baseball—can't stand using the things. He only carries one or two (as opposed to other, far less wealthy, people who carry six or eight) and uses them as infrequently as possible.

Credit cards are one of the best and worst conveniences of modern life. Like most good things, they are best enjoyed in moderation. The credit available through most credit cards is more expensive than any other kind of loan you can have. That's why the investment banker I know hates plastic.

On the practical level, credit cards are essential for certain activities of modern life: renting a car, staying at most hotels, or paying for things over the phone. Plus, having a credit card is one of the first steps you take in building the kind of credit you need to buy bigger things—like a car or a house.

Like the spending habits we talked about earlier in this book, credit habits have a lot to do with the way people feel about themselves and their place in life. Like many people in their twenties and thirties, you may think of credit cards as a way to borrow against money you'll make in the future. Don't. When you start thinking that you can borrow now against the future, remember that credit card companies are making money—between 12 and 20 percent a year—on that hope.

The interest you'll have to pay between now and when you're making more money in the future can diminish the impact of any raises or promotions.

That interest is the key issue in managing credit cards. There are numerous types of cards, and loads of rules for each.

The one rule that stands apart from the rest: Always pay the interest you owe on time. Everything else follows from that.

The Classic Credit Card

Visa and MasterCard are by far the most popular of the bank credit cards. Both are worldwide associations that coordinate their respective cards. Most of the cards are issued by banks that are members of the Visa or MasterCard network, although AT&T, General Motors and Ford, as well as numerous other non-bank issuers, have gotten into the act. Discover is a credit card offered by Sears, and Optima is a credit card offered by American Express. These work essentially

like Visa and MasterCard, although Discover is fairly new and not accepted by as many merchants.

Essentially, you deal directly with one of the credit card issuers. Typically you must submit a credit application, describing your income, bank accounts, other credit cards, name, recent addresses and social security number. The issuer will then order a credit report on you, and will typically verify your income with a call to your job.

After the gnomes at the credit card company have reviewed your credit card application, they will (hopefully) issue you a card with a pre-set spending limit, usually anywhere from $500 to $10,000. You are welcome to use the card to charge goods or services up to that limit.

Each month, you will receive a statement which itemizes all of the charges that you have made, and offers you two alternatives: either pay the full amount of charges that you have accrued, or pay some lesser amount, as long as you send the *minimum amount* shown on the statement. The statement usually confirms the amount of your pre-set limit, as well as the amount that you can still spend without exceeding your limit, and provides you with the due date of your payment. If you have borrowed up to the limit of your account or *maxed out*, you can't use it again until you pay off some of your bill.

How You Can Use Them

Credit cards can be used at a wide variety of merchants. Most can also be used in automatic teller machines to advance you money from your credit card account, and many will provide you with checks that are written on your credit card account. If your credit card is issued by your bank, you can also have it linked to your checking account. If you overdraw your checking account, your bank will automatically borrow money from your credit card to cover the amount, provided you have not maxed your credit card.

The Upside

If you pay the full amount every month, you are not charged any

interest. This is referred to as a *grace period* and usually lasts 25 to 30 days. The credit card issuer will still make money by keeping a small amount of the money that you pay, and passing the rest on to the places that you use your card. Many, but not all, credit card companies also charge you an annual fee of $25 to $50, whether you use the card or not.

The Downside

If you pay less than the full amount, interest accrues on the outstanding balance that you owe—and the annual interest rate on many of these credit cards is 18 to 19 percent or more. This is likely to be the highest interest rate you will ever pay on borrowed money, unless you borrow from a guy wearing a black silk shirt and a pinkie ring who pronounces *this guy* as *dis gay*.

If you owe even $1 on a credit card from a prior month, you start paying interest from the day you make any new charges until the day you pay your account in full. Also, cash advances and overdraft protection carry interest from the day the money is withdrawn.

The minimum amount on the monthly statement is enough to cover the interest accrued for one month on your account—and just a little more. (If your minimum payment gets too small, most credit card issuers will make you pay $15 so they don't have to handle very small payments.) If you are paying the minimum amount on a regular basis, you have one of the warning signs of a bad financial situation.

Trouble Ahead

If you don't pay at least the minimum amount on the day it becomes due, the credit card company will call you with a cheerful reminder. If you still don't pay, they will become less friendly and will report to the credit agencies that you paid your bill late. If you continue to fail to pay, they will eventually cancel your card and require you to pay the full amount that you owe immediately.

Choosing a Credit Card

There are three things to look at when choosing a credit card: fees, interest and perks. The deals you can get on Visa and MasterCard vary widely among issuers, while the terms for Discover and Optima are relatively standard, except for certain promotions.

Fees

Fees are relatively similar, except if you want a gold card or other "exclusive" card offered by many credit card companies. These usually entitle you to several benefits, such as quarterly spending summaries by category and special vinyl luggage tags in exchange for an extra $50 per year. Despite what you may have heard, there's not necessarily any difference in the credit limits on premium cards and regular cards.

If it's important that your credit card be gold-colored, you may want to consider these cards, but the regular cards seem to work just fine for most people. An exception is people who travel a lot—a gold or platinum card can entitle you to upgrades at hotels and on car rentals.

In addition to annual fees, most credit cards will charge you 1 to 2 percent to take cash advances, late fees, fees for exceeding your credit limit, and other random fees—so read the fine print.

Interest

Most cards charge interest of 18 percent and up, although some are as low as 10 percent. If you have $1,000 outstanding on your credit card bill for a year, the difference in interest is $80. If you have $5,000 outstanding, your savings is $400.

Perks

Most of the cheap cards do not offer perks. Most cards with bonus plans, such as frequent flyer miles, or cash rebates, or money toward a car down payment, charge you higher fees and more interest in

order to be able to provide these perks. The perks offered by the various credit card companies are usually not all they are cracked up to be.

For example: The Citibank-issued American Airlines Visa or Master Card gives you one frequent flyer mile for every $1 you spend. They also charge higher interest than many other cards (about 18.5 percent), and a $50 annual fee. Because it takes at least 25,000 frequent flyer miles to get a free ticket on American, it could take a real long time to get that free ticket by using this credit card. If the average airline ticket costs $500, you are basically getting a rebate of 2 percent of the $25,000 you spent. But if you pay an annual fee of $50 and 5 percent of additional interest, and it takes five to ten years to earn your ticket, you can wind up paying thousands of dollars of additional fees and interest.

These bonus plans only work for people who spend large amounts of money and pay off their cards right away. There's a famous story about a California real estate developer who bought an impressionist painting at a London auction house for something like $8 million dollars. He put the purchase on his American Express card—he had a large enough limit—and immediately earned something like 160 first-class tickets on an airline that was doing a promotion with Amex.

This may sound wonderful, but if you don't have the ready cash to pay off these cards immediately, the interest costs will significantly outweigh the perks. For a list of the terms of rebate and frequent flyer cards, send your name, address and a check for $4 to the Bankcard Holders of America (BHA) at the address provided below.

How to Get the Best Credit Card Deals

One way to reduce your credit costs is to move your outstanding balance to a low interest card. The difference between some of the highest credit cards available (over 21 percent, plus fees) and the lowest (about 6 percent, and no fees) is a full 15 percent, plus $40 of annual fees.

If you have $2,000 outstanding on your credit card, and you move it from a high rate card to a lower rate card, you would save as much as $340 on interest and fees. If your outstanding balance is $5,000, you could save almost $800. That means you might actually have a chance of paying off your cards during your lifetime.

For the best deals on bank cards (Visa and MasterCard), send your name, address and a check for $4 to the Bankcard Holders of America at the following address, and they will send you a list of the best deals in the country.

Bankcard Holders of America
524 Branch Drive
Salem, VA 24153

 Web Tip

RAM Research (800-344-7714) can provide similar information through its CardTrak newsletter. RAM also has information on credit cards, charge cards and other tools on its website at www.ramresearch.com. A number of the banks offering cards will allow you to download an application, or receive additional information about their cards.

Below are some of the best rates that were on the list the last time I checked with the BHA, as well as recent costs for Optima True Grace:

Issuer	Card	Annual Fee	Interest
AMEX/CENTURION BANK Wilmington, DE (800) 635-5955	Optima True Grace	None	7.9 percent fixed[1]
FIDELITY NATIONAL BANK Atlanta, GA (800) 753-2900	VISA	$20	7.9 percent fixed[2]
FIRST OF AMERICA BANK Kalamazoo, MI (800) 423-3883	MasterCard, VISA	None	9.8 percent fixed[3]
MELLON BANK Pittsburgh, PA (800) 753-7011	MasterCard	None	5.9 percent fixed[4]
USAA Federal Savings Bank San Antonio, TX (800) 922-9092	MasterCard, VISA	None	12.5 percent variable

Notes:
[1] 7.9 percent fixed for 12 months, 17.5 percent variable thereafter; 21.65 percent variable for cash advances
[2] 7.9 percent fixed through deadline date, 14.9 percent fixed thereafter
[3] 9.8 percent fixed for 6 months, 17.15 percent variable thereafter
[4] 5.9 percent fixed for 6 months, 14.65 percent variable thereafter

The Shell Game

As you can see in the chart above, some credit cards will offer a teaser rate in order to get you to switch to their card. This rate, often below 10 percent, lasts for six months or a year. For instance, Optima

True Grace, a regular credit card issued by American Express, is offering a first year rate of 7.9 percent. If you owe large amounts on your existing credit cards, it may make sense to get a new credit card and transfer the balances from your existing cards to this card. If you have $3,000 outstanding on existing cards, you can save $300 or more in a single year, and reduce your minimum monthly payment.

You may even get an initial grace period before you get charged interest on the balance that you transferred and some cards pay you a bonus to transfer. While I was writing this, BankAmerica was giving a $50 check to people that transfer at least $2,000 to their credit card—and Sun Co. was throwing in $50 of free gas at its Sunoco stations if you made the switch to its card.

There are some people that do nothing but transfer their balances every year to get a continuous low interest rate. If you want to try your hand at the shell game, make sure to do the following.

- Do your homework: Make sure that you read the terms of the cards you are considering, particularly the fee and the length of time that the low interest rate applies. The "disclosure box" on the application is usually the best place to read the terms without having to dig through a lot of advertising fluff.

- Choose the best card: Check to see which card will offer you a grace period for the first month of your new balance. If you have $5,000 outstanding on a card charging 18.9 percent, that's like getting $80 of free money.

- Clean up after yourself: After you successfully transfer your balance, cancel your excess credit cards. Having more than three or four major credit cards, even if they're not all being used, will make you look risky to lenders.

Bargain for Better Terms

I was surprised to learn that you can actually bargain for lower terms with your existing credit card—my sister Kelly and my brother-in-law Craig recently let me in on this little secret. They recommend

calling your credit cards' customer service desk, telling them that you're considering switching to another card, and asking them to cut their fees and/or interest. It helps if you know some of the rates offered by other companies, so they really believe that you might switch.

Keep in mind that the larger your balance, and the better your payment record, the more the company will cut its costs to keep you.

Charge Cards

Charge cards, also called travel cards, are designed for a completely different purpose than credit cards. The difference is that charge cards provide you with short-term credit that must be paid off when you receive your monthly bill. These cards are not designed to give you long-term credit, and they become quite unfriendly if you don't pay your bill after every monthly statement. The best of these cards by far is the American Express Card.

Diners' Club, another charge card, is not accepted at nearly as many places, so it's not worth having. (Can you tell I once got dissed by Diners' Club?)

The major benefit of American Express is that you do not have a preset spending limit, which is very important if you are traveling or have to spend a large amount of money without having access to your bank. Amex does not charge interest (as long as you pay your bills on time) and offers excellent service if you have a disagreement over a charge.

American Express is available in green, gold and platinum, with each progressive level providing slightly different benefits for somewhat larger fees. For a charge of $45 dollars per year, you can also rack up frequent flyer miles that can be used for most major airlines and hotels. Just ask the real estate guy from California who has a seat for himself and his Monet in first class.

Store Credit Cards

Many large stores will provide a credit card or cash card to purchase merchandise in that store. If you have a valid Visa, MasterCard or

Amex, you can be approved for credit while you shop, and get an introductory discount on the goods you just purchased. These cards should only be used to build a minimal wardrobe if you are just starting out and have little or no other credit.

Because store cards are easier to get, they can also be helpful in establishing a good credit record. However, the temptation to buy this year's fashions with next year's earnings is often too great to bear. Once you have established credit with a regular credit card, I recommend paying off these cards and closing your accounts.

Debit Cards

These are not credit cards at all, but they can be used in place of credit cards, and are a good substitute if you have bad credit or no credit, and cannot otherwise get a credit card. Debit cards are usually issued by banks under the Visa or MasterCard names. You deposit money in the bank, usually at least $300 to $500, and then you can use the card until either you empty the account, or send the bank more money.

This is like having a credit card with a limit equal to the money in your account, and from the merchant's point of view, it works just like a credit card. Most commercial banks offer these cards.

Secured Credit Cards

There are several banks that will issue you a Visa or MasterCard on a secured basis. These issuers require you to deposit money into a savings account as collateral for your credit card obligations. If you don't pay your bills on time, the bank can collect from your savings account. Most banks will offer you a credit limit equal to the amount you deposit into that bank, although some will allow you a limit of up to two times the amount of money you agree to leave on deposit in a savings account in that bank.

Keep in mind that although you pay interest on the outstanding balance on the credit card, you are earning interest on the amount in your checking account.

When choosing among secured credit cards, if you expect to pay your bills as you use the card, ignore the credit card interest—when you pay your balance every month, you won't have any interest. Concentrate on the amount your savings will earn at that bank. If you intend to carry a balance on your credit card for some time, compare the difference between the interest you pay for credit card interest, and the interest rate you receive from your savings account. The closer those two numbers are, the better for you.

These programs are designed for people who have either not had credit before and are trying to establish credit worthiness, or who have had problems in the past. In most other ways, secured cards are identical to regular credit cards. Most of the banks that sponsor these cards do not report to credit agencies that these are secured cards, although some do. If you are trying to establish your credit worthiness, ask first and then choose one that doesn't tell.

For a list of secured credit cards, and terms, send your request and a check for $4.00 to the Bankcard Holders of America.

Below are some of the best rates that were on the list last time I checked with the BHA:

Bank	Type	Deposit/ Credit Line	Interest Rate	Annual Fees
CALIFORNIA COMMERCE BANK Los Angeles, CA (800) 222-1234	MasterCard, VISA	$300-$2,000/ 100 percent of deposit	(savings account @ 2.25 percent) 12 percent fixed for purchases and cash advances	$80
COLUMBUS BANK AND TRUST CO. Old Bethpage, NY (800) 934-0101	MasterCard, H&R Block Card	$500-$5,000/ 100 percent of deposit	(savings account @ 3.5 percent) 19.9 percent variable	$22

Bank	Type	Deposit/ Credit Line	Interest Rate	Annual Fees
FIRST CONSUMERS NATIONAL BANK Beaverton, OR (800) 937-3795	MasterCard	$100-$5,000/ 150 percent of deposit	(CD @ 3 percent) 19.5 percent variable	$19.50 first year $30 thereafter
PEOPLES BANK Bridgeport, CT (800) 262-4442	MasterCard	$500-$1,500/ 100 percent of deposit	(savings account @ 2 percent) 16.9 percent fixed	$25

Web Tip

RAM Research provides similar information on its website at www.ramresearch.com and a number of the banks offering cards will allow you to download an application, or receive additional information about their cards.

Billing Errors

Credit card companies, like everyone else, make mistakes. Keep an eye on your monthly bill to make sure that the numbers that appear on the bill are yours. If you see a charge that you don't remember, or a charge that is for a different amount than you spent, you have a fixed amount of time (usually 30 days) to tell the credit card company. Usually a phone call is enough, but I recommend following up with either a fax or a letter confirming your conversation. That way, you will have a record of your complaint.

It is essential to get the name of the credit card representative for your records. Make sure to keep that name somewhere safe until your problem is fixed. Then file the details of your bill with a copy of your notes or letter, so that you know where to find it if you need it.

Disputed Charges

Although they are similar to billing errors, these are situations where you bought something and did not get what you bargained for. If you got food poisoning, if you bought a coat and the store won't honor its regular return policy, or if you have any other unresolved argument with a merchant, call your credit card company and provide the details of the disagreement.

The company will sometimes ask you to put the details in writing and then usually contact the merchant and argue your case for you. Most credit card companies are pretty good at looking out for your interests, although I have had the best service from American Express. Also, while the dispute is being investigated, you won't have to pay the charge under investigation.

Paying Late

No matter how good you are, you will probably have a month (or two or three) when you have to pay your credit cards late. If there is nothing else you can do, call the credit card company with some excuse and tell them the payment is on the way. This may help you avoid a black mark. Also, date your check as if the payment was on time; otherwise, you'll be admitting that you were late. Finally, keep at least one credit card that has a perfect record.

Lost or Stolen Credit Cards

Most cards will only hold you liable for a maximum amount of $50 if your card is lost or stolen. However, if you call the credit card company as soon as you realize the card is missing, the vast majority will not even charge you the $50. Keep a list of your credit card numbers, and their 800 phone numbers in your phone list, just in case you need them. If you are keeping a filing system like the one recommended in the beginning of the book, all of this information will be at your finger tips.

Other Types of Debt

Credit cards are a form of debt. The most common other types of debt are student loans, car loans, home loans (also called mortgage loans), home equity loans (also called second mortgages) and personal loans. In general, debt should be avoided. However, it is fairly difficult to get along without it. Student loans and mortgage loans are nearly impossible to avoid, but I recommend using the smallest amount of debt necessary to get along in each situation. Each of these kinds of debt is discussed later on.

 Web Tip

The Credit Card Network at www.creditnet.com provides lists of card issuers with information about rates, rebate programs and on-line applications—as well as suggestions for re-establishing a good credit record and credit care shareware including finance charge calculations and electronic bill payment.

Chapter Ten

Student Loans and Other Early Debt

Introduction

If you borrowed money to go to college or graduate school, you probably signed the papers with some—but not total—understanding of the terms and conditions of your loan. This is actually one of the worst aspects of the student-loan industry: It doesn't fully educate kids about what they're getting into.[1] So, it's little surprise that student loan default rates are higher than other forms of consumer credit defaults.

Even if you didn't borrow money to go to school, you probably experienced the common "senior credit binge." Inundated with credit card applications—some which promise to extend first payments until after graduation—many students load up with debt in their last months of school.

Consumer debt on top of student loans can be a crushing financial burden. A lack of experience dealing with credit can double the pres-

[1] To be fair, some colleges and grad schools have started improving on this situation by holding workshops and counseling sessions for people taking loans. They look at this as a preventative measure to control student loan default rates. And that's a good thing— but only a partial solution. Most of these programs focus on what you owe, not how to repay it.

sure. What follows is a crash course on dealing with student loans and other forms of early debt.

Frequently-used Debt Terms

Principal is the amount you originally borrow.

Interest is the fee that you have to pay the lender for borrowing the money. Interest is usually stated as a percentage of the principal over a given period of time. For instance, if you borrowed $100 at 12 percent per year, at the end of that year, you would have to repay the lender $100 of principal plus $12 of interest. If you paid the loan back after four months, you would have to pay the lender $100 of principal and $4 of interest.

Term is the amount of time between the day you take a loan and the scheduled day you repay the last part of what you owe.

Accrued Interest is the interest that you owe, but that you have not yet paid. Assume you borrow $100 and agree to pay it back at the end of the year with $10 of interest. After six months, you have accrued $5 of interest.

Compounding is the frequency that the interest on your loan is calculated. The more times something is compounded, the more interest there is. Assume you borrow $100 at 10 percent interest, compounded annually. At the end of the year, the lender will calculate the interest as $10. If the interest is compounded semi-annually, after six months the lender will calculate that you owe $100 of principal and $5 of accrued interest for a total of $105. Then at the end of the year, the lender will calculate the interest for the second half of the year based on the outstanding principal and accrued interest of $105. You will owe interest of $5.25 ($105 x 10 percent interest per year x 1/2 of a year) for the second six-months. In this case, if you had paid the $5 of accrued interest at the six month point, you would not have to pay the additional $0.25 at the end of the year. Most loans compound interest monthly.

Amortization is the act of paying off principal. If you make a pay-

ment to your creditor, the payment is first applied to interest, and then to principal. Most loans are *self-amortizing*, which means that the payment amount has been chosen so that you will fully amortize your principal on the final loan payment.

The following chart offers an example of a $10,000 loan payable on monthly installments over three years:

Principal $10,000
Interest 12.0 percent per year

Three Year Loan

Payment	Interest Component	Principal Component	Loan Amount Outstanding
$332.14	$100.00	$232.14	$10,000.00
332.14	97.68	234.46	9,767.86
332.14	95.33	236.81	9,533.39
332.14	92.97	239.18	9,296.58
332.14	90.57	241.57	9,057.41
332.14	88.16	243.98	8,815.84
332.14	85.72	246.42	8,571.85
332.14	83.25	248.89	8,325.43
332.14	80.77	251.38	8,076.54
332.14	78.25	253.89	7,825.16
332.14	75.71	256.43	7,571.27
332.14	73.15	258.99	7,314.84
332.14	70.56	261.58	7,055.84
332.14	67.94	264.20	6,794.26
332.14	65.30	266.84	6,530.06
332.14	62.63	269.51	6,263.22
332.14	59.94	272.21	5,993.71
332.14	57.21	274.93	5,721.50
332.14	54.47	277.68	5,446.57
332.14	51.69	280.45	5,168.89
332.14	48.88	283.26	4,888.44
332.14	46.05	286.09	4,605.18
332.14	43.19	288.95	4,319.09
332.14	40.30	291.84	4,030.14
332.14	37.38	294.76	3,738.30
332.14	34.44	297.71	3,443.54
332.14	31.46	300.68	3,145.83
332.14	28.45	303.69	2,845.14
332.14	25.41	306.73	2,541.45
332.14	22.35	309.80	2,234.72
332.14	19.25	312.89	1,924.93
332.14	16.12	316.02	1,612.03
332.14	12.96	319.18	1,296.01
332.14	9.77	322.37	976.83
332.14	6.54	325.60	654.45
332.14	3.29	328.85	328.85
Total $11,957.15	$1,957.15	$10,000.00	$0.00

Note that almost all of your early payments are interest while the later payments repay the principle amount. A shorter loan is harder to pay back, but it saves you a substantial amount of interest. Making extra payments to repay a longer-term loan early, you can achieve some of the same effect.

This may not be the best approach for dealing with a home mortgage loans, due to the tax advantage and relatively low interest rates.[2]

Secured Debt Versus Unsecured Debt. When a debt is *secured*, the borrower has provided the lender with the ability to take possession of specific property if the borrower does not meet the terms of the loan agreement. An example of a secured loan is an auto loan. The car is the collateral—if you don't pay the loan back, the lender will have the legal ability to take the car from you. Generally, the lender will sell the car and use the money to pay off your loan. If there is not enough money to repay the loan, plus any costs involved in repossessing and selling your car, you still owe the balance to the lender.

A mortgage is a form of secured debt, with the house serving as collateral. A loan from a pawn broker, or financing on an appliance you buy on credit (without using your credit card), is also secured debt.

Credit cards are usually a form of unsecured debt. This means that the debt is simply a promise to pay the loan back.

Unsecured Debt

Credit cards and personal loans available from most banks and consumer loan companies, such as Beneficial Finance and Household Finance, are unsecured debt. Bank loans tend to have lower interest rates than those from consumer finance companies. Credit card cash advances are a more expensive form of unsecured debt.

Alternative Sources of Secured Debt

There are several sources of secured debt that are usually cheaper than unsecured debt:

[2] Home mortgages are discussed in more detail in Part Eight of this book.

- **Home Equity Loans**. These are available if your home is worth substantially more than the outstanding mortgage on your home. Usually, the total of your mortgage and your home equity loan can't be more than 80 percent of the value of your home. These are usually available to people who have owned their homes for a long time, so that they have paid down their mortgage, or have seen the value of their home appreciate. Usually you can borrow up to $100,000 against your home equity and still get a deduction for the interest on the loan. Typically the interest rate on a home equity loan is about 1-2 percent higher than the comparable mortgage rate, and you will be required to submit an appraisal report to verify the value of your home. Refinancing your mortgage for a higher amount is an alternative to a home equity loan, although it may require even more expenses than a home equity loan. Refinancing is discussed in more detail in Part Eight.

- **Margin Loans**. Margin loans use your investments as collateral. Depending on the investments you own, you can borrow up to 50 percent (and in some cases up to 90 percent) of the value of your investments. Current rates are between 9 percent and 11 percent, and the lower rates apply to larger loans. These loans can be an attractive way of getting short term cash without having to sell your securities. Also, the interest on these loans is tax-deductible up to the amount of your dividend and interest income from your investments. This deduction does not apply if your collateral is a tax-exempt investment, such as municipal bonds, so you may want to separate such securities from an account that you are using for a margin loan.

 Be careful—if you borrow the maximum amount allowed, and the value of your investments goes down, you may be required to pay a portion of the loan back immediately.

- **401(k) Loans**. If you have a 401(k) plan, your plan may allow you to borrow money. You usually get an attractive rate (about prime plus one) and can borrow for five years, or up to ten if the money is being used to purchase a home. Plans that allow loans permit you to borrow up to 50 percent

of the vested amount of your 401(k), up to a maximum of $50,000. However, if you quit or get laid off, you are usually required to pay the loan back, or pay any taxes and penalties that would be due if you took a distribution from the plan. 401(k) plans are discussed in more detail in Part Six.

- **Cash Value Life Insurance Loans.** If you have a cash value life insurance policy (that is, not a "term" policy), you can borrow a portion of the cash value of your policy. If you die before you pay back the loan, the amount is deducted from any money paid to your beneficiaries.

Student Loans

This is usually the first big loan you take, and it seems like the last one you'll ever pay off. It doesn't help that many people put their student loan at the end of the list when it comes time to pay your bills. Your student loan is your first big opportunity with large scale debt, and can help you to establish or tarnish your credit record. Your monthly budget has got to have enough room to pay your student loan, and if it doesn't, you had better do something about it.

Grace Period

Most student loans come with a grace period of six months. That means that, just when you think you have some chance of paying your existing bills with the meager salary you're earning, you get knocked off your feet with your first student loan bill. Or worse, you don't get a student loan bill, and hope that they can't figure out where you live, when you get a letter saying that you have missed so many payments that they are accelerating the loan and they want all of the money immediately.

Rather than having to face either of these two events, use your grace period to figure out how you are going to pay your loan, and make sure that your loan bill gets to you on time.

Getting Information on Your Loan

You should be able to contact your lender through the information provided on your promissory note, the I.O.U. you signed to get the loan or loans. If you don't have a copy, ask your parents, your school or call your lender for a copy. If you can't remember who your lender is, you should be able to find out by calling the Federal Aid Information Center (800-4FEDAID), or the Educational Financing Group (800-646-GRAD).

Deferment

If you can't pay your loan, you may be able to defer, or put off, the date when you have to start paying your student loan. If you have already started paying your loan, a change of circumstances may allow you to stop paying. This usually involves a fair amount of paperwork, but most student loan lenders are happy to provide you with the forms and help you fill them out. Deferments are available for a number of reasons, including:

- unemployment,
- returning to school full time,
- parental leave, and
- joining the Peace Corps and certain other non-profit volunteer groups.

Sometimes when you defer a loan, the government continues to pay the interest on your loan, as they did while you were finishing school. In some cases, however, your loan still accrues interest which is then capitalized, or added to your principal, and which you will eventually have to repay.

Forbearance

If you don't qualify for a deferral, you may be able to get a forbearance. This means that you will still have to pay the interest on your loan, but not the principal portion. You may also qualify for forbear-

ance on the interest portion of your loan, although that means that the loan will continue to accrue interest, which is then capitalized, and which you will have to repay.

Extended Payments

You may be able to extend your payments from the standard 10 year period to as much as 30 years. This means that you will pay a lot more interest over the life of your loan. For instance, $10,000 over 10 years at 8 percent interest is a payment of about $121. If you extend to 30 years, you'll only decrease your payment to $73. However, you will increase your total interest cost from about $14,600 to $26,400. If you absolutely can't make your payment, you may want to consider an extension.

Remember, you can reduce your overall interest cost by making larger payments as soon as you can afford them.

Graduated Payments

If you can make a payment, but you can't afford to make your whole payment, you should consider asking for a graduated payment plan. Under this kind of refinancing package, your payments start out low and increase over time—ideally, as your earnings increase. These payments are generally increased every two years and you pay back the loan over 12 to 30 years.

Consolidation

If you have more than one student loan, and you owe a lot of money, you may be able to consolidate your loans into a single monthly pay-ment and stretch your payments over a longer period of time. This will reduce the amount you have to pay every month, although you will pay more interest over the life of the loans. When you consoli-date, you may have to pay a somewhat higher interest rate than you were paying before.

In order to consolidate, you must have at least $7,500 of loans out-standing, and you have to be reasonably current with your payments.

If you are not current, or if you are in default, prior to applying for consolidation you must have made satisfactory repayment arrangements with your lenders for each of your loans.

You can consolidate most types of student loans, including Stafford Loans, Federal and Student Plus, Perkins Loans, Federally Insured Student Loans and Health Professions Student Loans. Call any one of your loan holders for information on loan consolidation and the interest rate for consolidation loans.

Sample Loan Consolidation

The following is a sample of how a consolidation of your loans works. As you can see, you can significantly reduce your monthly payment. In the sample, you will save about $540 of take home pay every year. However, over the life of your loans, this will cost you more interest—about $4,400 in the sample. You can reduce the amount of additional interest you pay by making additional payments when you can afford them. If your expect your earnings to increase in several years, you can increase the amount of your monthly payments, or even make extra payments during the year to pay your loan off early and decrease your additional interest costs.

Separate Loans	Interest Rate	Monthly Payments	Term (Years)	Total Payments
$12,000	9 %	$152.00	10	$18,241
4,000	11 %	55.10	10	6,612
$16,000		$207.10		$24,853
Consolidated Loans				
$16,000	9 %	$162.28	15	$29,211

Making Changes with Your Loan

Your lender is the key person to contact if you want to make adjustments to the provisions of your loan. If you are extending your loan or consolidating two or more loans, you can call the Department of Educations' direct loan consolidation program (800-455-5889). Banks, credit unions and the Student Loan Marketing Association (Sallie Mae for short, at 800-643-0400) are other sources for consolidation or extension of your loan.

Chapter Eleven

Taking Control of Your TRW

Introduction

A credit report is a record of your good and bad credit history—your financial *Portrait of Dorian Gray*. Periodically, most lenders will report information to one or more of the three main credit reporting agencies, which keep a list of your existing and past credit cards, charge cards, loans, auto loans and student loans. It includes your payment history, your outstanding balance and notes things like accounts that have been closed. It also reports the people who have recently looked at your credit report, such as a potential lender, a potential landlord, etc.

Credit reports are an interesting meeting ground of various issues—money matters like your income history and money-management skills as well as political matters like your right to privacy and the direct impact of information technology on your life.

Many people have made persuasive arguments for reforming the way credit reports are used in the U.S. They claim that heavy reliance on

credit reports is an invasion of privacy and proof of the inability of corporate lenders to judge risks for themselves. Although there have been some recent improvements, credit reports continue to be a thorny issue.

Regardless of their credit history, most people feel uncomfortable when they have to call on their credit report. Applying for a car loan or mortgage usually gives people that "waiting outside the Principal's office" feeling that survives years of therapy.

Of course, you shouldn't fear. A credit report is just a tool for measuring your financial condition. Fortunately, it's not the only thing lenders rely on when they make credit decisions. If your report is less than perfect—or even horrible—there are things you can do to improve your position.

Order a Copy of Your Credit Report

TRW, Equifax and Trans Union are the three main credit reporting agencies. Typically, they do not contain identical information on them, so it may make sense to order all three. TRW will send you a free report once a year, and the other two charge $8 for each copy of your report, and $16 for joint requests. By law, if you have been turned down for credit, the company that turned you down has to tell you which reporting agency they used. You are entitled to a free credit report from that agency for 60 days, as long as you provide a copy of your denial with your request. Your request letter should include your name, address, social security number and birth date. If you are asking for a report for your spouse as well, make sure to provide information for both of you and both sign the letter. Send your request in writing, and a check if applicable, to the following:

TRW
Consumer Assistance
P.O. Box 2350
Chatsworth, CA 91313-2350
(800) 879-8848

Equifax
Information Service Center
P.O. Box 74201
Atlanta, GA
800-685-1111 for information (if your credit has been denied, you can fax your request with a copy of your denial to 770-612-3150. You can also call 770-612—3200 during business hours to order a copy of your report over the phone, but you will need a credit card to pay your fee unless you've been denied credit)

Trans Union
Consumer Relations Disclosure Center
P.O. Box 390
Springfield, PA 19064
(if your credit has been denied, call (316) 636-6100 for an interactive voice mail system that will allow you to order over the phone)

 Web Tip

You can also contact TRW and Equifax on the net at www.trw.com and www.equifax.com. These sites provide information on credit reporting, how to read a credit report, federal privacy laws and—on Equifax—receiving a copy of your credit report. The answers to specific, technical questions about fixing your report can be found here.

The following is an example of a credit report and the information it contains. After the sample report is a list of codes to let you decipher what the report says.

Company Name	Account Number	Whose Acct.	Date Opened	Months Reviewed	Date of Last Activity	High Credit	Terms	Balance	Past Due	Status	Date Reported
THE LIMITED	545-976	::	05/90	26	07/95	520		325		R1	07/95
BANK OF AMERICA	896-453	J	09/82	47	08/95	1030		0		O2	08/96
UNOCAL	352-328	I	02/93	12	06/95	65		42		R2	06/95
AMERICAN EXPRESS	654-382	S	05/91	07	02/97	1200		652		R1	02/97
VIC SECRET	752-681	I	04/92	28	12/95	543		278		R1	12/95

PRIOR PAYING HISTORY 30(01) 60(01) 90(01) 05/93-R2,08/93-R3,02/92-R4

Code\Meaning
This tells who is responsible for the account and who uses it.
J Joint
I Individual
U Undesignated
A Authorized user
T Terminated
M Maker
C Co-maker
B On behalf of another person
S Shared

Months Reviewed
This shows how long the account has been tracked.

High Credit
The highest amount you've charged—or the credit limit—on a specific account.

Balance
The amount you owed on the account at the time of the report.

Status
This shows the type of account (O = Open, R = Revolving, I = Installment) and how long it takes you to pay.
Example: R3 means a revolving account which you've been paying from 60 to 90 days late after the due date.

Code/Meaning
0 Too new to rate; approved but not used
1 Pays within 30 days of payment due date, or not more than 1 payment past due
2 Pays between 30 and 60 days of payment due date, or 2 payments past due
3 Pays between 60 and 90 days of payment due date, or 3 payments past due
4 Pays between 90 and 120 days of payment due date, or 4 payments past due
5 Pays more than 120 days, or more than 4 payments past due
7 Making regular payments under debtor's plan or similar arrangement
8 Repossession (indicates if it is voluntary return of merchandise by the consumer)
9 Bad debt

Prior Payment History

This the number of times you've paid late and how late your payments were made. For example, 30(01) 60(01) 90(01) means you paid 30 days late once, 60 days late once, 90 days or more late once.

It also shows the first late payment you made and the two most recent late payments. For example, the most recent late payments reported here were in May and August 1993. The first late payment was in February 1992.

141

Check Your Reports for Errors and Fix Them

Check your report carefully. Your creditors and the credit reporting agencies are not perfect, and they often make mistakes.

The first time I saw my credit report, I found that it included credit cards that have been active since 1955, years before I was even born. It also included information about deadbeats who had the same name—and not just the ones related to me.

In their reports, the credit agencies include directions of how you can ask them to make corrections to any mistakes contained in your report. They are required by law to investigate your request, and make corrections. Even if the credit report is correct, you can dispute any negative entries in the report. In some cases, if the agency can't verify the information, you can force it to remove the black mark.

I recommend reordering your report 60 days after an agency agrees to make a correction—in order to make sure it gets done.

Put in an Explanation

If bad marks on your credit report were caused by a dispute with your credit card company or some other reasonable cause (like the dog ate your bill), you can make the credit agency add an explanation of up to 100 words that will appear next to the black mark on your report. If you defaulted on a credit card, but eventually paid it off, you will also want to add that to your report.

Use the Information

When you are applying for a home loan or an auto loan, the person who is processing your application is often on your side. For instance, if the dealer wants to sell you a car, they may be willing to help you get your loan if you can explain the black marks on your credit report. Getting a copy of your credit report is one way to know what your black marks are.

Establish New Credit

The first thing to do is make sure you're paying existing debts on time. Most black marks are removed after five years—except bankruptcies, which stay on credit reports longer.

If your credit accounts have all been cancelled, you'll need to open new accounts—which can be difficult.

Look under the heading Debit Card and Secured Card in Chapter 9 to find out how to get a credit card when you deposit cash into a bank account. Make sure you make your payments on this credit card on time, and you can start to re-establish a good record. You may also be able to get a store credit card, based on your debit card, buy one or two items, and then pay off that card. This will add an additional positive card on your credit report, which may also help show that you have turned over a new leaf.

Avoid Credit Doctors and Credit Fixers

With the exception of a few non-profit credit counseling services, most groups that claim they can fix your bad credit report are scam operations. They usually can't fix your credit any better than you can, and they can cost a lot of money.

 Web Tip

Debt Counselers of America, a non-profit group, provides credit and money management advice to people who need it at shops.net/shops/GET—OUT—OF—DEBT. You can download software to dig out of a financial snow drift, details on credit fixing scams and advice on debt consolidation.

Chapter Twelve

Escape from Debt Hell

Introduction

If you have already gotten your credit card and other debt to the point where you can't afford to pay your bills and still have enough left to eat, you are in a severe cash crunch. You will need to restructure your life in order to get out of the crunch. Even if you haven't gotten to that point yet, there are several things you can do to get out of trouble.

First, don't panic and don't hide from your problem. The problem will not go away if you avoid it, it will only get worse. Try not to get too upset—it's only money, and although being broke is not fun, there are worse things that can happen to you.

Second, you need to assess your position. List all of the minimum payments on your debt, and all other fixed payments that you have to make, such as rent. If there's enough left over to live on, you are going to have to do some restructuring of your debt. If there is not enough left to live on, you will have to do some or all of the following in order of severity:

Credit Crunch Action Plan

Step 1. Drop all non-essential expenditures—quit the gym, bring your lunch to work, review Chapter 1 to see where else you can save money.

Step 2. Increase your income—take on a second job or additional shifts or overtime, if any of these are available.

Step 3. Apply for either a low-interest credit card or a debt consolidation loan and use these to pay off your existing cards and reduce your monthly payment. This may be easier said than done, particularly if you have missed a number of payments on your existing debt. A debt consolidation loan may also be harder over the long term, as you may actually pay more interest than you do on your current credit cards. Don't put in more than two or three applications for new credit. Your credit report keeps details of credit applications, and too many applications at once may be a red flag to a potential lender.

Step 4. Don't cut up your credits cards just yet. Although this is how you got into trouble in the first place, you may need to use any remaining spending power to keep going until you can implement your new financial plan. However, you will want to cancel department store credit cards that you haven't been using, as too many outstanding credit cards may decrease the likelihood of qualifying for new credit to replace your old credit. Once you have been approved for a low interest credit card, or debt consolidation loan, and paid off your old credit cards, cancel all but one, and keep that one for emergencies only.

Step 5. Reduce or consolidate your student loans—most student loans will give you a deferment of three months if you become unemployed or are otherwise in financial trouble. Also, if you have several loans that total over $7,000, you may be able to consolidate them into one lower monthly loan. The details on this are in Chapter 10: Student Loans and Other Early Debt.

Step 6. Negotiate lower payments on your unsecured debt. Most of your creditors do not want to see you go down, they merely want to

get paid eventually. If you are ever going to be late or unable to pay the minimum or required payment on any debt, your first reaction should be to call your creditors. Most creditors will agree to reduced payments, and work with you through a rough time, as long as you communicate with them.

The keys to this communication are:

- **Be honest.** Explain your problem, and let them know exactly what your situation is.

- **Don't be bullied.** They will suggest a reduced payment plan, and try to get you to agree to pay as much as you can. This is no time to be shy. Make sure that you know how much you can afford to pay each creditor, and don't make promises you can't keep.

- **Keep your promises and keep talking.** If you agree to a reduced payment plan, and realize that you can't meet the plan, call your creditor and tell them as soon as you know.

- **Be as friendly as possible.** These people are not your enemy, and as long as they think you are trying, they will work hard to accommodate you.

- **Ask them about your credit rating.** Your creditors sometimes have discretion as to whether they must report reduced payments, provided they are made on time. Ask to see if they can help you avoid trashing your credit report. Although they are supposed to report late payments, they do have some discretion if you talk to them up front—if you come up with a reduced payment plan, you can often get them to report the account as settled with a $0 balance. Make sure you get something in writing indicating how it will be reported. Otherwise, if some new employee changes the deal, you're out of luck.

Step 7. Negotiate extensions or accommodations with your secured lenders. Your mortgage lender will usually work with you if you get into temporary trouble. They may extend the term of your loan, thereby reducing your payments, or may actually forgive interest for

3-6 months, if you can demonstrate that you are likely to get back on your feet. Many lenders are likely to say that they have sold your loan, so they can't help you. Although this may be true, if you are still mailing your check to the same place, then that bank is still responsible for "servicing" your loan. That means that they can agree to changes in the payment terms, so be persistent. (If they are truly not in charge of your loan, they are required to tell you who bought your loan.) A phone call to that party is the best way to confirm the person who can help you.

Your auto lender is also likely to defer payments or reduce payments if you contact them as soon as you get into trouble. Be especially careful to call your auto lender before you get 30 days late, as they are likely to send someone out to repossess your car.

Step 8. Call the Consumer Credit Counseling Service (CCCS) at 800-388-CCCS. If you don't think that you will be able to go through these negotiations alone, the CCCS will help you find a nonprofit credit counseling agency that will help you negotiate with your creditors to come up with a payment plan that will work for you and your creditors. Avoid credit counseling or credit consolidation services that operate on a profitable basis—most of these are shams that collect money from desperate people and don't provide any real help. Besides, you're in no position to pay for this when you can get it for free.

Step 9. Give up your car or house. If your car or house is worth more than what you owe on it, and you are not likely to be able to continue to pay your loan, you will eventually lose your car and your house. You are better off selling your car, and going without a car, if possible, or selling your house and moving into an apartment you can afford. If your house or car are worth less than the outstanding loan, you are usually better off holding them as long as you can, and then trying to negotiate with your creditor to take back the property in complete settlement of your debt.

Step 10. If your situation is this dire, you will want to consider a consultation with a bankruptcy lawyer. Most will provide you with an initial consultation without a fee. This is usually more drastic than you may want to consider but it's good to know your options. If the

majority of your debt is student loans and unpaid taxes, bankruptcy may not be helpful, as these debts are not typically forgiven in bankruptcy.

Step 11. Don't let debt collectors hassle you. There are laws that protect you from debt collectors—they can't call you before 8 a.m. and after 9 p.m., and they can't embarrass you or use profanity. If you have any problems, make sure to call the Federal Trade Commission (202-326-3224) or your local Department of Consumer Affairs to report them. Aside from being helpful in protecting your privacy, it will probably help you feel a lot better to bust someone else's chops.

Part Four:

The Second Biggest Purchase

Chapter Thirteen

The Mechanics of Buying a Car

Introduction

Your first car is usually the largest financial obligation you will have, until you buy a house. Although it is much less complex, it still has many of the issues involved in buying a house. If you plan well, and work within your budget, you can avoid most of the common mistakes and get a good deal on a new car. If you don't stay within a reasonable budget, your car payment, registration, insurance and maintenance can be so expensive that you can end up as a prisoner of your automobile. When I was in grad school a good friend bought a cool little European convertible that he couldn't afford. He ran out of rent money for the semester and ended up living out of that two-seater.

Keep in mind that the sole objective of the car dealer or auto leasing company is to make as much money as possible. There are several ways for them to get you to pay more money. In this chapter, we'll consider these.

Sucker Sticker

New cars all come with a window sticker that tells you the Manufacturers Suggested Retail Price, or MSRP. A lot of dealers add their own *extra sticker* to get you to pay even more. This "sucker sticker" usually has some real options, some junk options and even a few charges that the dealer's simply made up.

Real options include things like special wheels or dealer-installed alarms or sunroofs. The price for these items on the extra sticker is usually two or more times what the things cost.

Junk options are pin stripe paints, clear coat, upholstery sealing, rust proofing, etc.—which are almost complete profit. For example: The dealer sprays two $14 cans of Scotchguard on the seats and carpet, and charges you $250. You can save a bundle by doing this yourself. The same holds true for clear coat: The factory paint job should be fine for years. If you're paranoid about paint, you can buy clear coat finish kits at most auto parts stores. Rust proofing has already been done by the manufacturer, so you don't need to buy it again.

The made up options are the worst. They represent 100 percent profit for the dealer. They have fancy names like dealer prep, dealer overhead, administration fee, etc. All of these are extra charges for nothing—or sorry attempts to get you to pay for the dealership's operating costs.

Overhead costs are the dealer's problem. If he's paying his wife's idiot sister $100,000 a year to count lug nuts, you shouldn't have to pay for it. Don't.

Don't Get Suckered

For the options that cost money, if you want them, offer the dealer 50 percent of the sticker price. Keep in mind that the dealer will also make money selling the stock wheels that they took off when they put the special wheels on. If you don't want an option that can be removed, such as wheels, ask the dealer to take them off.

For the other charges, offer the dealer 20 to 25 percent of the cost. Although this is still probably more than they are worth, you do save yourself some time and aggravation of having to buy the Scotchguard and put it on yourself.

For the charges that are additional dealer profit, take a line from Nancy Reagan and Just Say No. Unless the model you want is in very short supply, you should be able to avoid these charges altogether.

If all else fails, tell the dealer you would rather order the identical car without all of these add-ons. Because they want to sell you the car they have on the lot, this usually makes them a lot more flexible on the price of the car that you're considering.

A friend of mine used this tactic and ended up getting an $800 alarm system that the dealer had already installed—by accident—for free. It would have cost more for the dealer to take the thing out.

Delay of Game

While some car companies are reforming the way they sell their product, many still let their dealers drag out the sales process.

The salespeople at the dealership have to stay there until closing, so they don't mind waiting until you are so tired of negotiating that you'll agree to anything. They will often do things like take your car keys so that the mechanic can "inspect" the car you're planning to trade in, or leave you in one of those miniature offices while they "do their best" to get the manager to give you a better price.

Be patient, but don't be taken in. I've used some reverse psychology on these guys by bringing a magazine or book and happily reading while they make me wait. If you want to add an extra twist, bring the latest issue of *Consumer Reports* or *Auto Week* magazine. That always makes guys in plaid suits—and their hipper step-sons—sweat.

Keep Things Moving

Don't let salespeople take your keys unless you have some time to

spare. Otherwise, you will be stuck there for as long as they want to delay you. Tell the salesperson that you have exactly one hour; after that, you have an appointment that you can't reschedule. This usually moves them along.

If you are about to leave and you haven't bought a car, many dealers will ask you for a deposit, in order to force you to come back. Don't fall for that trick—it puts you in an awkward position if you want to buy a car elsewhere. Be friendly but firm when you say, "I intend to shop around, and can't afford to put down several deposits."

Package Deal

The dealer's favorite customer is the person who is buying a new car, trading in an old car and taking a car loan from the dealer. The dealer has three ways to attack, because he can give you a bargain on one part of the deal but make it back—and then some—on the rest.

Typically, they'll give you a great price on your trade in, but won't give you the best price on the new car. Or they may give you a great price on the trade in and the new car, but charge you a high interest rate on the financing.

Break the Package into Parts

First, ask your bank or credit union how much they charge for a car loan, and check with several other lenders. Find the best interest rates available, so you know what the going rate is.

Then shop for the model you want at several dealers until you have your best price. If they ask you whether you will be trading in your old car, tell them you don't think so.

When you've made your best deal on the car you want, tell the dealer you would like to get an estimate on the trade in value of your old car.

Finally, tell the dealer that you want to apply for a loan through their finance company. Many manufacturers have their own finance arm,

such as General Motors Acceptance and Chrysler Credit. Others have predetermined arrangements with banks or other lenders.

Call your bank or credit union in advance and get some ballpark quotes for interest rates on a car loan. If the dealer offers you an interest rate that is as good as the one you found from the credit union or bank, go ahead and sign the papers.

If the dealer quotes a higher interest rate, tell him about the better rate that you found and say you'll need a few days to apply for the loan elsewhere. Many dealers will match the rate, rather than let you walk away without buying a car.

Car loans, unlike consumer loans, are pretty formulaic. As long as the terms—the interest and time period—are reasonably close, one loan is basically like another.

Extended Warranty

For $200 to $1,200, you can buy a form of insurance that will pay for certain car repairs that occur after the manufacturer's warranty expires. This is almost pure profit for the auto dealer, and isn't a very good deal for you. Most flaws in your car will show up before the manufacturer's warranty expires.

The extended warranty covers major items that rarely fail, and doesn't usually cover the most common things that you will almost certainly need to replace, such as tires.

Also, the extended warranty usually has a deductible of $100 or more that you will have to pay before the extended coverage will pay the first dollar.

Don't buy the extended warranty on a new car. If you're worried about having to spend money to fix an expensive repair, put the money you saved into a special savings account.[1]

[1] If you're thinking about leasing a car, there's even less reason to buy an extended warranty. Because the car company is going to get the car back, it will often extend the basic warranty voluntarily. One couple I know leased a Ford and started having engine problems after they'd passed the mileage limit of the basic warranty. They were close enough to the end of the lease that the company fixed the engine under the terms of the expired warranty.

"How much do you want to spend a month?"

This is a classic ploy. The dealer will ask you how much you want to spend a month to avoid talking about the price of the car, or the interest rate on the car loan.

Let's say you're looking at a car with a sticker price of $13,000, and you tell the dealer you can afford $300 a month. There are at least two possible outcomes here:

- Option 1. The dealer could sell you that car for the sticker price of $13,000, and include an extended three-year warranty for $500, making the total cost $13,500, and charge you 12 percent interest on your car loan. Without focusing on the total purchase price, he will say "you can drive that car away with a monthly of $298 for 60 months, and that includes a three-year extended warranty."

- Option 2. The dealer could easily discount the price of the car to $11,800, and give you a loan with 10 percent interest, and you would also pay $300 a month, but you would only have to pay for 48 months.

The dealer is likely to stick you with Option 1, because he will collect $300 a month for an extra 12 months, or an additional $3,600. Even though he will have to pay $100 to the insurance company that sells the extended warranty, he still makes out like a bandit.

If you try to negotiate for a better price, a dealer may drop off two or three of your monthly payments, but you're still paying way too much. Clearly you want to take Option 2, and save $3,600. (You already know to avoid the extended warranty.)

The only way for you to know if you're getting a good price for your new car is by establishing the purchase price and interest rate you are paying, and to know how these compare to prices you could get from other dealers. So, if they ask you how much you can afford every month, simply tell them that you are looking to find out the purchase price of the car, so you can compare it to prices at other dealers.

Dealer's Invoice

Many car dealers advertise that they will sell a car for just $100 over their "factory invoice," which is the dealer's cost—or the amount that the dealer has to pay the manufacturer to buy the car. If you are getting down to the end of a negotiation, the salesperson may show you the invoice to convince you that you are getting the car at only a little more than the dealer paid for it.

This is a ploy—don't be fooled by it. The MSRP or sticker price is usually between 7 and 20 percent greater than the dealer's invoice or cost. But the auto manufacturers build a profit into the price they charge dealers. Ford, Toyota and the rest of the major car makers take about 10 percent of the car's sticker price as their profit.

Many times, the manufacturer will offer the dealer a portion of its profit in order to help sell cars. For instance, if the car costs $9,000 to build, the dealer will pay the manufacturer $10,000 and try to get you to pay $11,000. Even if the dealer offers to sell you the car for the price he paid—$10,000—he may have a deal with the manufacturer that will give him a rebate of $500 to sell that particular model. It's not uncommon for dealers to get rebates of $500 to $5,000, which lowers their cost significantly below the dealer's invoice.

If your local library carries *Auto Week* magazine, you can periodically find a list of rebates or incentives being offered to dealers. You can also get this and more information through USAA or AAA—as described below.

Blue Book

The "Blue Book" is a term used for the value list of used cars by year. Most of these have certain assumptions about mileage of the car and have adjustments for various options that the car has, such as automatic transmission or air conditioning. You should note that the adjustments for options are usually much less than what they originally cost, so when you are buying, choose your options sparingly. The important thing is that not all Blue Books are the same, and most of them aren't blue.

- **National Auto Dealers Association (NADA) Official Used Car Guide** is the book that most car dealers use to buy cars, and most banks use to lend money on used cars. (Incidentally, it's orange, not blue.) The NADA guide has the Average Trade In, which is what the dealer should pay or what you should try to pay when buying a used car, the asking Price Average Loan, which is what a bank will lend, and the Dealer's Asking Price, which is the price a dealer will put on the window of a used car. A dealer may show you his copy, or you may be able to get one at your local newsstand or book store, although it's easiest to find at the library. NADA also publishes a consumer version of the book that only includes retail prices—but you're better off using the professional version.

- **Black Book** is the book that auto dealers get, but the public doesn't. This book shows the retail value or highest value for used cars, rather than the wholesale value, or the price that a dealer pays. Dealers will show you this book when they are selling a used car, but will keep it hidden when you are negotiating the price of a trade-in.

- **Kelley Blue Book** is a used car guide for consumers, which provides similar information on used cars. This is the used car book you're most likely to find at the local Barnes & Noble. The Kelley book is fine, if you can't find anything else—but the NADA professional book is more complete.

Choosing Your New Car

A little preparation is important to getting the best deal on a new car. I suggest coming up with a list of at least three cars that you think you would like to price and test drive, even if your heart is set on only one.

Next, you have to do your research. There are dozens of car magazines and books. These are usually a good place to start. Most car magazines, such as *Motor Trend, Car & Driver, Automobile* and *Road & Track*, have regular articles rating cars of similar size and cost. They also have feature articles on specific cars that go into a great amount

of detail. Also, many of them have long-term reports—in which they keep a new car for a year and tell you how it holds up, including how much they had to spend on things like tune-ups and repairs.

Several other magazines, including *Consumer's Digest*, rate cars on the basis of quality and price. These others tend to be less interested in how fast a car can go from 0 to 60 miles per hour, and more interested in issues such as safety and practicality.

Many of these sources will supply the actual price, or the range of prices, that dealers are charging. Some even show the dealer's invoice cost. Market conditions can cause the actual price to be dramatically different from the sticker price.

As I mentioned earlier, call your bank or credit union to check the prevailing interest rates. If the dealers aren't offering attractive interest rates, you may get a better deal with another lender.

Timing Is Everything

In the second half of 1995, Ford released a completely redesigned 1996 Taurus and Chrysler/Plymouth came out with a completely revamped 1996 line of mini-vans. Because these were some of the most popular cars in the world, there were a lot of 1995 models on dealers' lots. However, because the new 1996 models are so different, the 1995 Taurus and the 1995 mini-vans became old hat—and you could buy them for much less than the MSRP.

One way that car companies try to increase their profits on these transition year cars is to keep the old price and load the cars with free or cheap options. Either way, you get a better deal for buying last year's model.

This also happens to a lesser extent when cars are changed even slightly. New models typically come out in the fall, which means that the dealers will start discounting during the middle of the summer. If they haven't sold all of the 1996 models by December of 1996, you can get even a better price, although you may not get the selection you want.

You can also get large discounts on good cars that are temporarily out of fashion. In the early 1990s, Volkswagen had a number of years in which their usually popular cars were not selling well. As a result, you could buy a new VW for significantly less than sticker price.

The only way to find these bargains is to pay some attention to auto industry sales trends and then get out there and shop. Try to keep an open mind as to the exact model of car that you want. This way, you're flexible enough to stumble across a deal.

Repair Costs

The more expensive a car, the more expensive the maintenance. This doesn't necessarily make sense, but that's how the repair shops work. Foreign cars, particularly European cars such as Audi, BMW, Mercedes, Saab and Volvo will cost more to maintain and repair. Cars with turbo-chargers may also require expensive repairs in the future, and those fancy racing tires or four-wheel drive tires that come with some cars are very expensive to replace. Keep this in mind when you're shopping.

Plan for the Future

Keep in mind that you may own your car for five or more years. If you are recently married, that little two-door convertible may look great, but it won't be very efficient when you have kids. You may want to consider a sporty four-door with a moonroof instead. You'll save a bundle (a convertible top on a Ford Mustang or Toyota Celica costs as much as an extra $5,000) and still get to see the stars.

Call for Insurance

The cost of insurance is a major part of the cost of your car, and different car models carry vastly different insurance costs. I like to call for an estimate of insurance coverage before I even leave the house. You can get a good idea of relative costs after about five minutes on the phone with your insurance agent or insurance company. At the very least, make sure to call your insurance company for a price quote before you buy.

Don't listen to a car dealer who says insurance on a Mercedes convertible isn't much more than coverage for a Hyundai. Two-door cars, sports cars, luxury cars, and cars with big engines are more expensive to insure—but only your insurance company can give you the true story.

Make sure that you have insurance coverage before you drive the car off the dealer's lot.

Shortly before I started researching this chapter, I replaced a six-year-old sports sedan with a brand new four-door—and actually reduced my overall insurance cost.

Sport Utility Vehicles

The 1990s has seen a craze for sport utility vehicles, like the Jeep Cherokee, Ford Explorer and Toyota 4Runner. Although they cost more than the average mini-van and have less room, most people find them more attractive. Unless you live on a dirt road, or in an area that gets a lot of snow, you will probably do just fine with a mini-van or station wagon.

Down Payments

Most lenders will require that you pay 10 percent of the cost of your new car as a down payment. This makes it very difficult for many first time buyers to afford a new car. If this applies to you, consider three options:

- Rebates: Try to find a car with a manufacturers' rebate. Some lenders will loan on the full amount of the purchase price, and then the manufacturer will send you a check for a portion of the price. If you have enough room on your credit card, you can pay the down payment with your credit card, and then pay some of the credit card debt with the rebate.

- Lease a new car (for more details, see Chapter 15).

- Buy a used car (for more details, see Chapter 16).

New Models

Try not to buy a car the first year it is introduced or after a complete redesign. As new car models are changed with greater and greater frequency, car makers often rush a car to market with minor or even major design flaws. They are usually cleared up by the second year of production, but those who bought the first model year have to live with the flaw—or take the car back to the dealer to have it retrofitted. Sometimes more than once.

Shopping

Now that you have identified a list of potential targets, it's time to go shopping. Don't overdress, leave the jewelry at home, and if you have a trade-in, wash it before you head out to the dealers.

I like to go to auto malls, so that I can look at everything in one trip. Most cities have one or two areas where new car dealers seem to be concentrated.

It's best to test drive each car on your list at the first dealer you visit, preferably a dealer near a road where you can get up some speed. If the car isn't satisfactory, you can cross it off the list without wasting any more time.

First Price

If you're still interested after the test drive, ask the dealer to work up a price. At first, you should tell them that you are not interested in considering a trade-in, but want to know the full price of the car, the down payment, monthly payment and interest rate they are offering.

It is important to get all of these terms so that you can compare the price against other dealers. Keep a pad of paper, and write down the sticker price and options, and all of the pricing information.

Trade-in

After each dealer gives you their price, ask for an estimate of the

trade-in value of your car. Based solely on the year, make and mileage of your existing car, plus a quick visual inspection, they should be able to come up with a pretty good estimate of value.

This happens because most dealers rely almost entirely on the same Blue Book to value your car. As we discussed above, it's the book with the lowest price.

Make sure you check the NADA coverage trade-in value of your car before you shop—and know both the wholesale and retail value of your car. Also consider mileage, optional equipment and anything also that might impact its value.

If your car has low mileage, a lot of options and is in especially good condition, you should be able to beat the wholesale price. Even if it isn't any of these things, you may still be able to do well if the dealer wants to sell you a new car. However, if you don't give the dealer a chance to look carefully at the car, he's likely to lower the price after his gorillas inspect it, regardless of what they find.

If you have the time, you can let the gorillas take your car for a test drive. But make sure to give them a time limit—such as fifteen minutes—or they will hide the car in the back lot while they try to pressure you into a deal.

Competing Prices

Next, go to at least two other dealers for competing prices. Tell the other dealers that you intend to buy that particular car and that you're shopping for the best price. That will usually get them to offer you a competitive price.

Salespeople at car dealerships often operate from a menu of pre-arranged negotiating styles. If you say at the beginning that you're shopping for price, they will respond accordingly.

Although they are certain to ask, do not tell them the price you were offered at another dealer—they will merely try to beat it by a small amount.

I have actually saved over $2,000 on a $14,000 car simply by shopping around, and so can you.

Car Reports and Brokerage Services

Both USAA and AAA can provide you with detailed information on that model—including dealer's invoice price, option costs, safety and other issues, fuel costs and even consumer rebates.

Better yet, both of these organizations will actually negotiate your deal for you. As long as you're a member of AAA or insure through USAA, their staff will contact car dealers in your area and hunt the best price. The catch: You have to know exactly what model and options you want.

Closing the Deal

Once you have found the best deal, it's time to sign the contract. Make sure the total price—including all taxes, license fees and delivery costs—is what you've negotiated.

You already know to avoid extended warranties. You can also skip credit life insurance, or credit disability insurance, which pay off your car loan if you die or become disabled and cannot work. These are much more expensive than regular life insurance and regular disability insurance (which you will learn about later).

If you're financing, make sure the number and size of payments, the time period and the interest rate are all what you've negotiated. Also, make sure the finance company is the right one—some dealers try to switch lenders after you've agreed to terms. Don't settle for assurances that all lenders are the same. They're not. Doing business with Ford Motor Credit may help you out with other financing later on in a way that East Jerkwater Acceptance may not.

In general, if the dealer tries to change any part of the deal at the last minute, don't be afraid to walk out the door. No matter how pushy they seem, most dealers will back down rather than lose a sale.

Chapter Fourteen

Borrowing the Money for a Car Can Be a Good Discipline

Introduction

To back up a few steps, there's some work you should do before you start shopping for new wheels. Most importantly, you should figure how much you can afford to spend.

A good rule of thumb is that your car payments and insurance should never exceed 20 percent of your monthly take home pay. That doesn't mean that you should plan on paying 20 percent, particularly if you make more than $35,000. If you have two cars, that limit should apply to both, although you can stretch the limit a bit if your combined incomes are less than $35,000 and you can't possibly get away with only one car.

Also, you should try to avoid having a car loan that lasts over 36 months.

You may find that these two rules of thumb make it hard for you to afford the car of your dreams. I spent all of my twenties and most of

my thirties muttering an automotive twist on Groucho Marx's famous line: I don't want any of the cars that I can afford.

But I've also realized that—aside from the occasional Stutz Bearcat you find at a widow's garage sale for $100—cars are a terrible investment.

Keep in mind that you should also be saving money for other things, such as a down payment for a house or a college education for a child. That may mean that a used car is a better way for you to go—if you want to buy more car. But used cars are often a maintenance headache.

How Much You Can Borrow

Using the 20 percent rule, you can estimate how much you can spend every month on your car or cars. Now you need to be able to calculate how much you can borrow. The chart below should help you.

Keep in mind that you will have to pay for auto insurance out of your car budget, so you must first reduce your monthly allowance by the amount of your car insurance. If you haven't chosen a car, you won't know how much insurance will cost, so estimate by using the insurance cost of your last car—or by calling an insurance company for a quote on a car that you think may be within your price range.

To establish your buying power, divide your monthly car payment allowance (after deducting the cost of insurance) by the "Loan Key" number in the chart below.

Auto Loan Key Numbers				
	Interest Rate			
Term of Loan	8%	10%	11%	12%
24 months	.045	.046	.047	.048
36 months	.032	.032	.033	.034
48 months	.024	.025	.026	.027
60 months	.020	.021	.022	.023

Let's say you estimate your car budget at about $350 per month, and after taking out for insurance, you have about $260 left. If the going interest rate is 10 percent interest, and you want to pay your car off in 36 months, then .032 is your Loan Key from the chart. Divide $260 by .032 and you get $8,125. That means that you can afford a 36-month car loan of $8,125. Keep in mind that you will have to pay a down payment, so you should probably be able to afford a car that is about 10 percent more than the amount of your car loan. If you are trading in a car, you can afford a car equal to the loan amount plus the value of the trade-in.

If you used the same amount and interest rate to take a longer loan, for instance 60 months, you would use .021 as your Loan Key. So $260 divided by .021 would permit you to borrow about $12,400. This would allow you to buy a much more expensive car, but as you will read below, it may be over your budget.

The 36-Month Rule

I recommend using a 36-month loan whenever possible. If you choose a longer loan, your monthly payments will be smaller, but you can easily get underwater with your car loan.

Underwater means that your car is worth less than the amount you owe on your loan. Most new cars are worth about 10 to 20 percent less than you paid for them as soon as you drive them off the dealers lot. That's because, although you bought a new car, once you drive it away, it becomes a used car. Your car continues to *depreciate*, or lose value, as it become older and as you put mileage on the car.

All this time, your car loan is being *amortized* or paid off, very slowly. Obviously, if you get a 60-month loan, you are paying the loan off much slower than a 36-month loan. This means that the longer your loan is, the more time you will spend underwater.

If you are underwater, it actually costs you money to sell a car because you won't get enough to repay your loan. When you sell a car that has a loan outstanding, you have to pay off the full amount of the loan. (In fact, until you pay off the car loan, both your name and

the bank's name are on the title and the insurance policy.)

If you can sell your car for $8,000, but you still owe $10,000 on your car loan, you have to come up with $2,000 to pay off the bank. Also, if you are in an accident and your car is completely destroyed, the insurance company will only pay you what the car is worth, or $8,000, rather than the amount outstanding on your loan.

Depth Gauge—How Low Can You Go

Let's say you buy a $11,000 car, put down $1,000 and borrow $10,000 at 10 percent. This chart shows how much the car is worth and how much you still owe.

| | Wholesale Car Value | Loan Outstanding | | |
		36-Month Loan	48-Month Loan	60-Month Loan
Day 0	$11,000	$10,000	$10,000	$10,000
Day 1	9,500	10,000	10,000	10,000
12 Months	7,800	7,254	8,046	8,518
24 Months	6,100	3,960	5,702	6,741
36 Months	4,975	0	3,112	4,777
48 Months	3,825	0	0	2,607
Monthly Payment		$322.67	$253.64	$212.47

As you can see, the shorter your loan, the less time you'll spend underwater.

Shorter Loan Means Interest Savings

A shorter-term loan will also save you money. Compare the total interest you would pay on the same $10,000 loan at 10 percent and 14 percent, if you paid the loan off sooner.

Loan Term	Total Interest Cost at 10%	Total Interest Cost at 14%
36-Month	$1,616	$2,304
48-Month	2,174	3,117
60-Month	2,748	3,961

Therefore, I suggest using a maximum 36-month loan. While this will increase your monthly payment, it minimizes the time you will spend underwater and saves you a lot of interest. The increased monthly payment also makes it harder to buy a more expensive car than you can afford.

The last benefit of the 36-month loan is that a two car family can get on a schedule of buying a new car every three years, and keeping each car for six years, without having more than one car payment at a time. With the constantly improving quality of cars, including American models, you should be able to keep a new car for six years without unreasonable maintenance expenses.

See how Nick and Nora managed to do this:

Years 1-3	Nick's new car 36-month loan	Nora drives paid for car	One 36-month new car loan
Years 4-6	Nick drives paid for car	Nora's new car 36-month loan	One 36-month new car loan
Years 7-9	Nick's new car 36-month loan	Nora drives paid for car	One 36-month new car loan
Years 10-12	Nick drives paid for car	Nora's new car 36-month loan	One 36-month new car loan

This system kept their car payments steady, so they had plenty of money to spend on other important things—like dry martinis and Asta, their precocious fox terrier.

Chapter Fifteen

Leasing a Car Means More Bang for Your Buck

Introduction

For many people, leasing a car is a cost-effective way of acquiring a new or used car. With a lease, you agree to pay a certain monthly payment for the use of a car, and promise to return the car at the end of the lease. You typically agree that you will not put more than 12,000 to 15,000 miles per year on the car, and that you will return it in good condition. You usually have the right to buy the car at the end of the lease for a price that is fixed up front. You have to provide insurance for the car and keep it in good condition.

How a Lease Works

The theory behind leasing is that you are buying only a portion of the car: the difference between the value of the car today and the estimated value of the car at the end of your lease.

For example: If you want to lease a new Mercedes C220, the purchase price is about $32,000. The dealer or leasing company may

estimate that in two years, it will be worth $20,000. Therefore, they can sell you the right to use that car for two years for $12,000, plus interest. When you give the car back, if they have estimated the value correctly, the dealer or leasing agent can then sell the car for $20,000. That way they have sold the car for a total of $32,000.

Because it is difficult to establish the price of the car that the lease is based on, the car company can often lease the car with less price negotiation than if it simply sold the thing.

Reasons to Lease

- Leasing usually requires less money up front, typically one month's lease payment and one month of security deposit at a minimum, in order to acquire a car. This is usually much less than the down payment required to buy a comparable car.

- A lease is a much cheaper way to drive a more expensive car, because you are only buying a part of the car.

- If you are interested in driving the fanciest car that your limited money will buy, or absolutely need to have a new car every few years, and don't mind that this will limit your spending or savings in other areas, then a lease is right for you.

- If you lease for relatively short periods, your car will always be under warranty, so you can avoid expensive repairs.

- If you are just starting out, and can't afford even the least expensive new or late model used car, a lease may be the most practical way for you to afford a reliable car within your means, and without a large down payment.

- Because you just turn the car in at the end of the lease, you don't have to worry about trading in or selling your old car.

- Some auto makers subsidize the lease of certain models that are not selling well, rather than cutting prices drastically or offering rebates. These are referred to as *subvented leases*.

Reasons Not to Lease

- If you buy a car, you own it when you are done paying for it. You can then enjoy several years of operation without a monthly payment. With a lease, you are paying for the privilege of using the car for a fixed period of time, and when the lease is over you must give the car back or buy it. That means you will always have a car payment.

- Leasing provides you with an easy way to spend more money than you should. You're probably better off staying within your budget.

- Leases are typically long-term arrangements. If you attempt to end them before they are over, you can be hit with large penalties that are almost impossible to calculate. With a purchase, you always have the right to pay off your loan, and you know the amount you owe.

The Tax Argument

Many people who favor leasing try to convince you that leasing provides you with tax advantages. Leasing or owning a car can only provide you with a tax benefit if you use the car for business other than commuting to work. The greater the percentage of use is for business (other than commuting), the greater the tax benefit.

If you own your car, you are allowed to take a portion of the car's decrease in value or depreciation, as a tax deduction. However, this is limited to $3,060 in the first year you own the car, $4,900 in the second, $2,950 in the third and $1,775 for each year thereafter. That should be enough for an average car, but it might take 20 years to get all the deductions for a Mercedes.

If you lease your car, you are allowed to deduct lease payments. Although these have certain limitations, they allow greater deductions for very expensive cars. These are described in IRS Publication 917— Business Use of a Car. This form isn't the IRS at its clearest, though. I'm a lawyer who reads IRS publications all of the time and I couldn't make heads or tails out of it.

The bottom line: For most people, leasing doesn't offer better tax benefits than owning. But, if you are leasing an expensive car and use it almost exclusively for business, there may be some advantages. If you think you fit this description, it's probably worth spending a few bucks talking to a tax professional.

The Basics of Leasing

Here's a list of the terms commonly used in leasing. The key thing to remember is that you are buying a portion of the car equal to the difference between the purchase price and the "residual" value of the car at the end of the lease. In order to compare one lease deal to another, you have to understand all of these terms and how they apply to your lease:

- **Price of the Car,** also called the Capitalized Cost or Cap Cost. This is the assumed value of the car when you lease it, and should be about the same as the purchase price you could get if you were buying the car. If the price of the car is the list price or if the leasing company won't specify the Cap Lost, you are probably paying too much.

- **Residual Value**. This is the estimated value of the car at the end of the lease. In most leases, you have the option to buy the car at this price, although you don't have to. If you are thinking about buying the car at the end of your lease, you will certainly want to compare residual values for each of the leases you consider. However, a higher residual value will mean a lower monthly payment.

- **Implied Interest Cost**. Although you don't pay interest as such, each lease has an implied interest rate. This is one of the factors that determines the lease payment.

- **Capital Reduction, or Cap Reduction**. This is a payment you make at the beginning of the lease to reduce your capitalized cost and lower your lease payment. The larger your capital reduction, the smaller your lease payment. A large capital reduction defeats one of the main reasons to choose a lease; namely, a minimal down payment.

- **Term.** This is the length of the lease, usually stated in months.

- **Upside Down.** This is like being underwater on the purchase of a car. During a lease, being upside down means that the amount you have paid to lease the car is less than the value of the car that you have used. Let's say that you lease a car for three years. After the first year, you may have paid lease payments, excluding finance charges and taxes, of $3,000. The car may be worth $5,000 less than when you bought it. This means that you are upside down by $2,000. Being upside down is not a problem—if you continue to lease the car to the end of the term. But if the car is wrecked or stolen, or if you decide you want to get out of the lease, you can expect to pay the leasing company the amount that you are upside down, plus potential administrative fees that can really add up.

- **Gap Insurance.** Gap insurance is a must if you are leasing a car and can't afford to pay the difference between the insured value of the car and the cost of getting out of your lease early if your car is totalled in an accident or stolen.

- **Open-end Lease.** Never ever take an open-end lease. If the value of your car at the end of the lease is less than the estimated residual value, you have to pay the difference.

- **Closed-end Lease.** The only kind you want. At the end of the closed-end lease, you have the right to buy your car for the residual value, but you don't have to buy it at all.

- **Purchase Option.** In most closed-end leases, you have the right to buy the car at the end of the lease for a fixed price— usually equal to the residual value plus some fees.

- **Mileage Limits.** Your lease provides maximum mileage limits over the term of the lease. If you exceed these limits, you will have to pay a per mile charge at the end of your lease. Although the annual limit is typically 15,000, you can opt to have a lower limit, such as 12,000, and get a slightly lower lease rate.

- **Normal Wear and Tear.** This is the most important phrase in your lease, and the one that can cause the most trouble. When you return your car at the end of your lease, the tires can be worn the amount that tires normally wear over a given mileage. So can the carpet. But if you have a cigarette burn on the leather seat, or several little dings in the doors, the lessor may be able to charge you anywhere from a minor amount to thousands of dollars to repair these damages.

- **Taxes.** Like almost everything in life, lease payments include a certain amount of taxes. Many dealers will quote you lease payments excluding taxes to make them seem more attractive. Make sure that all the estimates you get include taxes, so that you can compare them properly.

- **Fees.** Most leases have a number of fees, both at the time you lease the car (acquisition fees) and at the time you return it (termination or return fees). Make sure to include these amounts when comparing one lease to another.

- **Money Factor.** This is a number used to calculate the interest charge on your lease. If your leasing company tells you the money factor, multiply this by 24 to get your APR interest rate.

You can check your lease payment if you know the Cap Cost, residual value, lease term and either APR or money factor. First, subtract the residual value from Cap Cost to get the depreciation. This is the part of the car that you are buying. Divide this amount by the term of the lease—expressed in months. This gives you the monthly depreciation.

To determine the monthly finance charge, add the Cap Cost and residual value and multiply this sum by the money factor. Add the monthly depreciation and monthly finance charge to get your monthly payment—before tax.

Chapter Sixteen

Used Cars: Some Bargains and a Lot of Rip-offs

Introduction

The average new car loses 10 to 20 percent of its value the day you buy it, because the moment you take the wheel it becomes a used car. Most cars continue to decrease sharply in value for the first year and even the second year, while the car itself is still relatively new. After that, the value continues to decrease, but at a much slower rate.

This means that you can save a lot of money—up to 40 percent—by buying a used car that is less than two years old. In some cases, you can even get a finance company to lend you money at a new car rate (which is much lower than a used car rate) for a barely used one. This is one of the best tactics to consider whenever you're buying a car.

The following chart shows an estimate of the value of a used Ford Taurus Sedan in average condition.

Model Year	Price	Depreciation
1995	$14,000	$3,500
1994	11,775	5,725
1993	9,725	7,775
1992	7,500	10,000
1991	5,800	11,700
1990	4,700	12,800

The Differences Among Used Cars

Although many new car lots have trade-ins that they purchased from their repeat customers, most dealers buy their cars at car auctions, so they have no idea how the cars have been maintained. Used cars come from a variety of sources. Some of these may be cars that have been maintained well, but driven hard, such as rental cars or fleet cars. Others may be wrecked cars that have been rebuilt. Your best protection is finding a car dealer with a good reputation.

The best source of barely used cars is usually a local new car dealer, or a used car lot that has been in business for a long time. Although the new car dealer is likely to be more expensive, they are usually a little more careful to protect their reputation. A call to your local Better Business Bureau, listed in your phone book, will give you an idea of any complaints that have been made against a specific dealer.

You can also buy through the newspaper. This is one way to get the best price and to get a car that has been properly maintained. Be careful of people who make a business of selling used cars out of their homes or businesses. Although this isn't necessarily bad, they usually buy the worst used cars and try to sell them at greatly increased prices.

If the seller can't provide you with service records, or if the title has been recently transferred into their name, beware.

There are also some general things you should avoid:

- **Rental or Fleet Cars.** Although these are normally well main-

tained, the drivers are usually hard on them. Look at the title or call the manufacturer's zone office with the vehicle ID number to see if the car was a rental or fleet car.

- **Salvage Cars.** Many auto repair shops will buy cars that have been totalled in accidents, and repair them with used parts. Some states require that the titles identify cars which have been in serious accidents as *salvage*, but not all states have this requirement. You can best avoid this problem by buying from reputable people, and having a good mechanic inspect your car.

- **Diesel or Turbo-charged Cars.** Be especially careful of these used cars. They may require repairs that can total thousands of dollars, particularly for turbo-charged cars that have not been properly maintained.

- **Flood Damaged Cars.** Flood damaged cars must be identified as such under federal law, and you have to sign a document acknowledging that you are buying a flood damaged car. If you suspect that your car is flood damaged, check for telltale signs, such as a musty smell in interior or trunk, and mud or silt in the nooks and crannies in the engine compartment. Although a flood damaged car may seem fine, early rusting of the muffler system and body of the car, and failure of electrical components can make these cars a nightmare. Stay away.

- **Payment Without a Title.** Make sure that you get a valid title when you pay for your car, and that you are buying the car from the owner. Although this is rarely a problem with a dealer, it can be trouble when buying from an individual. Ask to see the seller's drivers license and take down the license number for your own protection.

Used Car Strategies

If you think you would like to buy a used car, most of the techniques described in buying a new car are applicable. There are certain issues that apply only to used cars.

Have the Car Checked by a Mechanic

Most mechanics will inspect a car for between $50 and $100. Unless you are an expert, there is no better way to make sure you are getting a good car. Also, you may be able to use the information from the mechanic to negotiate a reduction in price that more than pays for the inspection. It's best to use a mechanic that has experience with the type of car you are buying, because they will be more familiar with the normal problems with that model. Make sure that the spare tire, lug wrench and jack are in the trunk. You don't want them to be missing when you get a flat tire.

Ask for the Name of the Prior Owner

Although many dealers do not know the original owner of their used cars, dealers that have purchased their used cars on trade-in may be willing to give you the name and phone number of a prior owner. If they are, call the prior owner to learn more about the car's history.

Service Records and Manual

Another way to find out about the history of a car is to look at the services records if they are available. You can usually see how often the car was serviced, and if there were any recurring problems. This is also another way to find the name and phone number of the prior owner. Also, make sure you get the owner's manual so you can familiarize yourself with your car.

Warranty

Ask the seller if the warranty is transferable or, if you are buying from a dealer, if the car comes with a warranty. In many situations, the remainder of a new car warranty can be transferred with the car— unless the car was part of a fleet or was used as a rental car (car makers know who thrashes their product).

The seller should be able to tell you about any warranty, or there should be details in the owner's manual. Federal law requires that dealers put a sticker on the car that describes the warranty, or alerts

the buyer that the car is being sold "as is," or without any warranty. Even then, the seller may be required to guarantee the car for some minimal period of time, such as 30 days, or that the car will pass state inspection required for registration.

If you have any questions, a call to the zone office of the manufacturer will confirm whether the warranty can be transferred. You should be able to get the necessary contact information from a local dealer who sells the company's new cars.

Part Five:

Covering Your Assets

Chapter Seventeen

What to Insure...and What Not to Insure

Introduction

> The only mistake you can make about insurance is not having enough.
>
> —My Insurance Agent

Don't believe everything you hear. Insurance can be a great way to put the risk of everyday life onto someone else. However, it's one of the hardest bills to pay because, if things are going well, you feel like you're paying a lot of money for nothing. Most people need at least some insurance, and if you buy carefully, you can get all the coverage you need without getting ripped off.

Keep in mind that insurance is essentially legalized gambling, and the insurance company is the house. You are betting that something bad could happen and, if it does, you collect. The insurance company is betting that their clients will pay them enough money—your insurance payments are called, appropriately, *premiums*—to be able

to pay all the claims made, pay big commissions to the insurance agents, and still have enough left over to pay a lot of big salaries and buy big impressive buildings and immense computer systems. In other words, they always win.

What this all means is that you should only buy insurance for the big things that you absolutely need and that cost a lot of money. For the little things that you can afford to buy, you are better off saving your money. Over the long run, the money you save by skipping all those insurance premiums should be more than enough to cover any of those minor expenses.

Here are some examples of things I don't insure:

- **Televisions, stereos, washing machines, dryers, refrigerators** and just about any home appliance or electronic gizmos. The television you inherited from your parents just died after 16 years of faithful service. When you go to buy a brand new television for $349, one of the helpful salespeople at Circuit City offers you a three-year extended warranty for just $89. Don't do it. It is extremely uncommon that your new TV will wear out in just three years. The insurance company that writes that policy knows this. That's how they can afford to pay Circuit City a big fat commission, pay any claims that are ever made, and still make a large profit. If you really are concerned, stick the $89 in your savings account in case the television breaks after the normal warranty but before the three years is up. I'm betting that at the end of the three years, you'll wind up with $89 plus interest.

- **Credit card loss protection.** Clearly the worst insurance deal going. For a fee of about $50 per year, this insurance provides you with coverage in case your credit cards are lost or stolen and used by someone else. They'll even call all of your credit card companies to cancel your cards for you. All you need to do is write down your account numbers and the phone numbers of your credit cards, and send it to them along with the premium. When you call them to tell them your cards are lost, they do the rest. How stupid do they think you are? First, if you looked at the contract that came with your credit

card, you would notice that you are already protected for charges made by someone else of over $50. Second, if you call the credit card company promptly, they rarely charge you the $50. (I've lost my credit cards several times without a single charge, even though they have been used after they were lost or stolen.) Lastly, if you've already written down your credit card numbers and the phone numbers for the credit card companies, how hard is it to keep that sheet and call them yourself. Save your money.

- **Credit card or mortgage debt insurance.** If you die, this insurance pays off your debts. If it sounds like life insurance, that's because it is, except that it is a whole lot more expensive. If you have a lot of debt, you're better off buying a little more life insurance. Only consider this insurance if you are in bad health and can't qualify for regular life insurance.

- **Dental insurance.** Unless your employer provides dental insurance for you, it usually costs a lot of money, and has a small limit on the amount of dental work that is covered in a single year. You're almost always better off paying your dentist directly.

- **Any insurance other than the Big Six listed below.** Skip it.

Insurance Lingo

Insurance has a language all its own, so it will help to understand some of the terms used in the business:

- **Premium** is the money you pay the insurance company for your insurance.

- **Claim** is when something bad happens and you ask for money back from the insurance company.

- **Policy** or **binder** is the written contract that tells you how much your premium is and what claims the insurance company will pay.

- **Rider** is an addition to the policy regarding a specific side agreement you have with the insurance company.

- **Floater** is coverage for a specific additional piece of property. For instance, your homeowners policy may exclude collectibles such as jewelry, coins, baseball cards, etc., unless you get a specific "floater" to cover these items.

- **Exclusion or exception** is something that you thought would be covered by your policy, but isn't covered.

- **Pre-existing condition** is something bad that happened before you bought your insurance, and that your insurance company won't pay for.

- **Beneficiary** is the person who gets the money paid out by the insurance company. That's usually you, except in the case of life insurance.

- **Deductible** is the amount of money you have to pay before your insurance company will pay any money. A deductible can apply to a single claim or for a group of claims. For instance, your auto policy is likely to have a deductible for each accident. If your deductible is $250, you have to pay the first $250 to repair your car each time you get in a wreck before your insurance company will kick in any money. For health insurance, the deductible is usually cumulative for the year. If your deductible is $500, the insurance company will only pay a claim after you have spent $500 during the year, whether you spend the initial $500 on five visits to the doctor, or one trip to the emergency room.

- **Co-pay** is a partial payment you have to make for any claim. This is common in health insurance. After you have paid your deductible, your insurance company may only pay $0.80 of every dollar of medical expense, and you will have to pay the remaining $0.20. Most insurance policies have a cap on your total co-payments so that you won't go over $1,000, even if you have $50,000 of medical expenses. Another form of co-payment that is more common with HMOs may require you to pay $10 for each visit to the doctor, and the insurance company will pay the rest.

- **Rating** is the grade given to an insurance company by an independent rating agency based on how financially strong

they are. This is much more important for things like life insurance, where you are not likely to make a claim for a long time. The ratings are different with different agencies, but are usually AAA, AA, A, BBB, BB, B, etc., or A+, A, A−, B+, B, etc. The biggest of the rating agencies are Best's, Moody's and Standard & Poor's.

Rules of Buying Insurance

Shop around to get the best bargain. Just like any major purchase, insurance prices vary a great deal. By shopping around, you can usually get a better price for the coverage you want. You can buy insurance through the yellow pages of your phone book, by calling an independent agent who represents several insurance companies, or by calling major insurance companies directly.

- **Buy wholesale.** Insurance agents get huge commissions, and you are the one who finances them. Buying through a discount insurance agent can save you money. Discount agents usually sell life and disability insurance.

- **Check the rating on your insurance company.** All insurance companies are rated on the basis of their financial strength, which is usually a good indication of whether they will be around when it comes time for you to make a claim. You are better off sticking to insurance companies that are given one of the highest three grades by two or more agencies. Ask your insurance agent to provide you with the ratings of the insurance companies you are considering.

- **Get a bigger deductible.** The higher your deductible, the cheaper your insurance will be. Don't automatically buy the policy with the lowest deductible; ask your agent for the premiums at several levels of deductible and choose the combination of price and deductible that you can afford.

- **Make your agent work for you.** Your agent usually gets paid a percentage of the premiums you will pay over the life of your policy. They have a financial incentive to sell you the most expensive policy and more coverage than you may need.

If your agent seems hesitant to provide you with a number of options, or to explain the difference between policies with different prices, call another agent.

- **Only buy what you need.** If you are single with no dependents and have few debts, you probably don't need $1 million of life insurance. Use common sense to avoid overinsuring yourself or your things.

 Web Tip

Merritt Publishing's home page at http://www.insweb.com// merritt has detailed information about auto, homeowners, renter's and life insurance.

Insurance Net at http://insurancenet.com//index.html provides free descriptions of various types of insurance, references to insurance company home pages and other insurance resources. You can also find an estate planning calculator, tax planning guides and more than most people would ever want to know about insurance.

The Big Six

Now that you have the basics, let's talk about the Big Six kinds of insurance that you should consider:

1) **Health or medical insurance.** This pays for the costs of medical care if you get sick.

2) **Disability insurance.** This pays you a portion of your wages if you can't work because of sickness or injury. Workers' compensation insurance is a kind of disability insurance that your employer has to provide in many cases, but it only pays for injuries incurred when you are on the job.

3) **Life insurance.** This pays someone else if you die. We'll consider this in detail in Chapter 18.

4) **Homeowners insurance or renters' insurance.** This pays if your home is robbed or burns down or if someone gets hurt on your property. All banks that loan you money to buy a house will require homeowners' insurance.

Homeowners insurance provides you with coverage for losses or damages to your home and your belongings, including losses caused by fire, theft and accident. It also covers injuries to people on your property—like when the dog bites the mailman or your cousin who's had a few beers falls off the roof while helping fix your antenna before the Super Bowl.

Most landlords only have insurance on their building; they do not have insurance on your belongings. Therefore, if your apartment is flooded, and all of your electronic appliances are destroyed, you will have to replace them yourself. Also, if a thief takes all of your valuables, you will have to replace them. Depending on the value of what you have, renter's insurance may or may not be a good deal. Generally, it's pretty cheap: the cost to insure $5,000 of televisions, stereos, clothes, etc., should be less than $200 per year.

The problem is that renters' insurance usually only pays you for the depreciated value of your belongings. That means that the Bose stereo speakers you bought five years ago for $700 (and now cost $900) may only be worth $400 in the opinion of your insurance company. You have to make the judgment whether your stuff is worth covering.

5) **Auto insurance.** This pays for car repairs and injuries caused by you and your car. We'll consider this in detail in Chapter 19.

6) **Umbrella insurance.** This pays for claims that are over the limits of your homeowners', renters' or auto insurance. You probably don't need this unless you have a net worth of over $100,000. It is relatively cheap—you can pick up $1 million of coverage for about $100 to $300 per year.

Chapter Eighteen

Life and Limb

Introduction

Life insurance pays someone else when you die. It should be used to protect your family from having to take on a large financial burden in case you die. Life insurance is the easiest kind of insurance to buy if you follow one simple rule—if you need life insurance, BUY TERM INSURANCE.

Term Life Insurance

Life insurance comes in a wide variety of options. Term insurance is the simplest—you pay a premium to the insurance company, and when you die, they pay someone else a fixed amount of money.

The premium on a term life policy is based on your estimated life expectancy. No matter what kind of life insurance you choose, the insurance company will ask you how old you are, whether you smoke, and if the policy is large, will ask you to have a physical. Keep in mind that a white lie about smoking will help you save money on premium, but it could permit your insurance company to void your policy.

The company usually asks whether you've used tobacco products during the past year. If you smoked a couple cigarettes at a drunken New Year's Eve party, I wouldn't worry about it. But, if you really are a smoker, you're better off telling the truth.

The company may also ask whether you regularly undertake *dangerous activities*. This definition is a little vague, but it usually includes hang gliding, rock climbing and other extreme sports, skydiving, etc. You don't want to lie to the company about this stuff, if you do it. That said, you'll probably want to volunteer as little information as possible. If they don't ask, don't tell.

The following chart compares some prices for term life policies for healthy people starting at various ages and for smokers versus non-smokers. Both charts compare quotes that guarantee level premiums for ten years and are based on 12 equal monthly payments for an annual premium as shown.

How Age Affects Cost

Coverage	Annual Premium		
	Age 20	Age 35	Age 45
$100,000	$138	$138	$140
$250,000	225	225	288
$500,000	425	425	550

How Smoking Affects Cost

35-Year-Old Male Annual Premium

Coverage	Smoker Premium	Non-Smoker Premium
$50,000	$126	$101
100,000	201	139
250,000	417	273
500,000	798	509

You'll probably notice that insurance, like most other things, is cheaper when you buy in bulk. Part of the reason for this is that the more you buy, the more likely it is that the life insurance company will require a physical. If you're healthy, you can pay less; if you're not, you will have to pay more.

Annual Renewable Term Insurance

Annual renewable policies fix the premium rate for a single year, so the price can go up as you get older.

Typically, annual renewable premiums increase five to six percent per year. More important than the premium is that most annual renewable policies can be kept until you reach age 70 (although you should check yours to make sure). Even if you have a serious health problem, you can still retain your coverage.

Level Premium Term Insurance

Level premium term policies will allow you to lock in a premium amount for more than 5, 10, 15 or even 20 years. This usually means that the first few years of payment are higher than a similar annual renewable policy, but that the later years are less expensive. However, the policy usually has a life of 20 years or less. When it expires, you must re-qualify for coverage. If your health has declined in the interim, you can be refused coverage.

The Best of Both Worlds

There are benefits to both types of coverage, but for better protection, I lean towards annual renewable policies. Although it appears you have no protection against a price increase, as a practical matter you do. The market forces insurance companies to compete, and—if they raise the rate too high—they are likely to lose too much business. Some companies—such as USAA—even cap the maximum amount of your premium, and they rarely reach that amount.

One way to hedge your bets is to buy some of each. I recommend using the annual renewable term for your basic insurance needs, such

as providing for your spouse. Then use a 20 year or greater level term after you have children to cover the costs of raising and educating them. Once they are full grown, your insurance needs should be decreasing as your level term policy or policies expire.

The following chart compares the first year of a one year policy versus the first year of a policy that guarantees the price for fifteen years.

First Year Premium for One Year versus Multi-Year Policy		
Coverage	One-year Renewable	15-Year Level Term
$ 50,000	$ 96.50	$124.50
100,000	132.00	199.00
250,000	260.00	370.00
500,000	485.00	690.00

Whole Life, Universal Life and Other Kinds of Life Insurance

Other policies called whole life, universal life, variable life, etc., combine the benefits of a term life insurance policy with a savings account. With these, you agree for a period of years to pay a life insurance company a premium that's about eight to ten times more than the cost of a comparable term policy. The insurance company will use a part of your premium to pay for term life insurance and to pay your insurance broker a big fat commission, and will put what's left of your premium in an investment account. At the end of the term, you will have accumulated a significant amount of money. During the life of the policy, you can also borrow money from the account. However, the investment part of these insurance policies is not very good, and the commissions are immense.

Basically, you wanted to buy a good car stereo and wound up buying the whole car. And the car was a Yugo. You are much better off buying a term policy and saving the rest of the money in another type of investment.

Here are two examples of recent quotes I got for whole life policies. One is from Metropolitan Life, and the other is from USAA.

Whole Life Insurance		
Coverage	USAA	Met Life
$25,000	$335 (12)	$427 (14)
50,000	617 (12)	817 (14)
100,000	1,197 (10)	1,424 (12)
250,000	2,948 (9)	3,336 (11)
500,000	5,865 (9)	6,624 (11)

The difference between the two is mostly commissions: USAA doesn't charge any while Met Life paid 55 percent of the first year payments to the broker, and a smaller portion of the premiums for the following four years. The number in brackets is the number of years until the policy is self sustaining—that means the amount of income earned by the money you have paid in is enough to cover the monthly premium.

Because insurance agents typically make a lot of money on policies like whole life that combine savings and insurance coverage, they will try to sell you these policies with lots of reasons. Here is the other side of the argument:

Whole life forces you to save money. You can set up direct deposit into an investment account that will force you to put aside a certain amount of money every month. Also, you can change that amount whenever you want—with the insurance company you have to continue paying even if you have temporary financial troubles.

You can borrow against the money you save. Almost every investment you make lets you take your money out, and most don't require you to pay the money back if you don't want to. With other investments, you will build up your account more quickly.

Your premium won't go up. This is true, but not very important.

Investment-type policies have a fixed premium over the life of the policy. With a term policy, your premium can change as you get older, but the cost of term insurance is still cheap for many years. You can also get term with fixed payments. Finally, because term life costs a fraction of the price of most other policies, you are more likely to buy enough coverage.

You will get a tax benefit. This is true, the money you earn on the investment part of your account isn't taxed until you take it out. But you can get the same advantage with an IRA, 401(k) or a number of other investments, and you will probably earn more money in those. Also, the money you can earn in other types of taxable investments can often exceed insurance investment accounts.

How to Buy Life Insurance

Like most other insurance, it's best to buy as part of a group, particularly if you have health problems, because groups get the best rates. Also, make sure to follow the Rules of Buying Insurance we considered earlier.

Specifically, because life insurance can be a large amount of money and a long-term commitment, it is especially important to know the rating of your insurance company, and make sure it has received one of the top two grades given by that rating agency.

Many employers provide you with a minimum amount of life insurance, often 2 1/2 times your salary. That's a good start, but if you are young and married with a mortgage or children (or both) you are going to need more coverage. The first place to look is with the insurance company at your job—sometimes you can get additional coverage at a good rate. Also, look at other groups that offer coverage, such as professional organizations, alumni groups, even your auto club. Finally, check with direct insurers such as USAA (800-531-8111) and discount quote services.

Quote Services

One of the least expensive ways to buy term life insurance is through

a quote service. These are discount insurance brokers that have a database of information from a number of life insurance companies. Call them up and they will ask you your age, occupation, general health and smoking status. Tell them how much insurance you need, and whether you want an annual renewable or level term premium policy.

These services will provide you with a number of quotes for the coverage you have requested. You can have an application in several days, and after you pass your medical exam (if required) and pay your first premium (usually monthly), your coverage begins.

Some of the better known services include Quotesmith (800-431-1147), MasterQuote (800-337-5433), Life Rates of America (800-457-2837) and TermQuote (800-444-8376). Because they don't all have information on the same insurance companies, you should probably call more than one to get the best rate.

How Much Life Insurance to Buy

The reason you are buying life insurance is to pay for financial obligations that you won't otherwise be able to make. Therefore, you should estimate your obligations and buy insurance accordingly. Keep a few facts in mind:

- **Tax Effect.** You pay taxes on your earnings. Your family won't pay taxes on the proceeds of life insurance. You have to keep that in mind when calculating how much insurance you need.

- **Invest insurance proceeds very carefully.** Your beneficiary will get the insurance proceeds when you die, but that money will usually have to last a long time. Therefore, put the proceeds into safe investments. See Part Six for suggestions on low risk investments.

- **Inflation.** Your insurance proceeds will have to last a long time. Although inflation tends to make the prices of everything increase over time, even relatively safe investments, should be able to earn enough to more than offset the effects of inflation. If inflation hovers at about 4 percent, gro-

ceries that cost $100 this year are likely to cost $104 next year. A low risk investment portfolio will pay about 5 percent after taxes. That means that if you invested $100 of insurance proceeds today, they would be worth $105 next year when you needed to buy the groceries. So, make your life insurance plans based on the cost of things today.

- **Amount.** The amount of life insurance is a highly personal matter, and there must be a dozen ways to calculate what you will need. The following are only guidelines that can help you plan.

Lifestyle Issues

If you're single and have a mortgage or other large debts, you should consider buying enough life insurance to pay off your debts, including your mortgage. This will protect any equity you have built up in your home, or any other assets that you may want to pass on to beneficiaries. If you don't have a mortgage or any other assets that you want to protect, you probably don't need life insurance.

If you're married without kids, you should consider buying enough insurance to replace your earning power through retirement. If your spouse can live alone comfortably on less than the two of you currently earn, you should be able to buy less insurance. If you expect that your earnings will increase dramatically, you may want to buy a bit more insurance. If you have a mortgage or other large debts, you will want at least enough to pay off the mortgage and your existing debt.

The following chart tells you how much life insurance you will need to provide for your spouse if you are the only source of income, and you have a mortgage and other debts that you can currently afford. If your spouse works and makes $20,000 or more, you can use the column on the right no matter how much you make.

Years to Retirement	Multiple of Your Gross Income Income under $25,000	Income over $25,000
40	20 X	16 X
35	18 X	15 X
30	17 X	14 X
25	15 X	12 X
20	13 X	10 X
15	10 X	8 X
10	7 X	6 X
5	4 X	3 X

For example: If you are 30 years old and assume that you will retire at 65, you have 35 years to retirement. If you make $30,000, you should have 15 times your income in insurance coverage, or $450,000, if you want to replace your earning power.

If your spouse can take on a job or earn more money, or live on significantly less money than you both make, you should be able to get away with a lot less insurance coverage. Simply reduce the gross income you need to replace, and insure based on that amount.

Example: If you make $15,000 and your spouse makes $15,000 and you're both 25, and your spouse can live on his salary plus one third of yours, multiply $5,000 by 20, and $100,000 of insurance should be sufficient.

If you have children, you are likely to have additional costs to raise and educate each child. You should consider enough insurance to provide for your spouse, as well as enough to cover the majority of the cost of higher education. The cost of education in public schools can easily exceed $60,000 today; four years at a private university can easily cost over $150,000. So, married couples with kids should consider the same coverage recommended for married couples without kids, and increase total coverage by $60,000 to $150,000 per child. If you want to send your children to private school before college, you should include enough insurance to pay for the current cost of those schools as well.

The other adjustment you will have to make is child care. If you have chosen to stay home with the kids rather than work, your spouse is going to need to pay for child care so that he or she can continue to work. Therefore, use the cost of child care for the amount of salary, and use the age until your kids will be self sufficient as the years until retirement. This is additional coverage you will need.

If you can't afford the recommended amount of coverage, don't despair. You should still be able to afford at least enough to pay off your mortgage (if you have one) and other large debts, plus two to three years of your gross income.[1]

Health Insurance

Health insurance, also referred to as major medical, pays the costs of medical care if you get sick or injured. Most employers will allow you to buy health insurance through their company. Some will even pay part or all of the cost. This is almost always the cheapest way to get health insurance, because you don't need to take a physical and you won't be excluded by the insurance company if you have specific health problems.

If your employer does not make insurance available, the next best thing is to buy insurance through a group. Many business groups, clubs or alumni associations will provide you with affordable insurance. Some of the best are the Screen Actors Guild, the National Association of Certified Accountants, and other professional associations. USAA is also an attractive option.[2]

Blue Cross and Blue Shield are another reasonably priced source for health insurance. These policies are cheaper and easier to get because you are buying as part of a group. This means that the insurance company is more likely to get a balance of healthy and sick people that will allow them to make a better profit.

[1] Other insurance considerations regarding who should be the beneficiary, and how to best provide money to young children are discussed in Part Seven.

[2] USAA was originally formed to sell cheap insurance to members and former members of the armed services. They have some of the cheapest auto, life and health insurance available, and consistently provide great service. You still have to be a veteran or the child of a veteran to buy auto insurance and homeowners coverage, but life insurance and other products are available to the public. For information, call 800-531-8111.

There are three kinds of health insurance: traditional health insurance, Preferred Provider Organizations (PPOs), and Health Maintenance Organizations (HMOs). Most employers offer more than one plan.

Traditional health insurance is the most expensive. If you are sick or injured, you may go to the doctor or hospital of your choice, and you will be covered by insurance. Typically, you will have to meet a deductible before you can make any claims. After you reach your deductible, you are likely to have to pay 10 to 30 percent of your medical expenses depending on your policy and the type of expense you incur.

PPOs are large organizations that have contracts with local doctors and hospitals that give them discounted prices. This allows the insurance company to charge you less for insurance. Most PPOs allow you to use any doctor or hospital, but they will pay a greater proportion of the costs if you use doctors and hospitals that are on their list.

HMOs are large organizations that have contracts with doctors and own their own hospitals and clinics. They are typically the cheapest source of insurance, but you have to use their doctors and hospitals, except in emergencies or when you need a specialist that is approved by them.

Making the Right Choice

Even with the advice of a lawyer, doctor or Indian chief, most people have a hard time choosing among the different categories of health insurance, or the companies within a category. You can't know everything—but here's a list of questions you should ask either the person at your office who handles health insurance, the insurance agent, or the insurance or managed health group who is providing the coverage.

Benefits

Make sure you understand what's covered. Many services don't cover vision, dental, mental health or drug rehab costs. If you're a young

family, you probably want to ask about coverage for pregnancies and well-baby costs (preventative visits to your pediatrician that are covered by many plans). Also ask whether you are covered for visits to the emergency room, or if you are out of the country. Also check into coverage of preexisting medical conditions. Most coverage you get through your employer will cover preexisting conditions. But if you are already pregnant, or have a heart problem, or other preexisting conditions, you may not be covered.

Access to Care

Some plans, particularly HMOs, require that you use only doctors in their system. PPOs will usually allow you to use doctors outside their system, but you will have to pay more to do so. Make sure you choose a plan that has the doctors you need in your area, including a general practitioner, OB/GYN, pediatrician, etc. Most health plans require you to get their permission to see a specialist, such as a cardiologist or dermatologist, and won't pay for the cost of treatment unless you have the appropriate approval from your primary doctor or the PPO or HMO. Make sure you understand the rules, or you can wind up having to pay for the doctor's bills yourself. Also check to make sure that your plan includes local clinics, hospitals and pharmacies.

All in the Family

Recently, the cost to add family members to health insurance increased dramatically. However, the typical plan has a large increase in the premium for adding one dependent, but a small (or sometimes even no) increase for the second dependent.

For most working couples, it's cheaper for each to take the insurance offered by your employer. However, once you have your first child, it may become cheaper for you all to consolidate under the better of your two policies. Make sure to compare the benefits of one policy over the other.

COBRA

If your employer has more than 20 employees, and you are fired or

quit your job, you have the right to continue your health insurance coverage under a federal law known as COBRA. COBRA requires that you receive up to an additional 18 months coverage. Although you have to pay the premiums, you can't be charged more than two percent over the cost to your employer. More importantly, you don't have to qualify for coverage and you can't be excluded for a preexisting health problem. In the meantime, you can shop around for alternative coverage, or join your spouse's plan.

Disability Insurance

Disability insurance pays you a portion of your salary if an injury or illness prevents you from working. Usually the benefit is around 50 to 75 percent of your salary, not including bonuses. The closer the benefit is to your full salary, the more expensive the premium. There are two general kinds: short-term disability and long-term disability.

Short-term disability generally pays you a benefit for a period of one to six months immediately following an injury. Because temporary illnesses or injuries are more common than permanent injuries, short-term liability coverage is usually very expensive. Also, the benefits only last for a short while. For instance, if you make $40,000, and want to receive a benefit equal to 75 percent of your salary after you have been disabled for 30 days, you can expect to pay between $1,000 and $1,500 a year.

As you can see, short-term disability is extremely expensive for the coverage you get. And remember that most people never collect on short-term disability coverage. You would have to be disabled several times during a 45-year work life to make that coverage make any sense.

If you simply save enough to have three to six months of earnings in reserve, you can avoid paying thousands of dollars in lifetime premiums.

Long-term disability insurance protects you against an illness or injury that lasts a long time, even a permanent injury. After an initial waiting period has passed, usually somewhere between three and six

months, long-term disability insurance pays you a portion of your salary, typically as long as you are disabled, until you reach a certain age.

Because this is a far more likely risk, long-term disability is a more important issue for most people than they realize. It's a bigger deal than life insurance—especially for young people in the early stages of careers.

You get to choose the length of the initial period after which the policy will start paying a benefit. The initial period is a bit like a deductible on other kinds of policies; if you elect a longer initial period before your benefits start, your premium will be lower. A policy that starts paying a benefit quicker will cost more. Like all other insurance, the greater your coverage, the greater your premium.

Most insurance companies won't let you buy coverage of more than three-quarters of your salary because they don't want to make it more attractive for you to stay at home after an injury. Most policies last until age 65 when you are expected to retire.

You can get a lower premium by choosing a policy that does not pay you all the way to age 65, but that means you will need to have enough money to carry you over the gap between when your disability insurance ends and when the benefits from your retirement planning kick in.

The best place to find long-term disability insurance is the same source as your life insurance—in most cases, your employer. Keep in mind that if your employer pays for your premiums, your benefits are fully taxed. If you pay for the premiums yourself, the benefits are tax-free. Therefore, choose your amount of coverage accordingly.

Questions to ask about your long-term disability policy include:

Does the policy cover for long-term disability caused by pregnancy related problems? Some policies exclude coverage for pregnancy and any related disability.

Does the insurance cover me if I am prevented from continuing at my specific job, or does it require me to learn another job? If you blow out your knee rollerblading, your disability could prevent your existing job as a lumberjack. If you have an "own occupation" policy, you would be able to collect benefits. Some policies require you to learn another job, if possible. "Own occupation" policies are more expensive, but if you have a high paying job, particularly one that requires more than sitting at a desk, you may want to consider the added expense.

Make sure you understand the policy's definition of the word "disability"; some policies have severe limitations that may make the policy worthless.

What about workers' compensation insurance? Workers compensation insurance, which is required in most states, is a combination of health insurance and disability which covers you for injuries incurred on the job. Workers compensation insurance premiums are paid by your employer. Although these policies are useful if you can't afford any other coverage, the benefits are not generally as good as your own insurance, and you are only covered for injuries incurred on the job. If you hurt yourself away from your job, you won't get a dime.

Chapter Nineteen

Insuring Your Moveable Feast

Introduction

Other than health insurance, auto insurance is the most expensive insurance you are likely to buy. Auto insurance protects against three things: *bodily injury* that you cause to people with your car, *property damage* that you cause with your car, and loss or damage to your car, including *collision*—when your car gets damaged in an accident—and *comprehensive* or comp—non-accident loss or damage to your car, like when someone steals your car stereo or even the whole car, or your car is destroyed by fire.

Most states require that you have at least bodily injury and property damage coverage in order to drive. Collision or comprehensive insurance is optional if you own a car, but if your car is leased or if you have an outstanding auto loan, you will be required to have collision or comp coverage as well.

Like all other insurance coverage, you have to follow the Rules of Buying Insurance. With cars, you have to pay close attention to the following:

- **Property and Bodily Injury Coverage.** For a major accident, it's really very difficult to protect yourself, but coverage equal to two times your assets should be sufficient in most cases. If you have a lot of savings or equity in your home, you probably want to consider an "umbrella" policy.

 If you don't have much in savings or assets, you should consider buying the minimum bodily injury and property damage required by your state. This should be enough to protect you and your passengers, without being too expensive.

- **Collision and Comprehensive Coverage.** Collision coverage is a large part of your insurance bill, particularly for a more expensive car. Comp coverage is much less. The best way to save a lot of money on insurance is to pay cash for an inexpensive car, and skip the collision and comprehensive (theft and fire) coverage. The cheaper the car, the less risk you'll be taking. With a little luck, the money you save on car expenses in one year could be enough to put you on the road to financial health. Because insurance companies will only pay you the value of your car, it makes no sense to pay $800 for collision insurance on a $500 1964 Ford Fairlane. If your car is six or more years old or worth less than $3,000, and it's paid up, you usually come out better by dropping your collision coverage. But keep in mind that if you owe money on the car, the lender will require you to keep collision insurance.

- **Deductible.** Take the highest one that you can afford. Ask for insurance quotes at several deductible levels to see how much a higher deductible will save you. If an accident is clearly caused by the other driver, that driver has to pay your deductible in most states.

Additional Auto Insurance Points

Choice of cars has a great amount to do with your cost of insurance. The best way to find out the cost of insurance on a particular car is to call your insurance company or agent for a price quote. Most will give you quotes on several cars so you can compare for yourself.

In general, the following cars will cost more to insure:

- Expensive cars will cost more to insure, because of the higher cost of repair or replacement. Sports cars and particularly cars that have only two doors, two seats or big engines in relation to the size of the car are more likely to get in accidents, so insurance costs more (contrary to popular myth, red cars are not more expensive to insure).

- Thief bait—lots of sports cars, luxury cars and sport utility vehicles are attractive to thieves, and therefore cost more to insure. Even some common models that are desirable for parts are popular with thieves.

According to the Associated Press, the following ten models are most often targeted by thieves:

Rank	Make and Model
1.	Oldsmobile Cutlass Supreme
2.	Jeep Grand Cherokee 4x4
3.	Honda Accord LX
4.	Buick Regal
5.	Chevrolet Camaro
6.	Cadillac Deville
7.	Chevrolet Caprice
8.	Oldsmobile Cutlass Ciera
9.	Toyota Corolla
10.	Ford Mustang

Other often-stolen models include: BMW 300 series coupes, Mercedes-Benz SL model coupes, Toyota 4Runner sport utility vehicles, Ford Explorers, Ford F-series pickup trucks and Volkswagen Jettas.

A key point to remember is that new cars aren't more likely to be stolen than cars that are a few years old. In fact, the prime targets are the models listed above that are between four and seven years old.

Among the least stolen cars: Ford Taurus station wagons, Subaru Legacy station wagons and several of the Chrysler minivan models.

Discounts are often available for a variety of things, so make sure you check to see if you qualify:

- **Low Mileage Drivers.** If you don't put a lot of mileage on your car.

- **Safety Equipment.** If you have safety equipment such as ABS brake systems, alarms or tracking devices, or air bags, most insurers will give you a discount.

- **Good Student/Drivers' Ed.** Some insurance companies will give you up to a 10 percent discount if you qualify as a good student or take a drivers' ed course.

- **Older Drivers.** Older drivers, especially ones with good driving records, are eligible for better rates.

- **Other Cars.** If you insure other cars with the same insurer, you should be able to get a lower rate, particularly if your policy has more cars than it does drivers.

Insurance Costs on Your Block

Where you live may have higher rates of car theft, more expensive repair services, and people that are more likely to sue you, so the place you live and work can have a great effect on your car insurance. New York City and Los Angeles are notorious for high insurance, while adjacent areas can be much lower. Check with your insurance agent to see which zip codes in your area have lower insurance rates.

Because some areas have much cheaper insurance, it may be tempting to lie to your insurance company. If you are in an accident, they will usually want your registration, driver's license and work and home address and phone number. If these don't match the information you've provided the insurance company, and you haven't recently moved, you may have a hard time collecting on your insurance. However, if you truly keep a car at your parents' house, or a friend's house

for use on the weekends, you may be able to save a significant amount of money by registering and insuring your car at that location.

When Cars Collide

If you are in an accident and there is no real injury or extensive damage, most states do not require the involvement of the police. If everyone involved agrees about who was at fault, you merely exchange insurance information and report the accident to your insurance company.

If the damage is really minor, it may be best to take care of it yourself and not make a claim with your insurance company. A $600 claim with a $500 deductible will only mean $100 in coverage—but may result in a insurance premium increase the next time you renew.

If you have been drinking alcohol or believe you were at fault in the accident, it's a good idea to keep the police out of the proceedings. If someone else was drunk or at fault, you'll probably want to give them a call. In either case, make sure you do the following:

- Collect information on each vehicle and driver involved, including drivers' names, addresses, license numbers and phone numbers, vehicle plate numbers and insurance company names and policy numbers.

- Collect information on any witnesses—their names, addresses and phone numbers.

- Keep your mouth shut about details. You don't know everything about traffic rules and—no matter what you saw—you're just one perspective. Don't rush to assign fault.

If the accident results in major damage, damage to public property or injuries that require medical treatment, most states require that you call the police. If the police show up, there's even more reason to keep mum—whether or not you were at fault.

Uninsured Motorists Coverage

Uninsured Motorists Coverage pays for things that the other driver would have to pay for, but can't because they didn't have insurance. The most obvious is your deductible. This additional coverage makes sense because of the large number of uninsured motorists on the road—and to protect against hit-and-run drivers.

My family's last three accidents involved uninsured motorists, all of whom were at fault. With this inexpensive addition to our auto coverage, we avoided large and out-of-pocket costs.

How to Buy Auto Insurance

Allstate and State Farm are two of the cheapest of the major auto insurance companies. If you or one of your parents was in the armed services, you may qualify for USAA, which is both inexpensive, and provides great service. Buying direct from Geico (800-841-300) and Amica Mutual (800-242-6422) can also give you cheap rates with two solid companies, but they are very selective, so if you have accidents or tickets on your record, you may not qualify.

Part Six:

Playing at the Wall Street Casino

Chapter Twenty

The Basic Concepts of Investing

Introduction

As I've noted before, capitalist economies are called that for a reason. They reward people for having capital. If you have some money, all kinds of people and companies will pay you for letting them use your money. In fact, they'll bid against each other for the right to use your money and drive up the reward you get for having the money in the first place.

So, if you put your money in the right place, there will be a lot more of it later—when you're ready to spend it. Although it can sound terribly serious, investing is nothing more than the process of deciding where to put your money.

The best place to invest your money is the place that provides you with enough profit to make you happy and enough security to let you sleep at night. Also, investing shouldn't dominate your waking thoughts—even if you do it for a living.

That's the theory. In this section, I will try to give you enough practical information to make basic investment decisions, even if you have just a few hundred dollars to invest.

First, we will talk about some basic rules of investing and the planning that goes into investments. Then we'll look at the most common investments, and how to make them. Keep in mind that this is a fairly basic discussion—if you get interested, or if you have a couple of million dollars lying around the house, you may want to buy some books that are dedicated to investing.

A warning: Some math is involved in this discussion—but it's not too complicated.

The Theory of Financial Relativity

Most financial decisions are alternatives—every time you ask "should I use my money for this?" you have to consider your alternatives.

Even if you're the Sultan of Brunei, you can't buy everything. Okay, maybe he can—but no one else can. So, you have to use your limited resources to get the things you need and want. Once you've decided where to put your money, you still have decisions to make—namely "how does this investment compare to my alternatives?"

For a more reasonable example, you may ask yourself, "Is three percent a good interest rate on my savings account?"

It is...unless you can get four percent at another bank down the street. If you invest $100 at the bank down the street, and leave it there for a year, you will earn an extra $1. After you pay taxes, that's something like an extra $0.70. And you got this for doing nothing more than picking one bank over another—clearly, the right financial decision.

Karl Marx couldn't stand the fact that it was so easy for people with money to make more money. He didn't really hate capital as much as he hated how capital was rewarded. He and his followers tried to come up with a system that limited your ability to make an extra dollar just by moving your money from one bank to another down the street.

What these guys failed to understand is that the choices people make about their money almost always include personal factors as well. If the teller at your bank is cute and gives you a big smile every time you make a deposit, you may not want to move your money to the bank down the street to earn the extra $0.70 per year. Particularly if the other bank has tellers who look like Howard Stern in drag.

More likely issues: If the bank down the street isn't open on Saturdays or charges an annual fee for small accounts, you may be satisfied with the lower interest rate.

The point is that every investment requires a decision maker to consider a virtually endless series of factors, including personal (what the gnomes at the Federal Reserve contemptuously call "non-economic") ones. No two people ever reach the same conclusion about what to do with their money. That's why Warren Buffett buys convertible preferred stock in Coca-Cola while your Uncle Everett buys Azerbaijani treasury notes.

Equity, Debt and Cash

Every investment you will ever consider is either equity, debt or cash, although some investments have aspects of each.

In an equity investment, you are an owner or part owner of a business or property. Stocks, partnerships and real estate are the best examples of equity investments. If that business prospers or the property appreciates in value, your investment will increase in value. However, your investment can decrease in value. Theoretically, your potential loss is your entire investment, and your potential profit is unlimited.

In a debt investment, you are loaning your money to someone. In exchange for that loan, they agree to pay you back with interest. Examples of debt investments are corporate bonds and municipal bonds. Because of the nature of debt investments, they are also called *fixed income* investments. That's because the borrower pays you a certain amount of interest, and you are not entitled to receive anything more than the interest and the return of the amount you loaned.

Unless the borrower goes bankrupt, you will receive exactly what you expected—your money back with interest. With many debt investments, you can also make (or lose) additional money by selling your investment to someone else before the borrower repays your loan. Bonds generally limit the amount of money you can earn, but they also provide you with some measure of certainty.

Cash is not just the money in your wallet. When used in the context of investments, cash also refers to debt that is generally considered to be low risk and very liquid, and therefore similar to holding cash. Cash usually includes money market funds, certificates of deposit and short-term treasury bills.

In general, equities tend to be more risky than debt, and debt tends to be more risky than cash. Therefore, equities generally offer greater returns than debt, and debt offers greater returns than cash.

Understanding Your Investments

Before you invest your money in anything, make sure to ask yourself the following questions about your investment:

How quickly can I get my money? Liquidity is the measure of how quickly and easily you can get out of an investment. Money in a savings account or a money market fund is easy to access—you just need a withdrawal slip to get your money from your bank or brokerage firm. These are examples of liquid investments.

Money invested in your house is not so easy to get—you either have to sell your house, or take out another loan on your house. This is an example of an illiquid investment.

Some investments, like certificates of deposit—what financial types are talking about when they mention CDs—require that you invest your money for a fixed period of time. If you buy a 12-month CD and need to withdraw your money for an emergency after only six months, you will have to pay penalty fees to your bank. Although you can technically get your money, penalties make a CD illiquid.

Other investments, like stocks, regularly go up and down. Although you can usually sell stocks very easily, you don't want to be forced to sell your stocks at a time when they are temporarily down, particularly if you think the stock price will improve in a short period of time. Therefore, you probably should think of stocks as somewhat illiquid. Choose investments that match your goals, so that you will have access to your money if you need it.

What are my chances of losing my money? Risk and reward are interdependent factors—the more risk you take in a given investment, the greater the potential for making money should be. Conversely, the less risk you take, the less money you are likely to make.

Anyone who has ever been to a racetrack has seen these rules at work. If you bet on the favorite horse, you are likely to turn a $2 bet into $3—although sometimes you will lose. If you bet on a long shot, you can turn your $2 bet into $200—but most of the time you will lose and end up screaming at the doped-up nag and its crooked jockey.

Investments *usually* work the same way—the greater your chances of making a lot of money, the greater your chances of losing whatever you put in. Unfortunately, there are some investments that are high risk with small rewards—like limited partnerships and commodities portfolios advertised on the radio or late night TV. These are almost never good investments.

Savings accounts, CDs and money market funds will never make you more than a minimal interest rate, but you aren't likely to loose your money. Speculative stocks can make you an unlimited amount of money, but they can also become worthless. For every investment you consider, always assess the risk.

How much money should I put in a single investment? If your mother ever told you "don't put all your eggs in one basket," she was talking about concentration. If you put all of your money in rare baseball cards, and your house burns down, you strike out.

The same thing applies if you invest all of your money in your company's stock option plan and the company goes out of business—

you lose your job and your investment. Listen to your mother. Spread your money into several investments, or make investments in things that spread the risk for you, like many mutual funds. By diversifying your investments, you reduce the risk that some catastrophe will wipe out your savings.

Avoid Investments Sold on TV

Don't ever give money to someone who advertises a specific investment on television.

I'm not talking about general advertising, like the spots that tell you that "Merrill Lynch is bullish on America." I'm talking about the hucksters that come on at two in the morning to tell you that you can change your life by investing in wireless cable television companies or oil and gas futures or other get rich schemes. These fall into the category of high risk and low reward, because the people selling you these investments charge huge commissions and "hidden" costs that make it almost impossible for you to win.

Just ask yourself, if this investment is a sure bet to reap immense financial rewards, why are these people spending millions of dollars on television advertising to tell you about it? Why don't they invest their money in this great investment opportunity and reap the rewards themselves?

The answer is that they intend to reap more money off the commissions and hidden costs that you are going to pay, even after deducting the cost of their television commercials, than they could possibly make investing in the opportunities they are selling to you.

Calculating Your Reward

Unless you are playing craps at a casino, it's very difficult to calculate your risk. Some investments are clearly more risky than others, but it's hard to put a number to the relative risks involved. Calculating your reward is a little easier. To calculate the reward on an investment, also called your "yield" or "return," simply divide the profits

you made by the amount you invested. The formula for return would look like this:

$$\text{Return} = \frac{\text{Profit}}{\text{Original Investment}}$$

For instance, if you buy 100 shares of Starbucks stock at $20 each, you have invested $2,000. Let's say you sold those shares at $22.40 each, and got back your original $2,000, plus a profit of $240. Your return on the investment—your *yield* in financial jargon—is $240 divided by $2,000, or 12 percent. That formula would look just like this:

$$\text{Return} = \frac{\$240}{\$2,000} = 12\,\%$$

In order to compare one investment to another, you need to know the "annual return," or how much your return would be if you had owned the stock for a year.

In the example above, you made $240. If it took a year to make that $240 profit, that would be a pretty good investment. If you could make that same profit in three months, you would be doing even better. If it took three years, it wouldn't be quite as attractive. It also wouldn't be Starbucks.

Calculating the "annual return" allows you to compare the returns for investments of different lengths. Simply divide your return by the term of the investment in years. If the investment is less than one year, use a fraction or percentage. The formula is:

$$\text{Annual Return} = \frac{\text{Return}}{\text{Years Invested}}$$

For example, if you made the same investment in Starbucks, and earned the same $240, but did it all over two years, your annual return would be 12 percent divided by 2, or 6 percent. If you made the same investment and earned the same amount over three months, you would have a return of 12 percent divided by .25 years, or an annual return of 48 percent.

This formula is essential to investing because it's how you keep score. The higher your annual return, the better. As you might expect, the following chart shows that it is better to make the same amount of money over a shorter period. The three examples below demonstrate how this works.

12 percent in one year

$$\text{Annual Return} = \frac{12\%}{1 \text{ year}} = 12\%$$

12 percent in two years

$$\text{Annual Return} = \frac{12\%}{2 \text{ years}} = 6\%$$

12 percent in three months, or 1/4 year

$$\text{Annual Return} = \frac{12\%}{1/4 \text{ year}} = 48\%$$

Leverage Increases Your Risk and Your Reward

Leverage is that idea you may remember from physics—with a long pole you can move a big rock. With a big enough stick, some Greek philosopher said, he could move the whole world.

Financial leverage is when you use a small amount of money to con-

trol a big financial asset. Using leverage increases your reward, but it also increases your risk, so it doesn't always make sense. For instance, let's say that you buy a house for $100,000 cash. If the value of the house goes up by $10,000, you made a return on your investment of 10 percent ($10,000 profit divided by $100,000 invested). If the value of the house decreases by $10,000, you lost 10 percent of your initial investment.

If you only use $10,000 to buy the house, and you borrow the remaining $90,000, you are using "leverage." If the house increases in value by $10,000, your initial investment of $10,000 has doubled. You could sell the house and make a profit of $10,000 on your initial investment of $10,000, or a return of 100 percent on your investment. However, if the value of the house decreases by $10,000, and you sell it for $90,000, you just lost 100 percent of the money you invested. Options, futures and, to a lesser extent, margin accounts are classic ways for you to leverage your investment dollars, and all carry a greater potential for profit and an enhanced degree of risk.

Time Is on Your Side

In all but the most extreme cases, the longer you invest, the more money you will make. That's because your savings will earn money, and then the money you earned will earn even more money. If you ever made a snowman out of a snowball, you know how this works. This is because of the almost magical quality of compounding.

I've talked about compounding already. And I will again before this book is over. It's the strongest financial advantage that young people have over older people. The next time your father boasts about how much money he's made on Netscape stock, remind him that you can own Netscape for forty years—and still be around to cash it in for a trip to the Aran Islands.

Longer Investments Make More Money

Keep in mind that you will usually earn more money on investments that require a longer investment, because you have agreed to take the "risk" of that particular investment for a longer time. The idea

that longer investments provide higher returns applies best to investments that pay interest, such as savings accounts, CDs, notes and bonds.

The following chart is an example of the interest rates being paid on a variety of investments compared to a savings account, which is completely liquid and almost risk free. (Keep in mind that interest rates change every day; these were the rates on the day that I did this chart.)

Investment	Annual Interest Rate
Savings Account	2.35 %
Six-Month CD	4.83 %
One-Year CD	5.02 %
One-Year Treasury Bill	5.36 %
Five-Year Treasury Note	5.65 %
Ten-Year Treasury Note	5.85 %

I put two different one-year investments in the chart to make another point—the term of the investment is only one of the factors that affects your return. In this case, the one-year CD pays less interest than the one-year treasury bill. That is because the CD is an obligation of your bank. It's also guaranteed by the FDIC. Because there are two sources of repayment, it is a safer investment and therefore pays less interest.

Calculating Your Tax Advantage

Taxes are designed to reward certain uses of money and to punish others. You can use taxes to your benefit if you know the rules.[1]

The most common investment that provides a tax advantage is the municipal bond. The interest paid on municipal bonds (borrowing by state and local governments) is tax exempt in order to encourage people to lend money to government projects. For instance, if you invest $1,000 in a bond issued by the New Jersey Turnpike Authority

[1] Much of this information is also covered in Chapter 5 and elsewhere in Part Two.

that pays 5 percent interest, you don't have to pay taxes on the $50 you earn, so you really earn a true $50.

In order to compare earnings from a taxable investment to earnings from a tax free investment, you have to reduce your taxable earning by the amount of your taxes. If you are in a 15 percent tax bracket, you reduce the taxable earnings by 15 percent. If you invest $1000 in a CD at 6 percent, the CD pays you $60 and you would have to pay taxes of $9 ($60 earned x 15 percent tax rate), leaving you with $51. Even after taxes, the $51 you would earn on the CD is more than the $50 of tax free money you would receive from the New Jersey bonds. This means that the tax free investment is not a good idea for you.

If you were in a 28 percent tax bracket, the $60 of interest from the same CD would require $16.80 of taxes, leaving you with $43.20. In that case, you would be better investing in the tax free bonds and earning $50. As you can see, just because an investment is tax free doesn't mean that it's better.

The following table shows how this works:

Investment	Profit	Less Taxes	Net Income
15 % Tax Bracket			
$1,000 CD paying 6 %	$60	$9	$51
Tax free bond paying 5 %	$50	none	$50
28 % Tax Bracket			
$1,000 CD paying 6 %	$60	$16.80	$43.20
Tax free bond paying 5 %	$50	none	$50

The formula for calculating your after tax income or net income from an investment is:

$$\text{Net income} = \text{Profit} \times (1 - \text{Marginal tax rate})$$

This is a short cut of calculating the taxes, and then deducting the taxes from your profit. Applying this formula to the CDs in our example would look like this:

15 % Tax Bracket

$$\text{Net income} = \$60 \times (1 - .15) = \$60 \times .85 = \$51$$

28 % Tax Bracket

$$\text{Net income} = \$60 \times (1 - .28) = \$60 \times .72 = \$43.20$$

The Risk/Reward Pyramid

The following chart lists various categories of investments, starting with the highest risk/highest return deals—then moving down to the lowest risk/lowest return.

Although each of these investments is described elsewhere, this chart is a handy way to see how your potential investment compares to other potential investments. Most advisers believe that you should have more of your money in the low to moderate risk investments at the bottom or middle of the pyramid, and little or none in the high risk investments at the top.

I recommend you avoid the top spot entirely.

The pyramid shape, which is broadest at the bottom and smallest at the top, is supposed to graphically illustrate this concept.

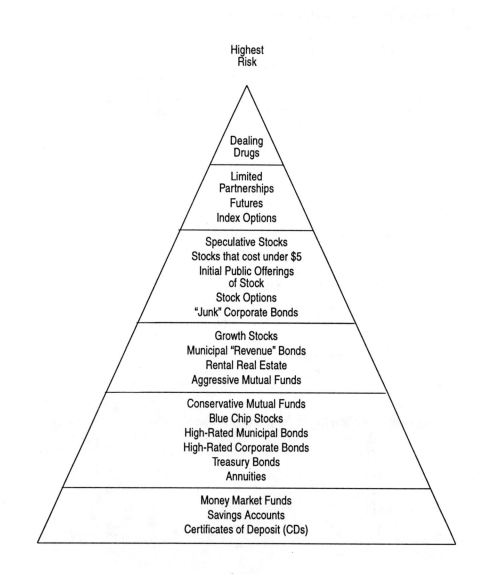

Dollar Cost Averaging

Investments go up and the market goes down. If you invest small, regular amounts of money, the odds are that you will buy some investments at below the average price, some at the average price and some above the average price—put them all together, and you're paying the average price. That's dollar cost averaging or DCA.

Unless you just inherited a big pile of money, or got some huge bonus, you're probably investing small amounts of money over time. For instance, if you contribute money regularly to your 401(k) plan you were dollar cost averaging without even knowing it.

Lots of financial planning guides talk about DCA as if every investor had millions in stock portfolios. For this reason, I don't really put much faith in DCA as an investment rule for people just starting out—but it's a good thing to understand. And it can become meaningful when you have very large investments to make, such as life insurance proceeds or inheritance money.

Dollar Cost Averaging

Regular Investment	Shares Purchased	Share Price
$100	20	$5
100	15	6-5/8
100	14	7-1/4
100	12	8-3/8
100	11	9-1/8
100	10	10
Total $600	82	

Total Investment	$600
Total Shares Purchased	82
Average Price	$7.30

In this example, Ivan put $100 into the market over a six-month period, buying as many shares as he could for $100. During that time, the stock went from $5 per share to $10 per share. By dollar cost averaging, the average price was $7.30.

At the end of the six months, Ivan ordered 82 shares of stock worth $10 each—for a total of $820. That meant that he had a paper profit of $220 ($820 less his $600 investment).

However, if he had bought all of the stock in the first month for $5 a share, he would have owned 120 shares worth $1,200—and his profit would have been $600. In this case, dollar cost averaging reduced Ivan's profit. He could have used some inside information.

Whenever you have a rising market, you will always come out ahead by investing early. However, in a market that is declining or subject to wild swings up or down, dollar cost averaging can help smooth out the rough spots and help you avoid buying all of your stock at one high price.

Chapter Twenty-one

Matching Your Investments to Your Goals

Introduction

If you are saving for a car that you hope to buy in six months, or a house in two years, you want to make sure that you can get your money when you want it.

If you're putting away money for a down payment on a house, and you almost have all of the money you need, you don't want to invest in high risk investments.

If you're saving for your retirement in 40 years, longer term investments will make you more money, and make more sense.

In general, short-term goals require investments that don't have a lot of risk, and that allow you easy access to your money when you need it. Longer term goals are more compatible with investments that may limit access to your money, and carry somewhat higher risks and rewards. Having a goal and a time frame to achieve it is the best way to help you plan. Putting a picture of your goal in your wallet or on your refrigerator can help you focus.

Make Savings Automatic

If you can somehow make your savings automatic, it is much easier to reach savings goals. Here are some examples:

- **Direct Deposit.** Instruct your company to pay a small portion of your paycheck into a savings or brokerage account. I like to do this if I get a raise with some or all of my additional income. That way you hardly know it's gone.

- **Save Your Extra Paychecks.** If you get paid on a weekly basis, you usually get four checks per month. However, four times a year, you get a fifth check. (If you're paid biweekly, you'll get an extra paycheck twice a year.) Try to live off your weekly checks, and put all of your "extra" checks into savings. If you can do that, you're already saving almost 8 percent of your salary.

- **Join Your 401(k) Plan.** If it makes sense for your investing goals, a 401(k) plan lets you save automatically, with a great tax advantage, and some employers actually match all or part of your savings.

- **Split Your Bonus or Tax Return.** Although this is not really automatic, resolve to put part or all of any bonus or tax return into savings before you get it. That will reduce the temptation to blow it all in a night of drunken bliss, or a day of impulse shopping.

Set Your Goals

Write down a list of your financial goals, your time horizon and what you will need to do to achieve them. Retirement should always be one of these, and others might include saving for a car, buying a home, starting a business, educating a child, building an emergency cash reserve, etc.

You shouldn't have more than three goals at a time, or you'll spread yourself too thin.

	Goal	Time Frame	Total Target Amount
#1	_____	_____	$ _____
#2	_____	_____	$ _____
#3	_____	_____	$ _____

Then, use the charts below to estimate your monthly savings for each goal.

Under 5 Years
4% Return
Monthly Investment $10

1 year	2 years	3 years	4 years	5 years
$122	$250	$382	$520	$663

5 Years Plus
8% Return
Monthly Investment $10

5 years	10 years	15 years	20 years	25 years
$734	$1,813	$3,398	$5,727	$9,149

For instance, assume you want to save $10,000 as a down payment for a house and your time frame is four years. Divide $10,000 by the number for four years (520), and you get 19.1. Multiply that number by $10, and you need to save $191 per month to reach your goal. Another example: If you wanted to save $50,000 to help fund a col-

lege tuition in 20 years, divide your goal of $50,000 by the 20-year amount (5,727), and you get about 8.7. Multiply $10 by 8.7 and you would need a monthly payment of $87.

For a time frame that is not on the chart—for instance, eight years—you can estimate a number between five years and ten years, and get close enough for planning purposes.

Remember that my assumptions are relatively conservative, and you have to have more money than you need. However, you might also be short of your target, so plan accordingly.

Investment Benchmarks

Understanding historic performance of various investments helps you to understand which are appropriate for short, mid-term, and longer goals. As you can see in the following information, stocks are best for long-term investment plans, while short-term treasuries (or money-market funds that invest in these similar short-term corporate notes) are best for parking money that you will be using in the near term.

This information is measured by the total return (income and capital gain) and is courtesy of Ibbotson Associates.

Bad News:		
	Worst Annual Performance	Year
Small company stocks	down 58.0%	1937
Common stocks	down 43.0%	1931
Long-term treasuries	down 9.2%	1967
Long-term corporate bonds	down 8.1%	1969
Intermediate treasuries	down 2.3%	1931
Treasury bills	down 0.1%	1938

Good News:	
	20-Year Annualized Returns
Small company stocks	18.8%
Common stocks	12.8%
Long-term treasuries	10.1%
Long-term corporate bonds	10.2%
Intermediate treasuries	9.9%
Treasury bills	7.5%

As you can see, small company stocks offer the highest average returns, but also provide the greatest amount of downside in a single year. You should note that the 20-year annualized returns don't include 1995, one of the best years ever for equities (S&P 500 up 37.5 percent) and a good year for bonds as well.

Ibboston Associates also reports that if you invested equal amounts every month over any five-year period in the past 70 years, you would have made money almost 90 percent of the time, and beaten the performance of bonds 86 percent of those periods. However, over any ten-year period, you would have made money 98 percent of the time, and beaten bonds 88 percent of those periods. The longer your time horizon, the better your chances are of winning with stocks. If you choose any 25-year period, you make money and beat bonds every time you invest in stocks.

The conclusion: For long-term investments, stocks have historically been the best way to go. For Short-term investments (less than five years) you should minimize the risk of stocks and move to the relative safety of short-term and intermediate bonds.

What Investments to Use

I strongly recommend mutual funds for anyone who doesn't have a lot of time to concentrate on investing and a strong desire to learn more about investing than I have provided in this book.

For long-term (over five years) investments seeking growth or aggressive growth, I like to use index funds for two reasons.

First, index funds invest all of their money in a fixed basket of stocks, and try to match the performance of the market. In 1995, only about 16 percent of the stock mutual funds beat the performance of the market as measured by the 500 stocks in the S&P 500. That means that an index fund would have beaten four out of every five mutual funds in that year.

Second, index funds are not actively managed. They buy a fixed list of stocks and hold them, which means you don't have to pay big

bucks to professional fund managers. You save on trading costs and you minimize taxes that you have to pay when a mutual fund sells stocks they own. This means you will save money on fees and reduce taxes on index funds, and thereby maximize returns.

Strategy

We know the following facts:

1) Over time, stocks have consistently beaten bonds for making money.

2) For periods of less than five years, investors who buy bonds, and particularly short-term bonds and T-bills directly or through money market funds, are much less likely to lose money in a down market.

Therefore, you should use stocks to "make" money and bonds to "hold" money. For large savings goals, such as a house, college or retirement, I recommend using stocks to build your savings, then transitioning into bonds before you need the money (I discuss this in detail below).

Diversify and Conquer

Diversification is the term for spreading your risk into various investments—stocks, bonds and cash. For now, we will look at how much to invest in the three major categories:

Cash for Crisis

Cash is the basis for financial stability, and the foundation of your investment strategy. As we have discussed elsewhere, cash doesn't mean a bag of $20s stuffed into your mattress, but rather a low-risk, high liquid place to invest your money. Other than your mattress, the most common "cash" investments are checking accounts, savings accounts, CDs, treasury bills and money market accounts or funds.

I prefer money market accounts, which usually have better returns

than CDs, savings accounts or checking accounts, but the same or better liquidity—you can usually write checks on your money market account.

The next question is how much to keep in cash. The general consensus is that you should keep enough money for six months of living expenses. That thinking is at least partly based on the assumption that, should you lose your job or have some other emergency, this should be enough to see you through. I think saving enough to cover your operating costs for three months is plenty, particularly if you have two incomes in your household. Also, if you have other investments which can be sold, or if you can borrow from your 401(k) plan, you don't want much in cash.

Practically speaking, even if you are able to save ten percent of your income, it will take you almost two-and-a-half years to save three months of earnings (25 percent of a year) that may seem like the goal that you will never achieve. Especially when every time you get a few dollars together, your transmission goes. Don't let that be daunting— by putting a larger share of bonuses, birthday gifts, etc., into savings, plus the earning that your money will make, this is both the toughest and best financial goal that you will ever meet.

Additionally, as we will discuss below, as you reach the time when you will be spending the money you have earned in other investments, you will want to move that money into cash to avoid potential losses immediately before you will be spending your money.

Rule of 100

One general rule is to take the number 100, less your age and invest that percentage of your savings in stocks. The rest of your money should be in cash and debt. For example, if you are 25 years old, 75 percent of your investments should be in stocks and the rest should be in bonds and cash. At age 65, you should hold about 35 percent of your investments in stocks and the rest in bonds and cash.

The basis of this theory is that, over time, the return on stocks will beat the return on bonds. However, stocks are typically more volatile

than other investments, which means that they go up and down in value more often, and when they do the swings in value are greater than other investments. When you are younger, you don't mind if your investment in stocks is temporarily depressed because they have a long time to come back. As you get older, and closer to the time you will begin to use your money (and the income it provides) to pay college tuition and to fund your retirement, you will want to switch more of your money to cash and generate more current income through interest payments and cash.

I like this general rule, but I recommend a few adjustments for balancing your risk with your goals as time goes on.

Portfolio Strategy for Retirement

Despite the Rule of 100, I think that you should freeze your retirement portfolio mix at 50 percent stocks and at 50 percent mid-term bonds and cash equivalents when you reach 50 years old, and reach retirement with at least 50 percent of your investments in stocks. At that point, you should be calculating how much your investments will generate in current income. If your current balance is enough, leave well enough alone. But if you think you'll need more current income as you near retirement, start transitioning more money into bonds. Reassess your needs every year and adjust accordingly.

When you move into bonds, I suggest a low-fee bond fund with average maturities of five to seven years. Although these funds won't pay as much income as bond funds holding longer term bonds, you will avoid most of the risks from big savings in interest rates.

Portfolio Strategy for Large Single Expenditures

Regardless of age, I recommend that 75 percent of your savings should be invested in a mix of stocks or equity mutual funds. If you know you are likely to be buying a house or starting a business in the next four years, you should start moving money into cash each year, so that one year before your expenditure, you have moved almost all of the funds dedicated to this purpose into cash investments. This is a

bit conservative, but you can avoid big movements in the market that might diminish your ability to fund these major expenditures. If you're less than five years away from your expenditure, and the stock market happens to be down, you don't want to rush into conservative bonds or cash. Wait for the market to return to equilibrium, which rarely takes over two to three years.

Portfolio Strategy for College Savings

As with large single expenditures, I recommend 75 percent of your investment portfolio in equities and equity mutual funds until about four years after your child starts school. Because college is usually a four-year expense, I recommend beginning your transition to bonds five years before college tuition bills start, but moving only 1/8 of your savings for that child per year. That means that you'll be moving the last of your money from stocks to bonds just as, hopefully, your child is about to graduate.

Additional College Strategies

Despite information that tries to tell you otherwise, saving for college is nearly identical to saving for any other major expenditure. So ignore the experts who are trying to convince you that this special need requires some unique investment strategies.

There are only two basic differences in saving for college:

- **Student Aid.** Your kid's ability to get student aid, grants, loans, etc., is partially based on how you save, so some methods are better than others.

- **Savings Bond Tax Break.** U.S. Savings Bonds, which are not typically a first-class investment, jump to the head of the bond investment class if you qualify for the education tax benefit.

The following are some strategies that other financial advisors have suggested, and how they might affect your college savings goals.

Avoid Gimmicks

There are several different companies out there that advocate specialized college savings plans. None of them is any better for this purpose, and most are not as good as investing in a solid portfolio of stocks and mutual funds.

Putting Money in Your Child's Name

This can be a way of saving money on your taxes, but it may not be the best way for you to save for a college education. As we discussed in the tax section, your kids are in a lower tax bracket and therefore will pay fewer taxes on earnings than you would. The first $650 they earn is tax free and the next $650 is taxed at 15 percent. However, until your child turns 14, if they earn more than $1,300 of investment income, the IRS can tax the rest at the parent's rate (under the so-called "Kiddie Tax"). That probably won't affect you until you have moved a large amount of money into your child's account, or if you invest in longer term investments such as stocks.

The second reason you may want to avoid putting money in your child's name is financial aid rules. Financial aid rules currently expect students to be able to put 35 percent of their assets toward tuition each year. That cut-off is only about 5.6 percent for parent's assets. This means that by putting money in your child's name, you may be inadvertently reducing their ability to get student aid. Also, if your state gives full control to your child once they hit 18, that money may be spent before your kid even fills out those college applications.

Paying Down Your Mortgage

This isn't usually the best use of your investment dollars, as you get a tax break on your mortgage payment, and you can usually earn more investing your dollars elsewhere. Also, you may not be able to borrow against that home equity, and use it to cover tuition costs, if you do not meet all of the requirements of a lender—for instance, if you are temporarily unemployed.

However, federal financial aid programs, and the majority of schools,

don't count home equity for calculating financial need. Colleges don't expect you to spend that on tuition. Some private schools are now including home equity as part of the financial aid guidelines used for scholarships and other aid provided through the schools.

I've said that for the four years prior to starting college for each child, you should start moving funds from stock investments to more liquid and more conservative bond investments. At that time, calculate your mortgage interest cost after taxes. If you use these funds to pay off your mortgage, you will have to borrow them again to pay your kid's tuition bills. The bad news is that you will usually be paying off a mortgage, and quickly replacing it with a home equity loan that is almost always more expensive.

The only way to justify paying off your loan is if the loan carries a high interest rate and you intend to refinance at a lower rate. Otherwise, even though your investments will be counted for purposes of calculating your assets, you are better off investing in conservative bonds.

Retirement Plans

Many advisers will tell you to put your money in retirement plans, because money put into retirement plans in the years before you apply for financial aid is not counted as assets for calculating your expected contribution to your child's education costs. But keep in mind that moving large amounts into retirement plans and annuities will prevent you from tapping that money without penalty until you reach 59 1/2. Even if it is counted as an asset, existing rules only expect you to make 5.6 percent of your assets available (per year of college education). Therefore, you are usually best served by making your retirement plans to suit your retirement needs, and not trying to hide funds you will need for college tuition in the same plans.

Fending for Themselves

One way to help your children to prepare for both their college expenses, and life in general, is to have them help save for college. A summer job, even if it is part time, isn't going to kill anyone. Also, it

may give them the incentive to work a little harder at school, teach them an appreciation for money, and get them out of the house. If you've spent much time recently with young teenagers, this may not seem like such a bad idea.

Savings Bonds for Education

U.S. Savings Bonds can be a great way to save for school bills. In general, savings bonds are a safe, but low-yielding investment, that have an attractive tax-free twist. The interest you earn on savings bonds is free from state and local taxes, but it can also be free from federal income taxes, if you use the money you earn to pay for school. The break is aimed at people who use the bonds to pay tuition and fees for themselves, their spouses or their kids.

When I was writing this book, the yield on Series EE Savings Bonds, which you can buy at any bank, was about 4.75 percent. Although that's a fairly modest rate, if you are in a 28 percent tax bracket, your return is close to 6.6 percent, including the taxes that you save. That makes these bonds a pretty attractive investment when you are moving your investments out of stocks and into bonds or cash investments.

The rules are spelled out in the pamphlet U.S. Savings Bonds Investor Information, which you can get at almost any bank. Be careful to follow them closely, so you don't accidentally miss out on the deduction. Some of the most important rules include the following:

- **You Can't Make Too Much Money.** You can only take advantage of this tax break if you are single and make less than $42,300 or if you're married and filing jointly with less than $63,450. If you make more than that, you still get a decreasing advantage up to $57,300 for singles, and $93,450 if you're married. These income levels increase every year to keep up with inflation, so make sure to get that pamphlet.

- **Buy the Bonds in Your Name.** The tax break goes to the person who owns the bonds. That means they should be in your name. If you buy them in your kids' names, they get the deduction—but they probably don't make enough money to

need help with their taxes. You may be able to change the name on your bond by filing Federal Reserve Form PDF4000, which you can get from your bank.

- **Spend the Money Correctly.** You can only spend the money on tuition and fees in the same year that you redeem the bonds. Don't redeem them early or late, and don't use the money for room and board, books or beer money, or if you do, don't tell Uncle Sam.

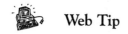 **Web Tip**

There are over 200,000 scholarships, grants and loans for undergraduate and graduate students. One way to access them for free is over the internet. Simply dial up a software program called fast Web (http://web.studentservices.com/fastweb) and complete a questionnaire, including information about your special interests, grades, ethnic background and potential major. The program will search the database, and provide you with a list of financial aid sources, with addresses and even form letters requesting details.

Speculative Investments

Once you have the money put away, you may find that you enjoy investing. You may want to learn and do more—like getting into options, futures and other exotic investments. A few suggestions: Never invest more than you can afford to lose in these things; and never put more than five percent of your portfolio in them.

Chapter Twenty-two

Stocks, Bonds and Mutual Funds

Introduction

This chapter looks at stocks, bonds, and mutual funds—as well as most related investments such as options, futures, etc. Here, we'll talk about methods to evaluate one particular investment against another—one stock versus another, one bond versus another. These are the small, detailed choices that separate Wall Street legends—Benjamin Graham, Warren Buffett, Peter Lynch—from the herd of neurotic bozos wearing power ties and suspenders with naked women on them.

Stocks

Stock, also referred to as equity, represents ownership in a business. It's the basic building block of the financial world. It entitles you to all the benefits and risks of a owner. When the business prospers, the value of the stock increases; when it does not, the value of the stock decreases.

Stockholders, also called shareholders, are entitled to vote at stock-holder elections, usually held at least once a year to select the members of the board of directors of a company. The board of directors is in charge of protecting the stockholder's interest, and in hiring and guiding the senior executives of the company.

Making Money on Stocks

The entire strategy of investing in stock is summarized in the insufferable phrase "buy low, sell high." If you can consistently apply this simple concept, you will do something that most professional investors dream about—beat the stock market. But even if you can follow this rule more often than not, you can still make money.

As we discussed in the tax section of the book, stocks are a capital investment. That means that if you buy for $100 and sell for $150, your $50 profit is a capital gain—which may entitle you to a tax break, depending on your bracket.

Dividends

A secondary way to make money on stock investments is dividends. Dividends are payments made to shareholders, usually when a company is profitable. These payments are not required, but are made at the discretion of the board of directors of the company. Not all companies pay dividends—and some only do so erratically. Many smaller and mid-sized companies need to use all of their available funds to pay for growth, so they are less likely to pay dividends.

However, there are numerous companies that haven't missed a dividend payment in decades. Most of these are large oil, chemical, pharmaceutical and other major industrial companies that pay dividends every quarter.

In most cases, your primary source of profits from investing in stocks is your capital gain. Even the companies that pay regular quarterly dividends don't typically pay more than four or five percent of the value of the stock each year.

Calculating Your Return

In order to compare your return on one stock versus another, you have to look at the return, or the amount of money you made on your investment over the period you invested. This includes both the increase in the value of the stock and any dividends you received. You should also deduct the fees and commissions from the profits you made.

The formula for an annual return on a stock investment looks like this:

$$\text{Annual Return} = \frac{(\text{Profit on sale} + \text{dividends} - \text{fees})/\text{Amount invested}}{\text{Years invested}}$$

Let's say you bought 100 shares of Starbucks at $14 a share and sold it one year later for $18. It paid no dividend, and you paid fees of $50. You made a profit of $400 ($4 per share times 100 shares), less fees of $50, or profits of $350 on an investment of $1,400.

$$\text{Annual Return} = \frac{(\$400 - \$50)/\$1,400}{1 \text{ year}} = 25 \text{ percent}$$

This equals a return on your investment of 25 percent.

Three Grades of Stock, and Many in Between

Blue Chips. Named after the most valuable chip at the gaming tables, these are large, established companies like GM, Ford, Exxon, Dow Chemical, DuPont, 3M, AT&T, Xerox, McDonalds and Johnson & Johnson. These companies are valued for their stability and rarely go out of business. Most of them pay a regular dividend.

Blue chips tend to be solid performers as a group, although each will have its ups and downs over time. You are not likely to lose a lot of money investing on stocks in this group; however, you probably won't make five times your money either. These are conservative invest-ments—though they may not be as thoroughly reliable as they once

were. A number of stock gurus argue that the speed with which financial information travels in the computer age favors smaller growth companies at the expense of giants.

Growth Stocks. These tend to be companies that are newer and still on the move—attacking new territory, expanding into new areas. Growth stocks usually don't pay high dividends. Many don't pay dividends at all; they prefer to use their cash to fuel further growth, rather than distributing it to their shareholders. They believe that they will make the shareholders more money by plowing the money back into the company.

Companies in this category would include Starbucks (coffee houses), Oracle (computer software), Netscape (Internet) and MFS Communications (alternative telephone service). These can make you a lot of money, but they can also have the normal growing pains—or worse. Choosing carefully, you can make very healthy returns on stocks in this group, but you will also have more risk than you would investing in blue chips.

Penny Stocks. These are stocks that trade for less than $5 a share and make up the wild frontier of investing. They are usually unproven companies with little or no track record. Many investors avoid them as being very risky, but some claim that this is where you can find the unpolished gems of the stock world. If you don't know much about stocks or investing, be afraid. Be very afraid.

Almost all of these companies have a great story about how they are going to be the next Microsoft, but many more will be bankrupt within a year. Penny stocks also draw the attention of the brokerage firms who are out to make money off you through questionable trading practices, so look out.

Stock Exchanges

Stock exchanges are the marketplaces in which shares and other investments are actually bought and sold. The oldest and most important exchange in the United States and probably the world is the New York Stock Exchange. The NYSE is based on a specialist sys-

tem, which means most of the transactions take place at particular location and involve particular traders, who are supposed to know a lot about the stocks they buy and sell.

This system isn't perfect—orders aren't always executed on time or precisely as requested—but it does allow all traders to operate openly in a single marketplace. This gives the exchange an immediacy that some people liken to a collective consciousness.

Almost every large blue chip stock and most of the best growth stocks are traded on the NYSE. If you see a stock ticker, NYSE shares will be the ones with codes that have from one to three letters.

NASDAQ is the second most important exchange. But it's not a traditional exchange in the sense of being a noisy place where traders scream buy and sell orders at each other. It's a computerized system comprised of different levels of activity that occur over phone lines with no controlled location.

Advocates argue that this operates more precisely than the NYSE, but NASDAQ has been plagued by allegations that computerized trading benefits trading companies and stockbrokers at the expense of investors. Critics claim the computer system encourages unnecessary trading and makes fraudulent—or at least questionable—business easier to hide.

NASDAQ is home to many of the biggest technology companies and many mid-sized and small growth companies. It also trades some penny stocks. You can identify NASDAQ stocks on a ticker because they are the ones with four-letter codes.

A number of smaller stock exchanges, mostly regional in focus, specialize in companies too small for the major exchanges.

Common Stock vs. Preferred Stock

There are two basic types of stock—common stock and preferred stock.

Common stock is the standard. Common stock is the closest to being the owner—the better the company does, the better you do, but nothing is guaranteed.

Preferred stock is a hybrid of a stock and a bond and tends to be less risky—and less profitable—than common stock.

Preferred shares usually have a stated value and a dividend percentage. For instance, you might buy a $100 preferred stock with a 5 percent dividend. That means that the stock is entitled to a dividend of $5 per year, before the common shareholders can get a dividend.

Cumulative preferred means that if the company doesn't declare dividends in one or more years, the preferred stockholders are entitled to back dividends before any money can be paid to the common stockholders.

Convertible preferred means that the stock can be sent to the company and exchanged for common stock at some pre-determined rate. This is valuable if the exchange rate is near or below the current trading price of the common stock.

Owners of preferred stock get in line before common stockholders if a company goes out of business to share in any money that may be left after lenders are paid. Also, preferred stock gets in line first for dividends, and usually gets bigger dividends than the common stock. Because the preferred stock gets these benefits, it does not usually get the full benefits of ownership that the common stock holders receive when the business prospers. In some cases preferred stockholders receive nothing beyond their preferred dividend.

Picking Stocks

There are probably a thousand different methods that professional investors use for picking stock. Some people buy stock in companies that make products they like. Some look at recent financial performance, and try to project how well a company will perform based on its trading history. Others look at graphs showing the stock's recent price trends and believe they can divine which direction the stock will move, without even knowing the name of the company.

I'm sure some even rely on the Psychic Friends Network.

Value vs. Momentum

In general, there are really two basic types of investors: value investors and momentum investors. Value investors try to find stocks in strong companies, which they believe will outperform other stocks. They tend to invest in stocks for longer terms, and wait for the performance of the company to lift the price of the stock.

Warren Buffett, one of the richest men in the United States, falls into this category. He makes large investments in companies that he believes have significant advantages over their competition and holds the stocks for a long time. He likes to make his investments when the stocks are temporarily depressed.

One of Buffett's classic investments is in The Coca-Cola Co. He saw a company that had a strong franchise in the U.S., a great management team and an enviable ability to penetrate growing international markets. When the New Coke fiasco caused the price of Coke's stock to go down, he pounced, buying a large block of stock. He has added to that investment over the years, and has made millions of dollars as Coke has continued to grow.

Momentum investors rely more on the ebb and flow of the markets. They try to pick stocks that are moving up for a variety of reasons, and then sell the stocks as the price hits a higher level. These investors tend to invest for shorter periods, sometimes selling on the same day that they buy. Most of these investors are professional investment advisers that have access to far more information than the average casual investor.

While both of these approaches can work well, value investing is more practical for most people who don't have the time or ability to closely watch the market.

Every so often, the *Wall Street Journal* has a contest in which several industry experts, usually either research analysts or newsletter publishers, are allowed to pick their favorite stocks, and compete against

stocks chosen using a dart board. The darts beat the experts on a fairly regular basis. The point is that no stock-picking method is foolproof, but there are some basic things you should examine to determine whether to buy a stock. Both types of investor look at several key yardsticks to judge a potential investment.

Earnings per Share

In order to be able to understand the value of a share of stock, you need to know how much money the company makes. However, unless you're Daddy Warbucks, you are not likely to buy the entire company—you will probably just buy a few shares of stock. For that reason, all public companies report their *earnings per share*. This number is calculated by taking all of the profits a company makes and dividing those profits by the number of shares that the company has issued.

For instance, if a company makes $1 million of profits, and has 2 million shares of stock, it has earnings per share, or EPS for short, of $.50. Don't confuse earnings per share with dividends. Earnings are the profits a company makes from its ongoing business. Dividends are usually a small portion of the company's earnings that they distribute to shareholders. Even if a company loses money in a particular year, it may still distribute a dividend out of its savings.

Price to Earnings Ratio

This is probably the most used—and misused—measure of the value of a stock. Still, it gives you an idea of the relationship between the price of a stock and the company's earnings per share. And it is a good way to compare the stock of similar companies.

If you had to choose between buying a share of Maimway Industries for $50 or a share of Spudco for $50, you would have a hard time making a decision without more information. If I told you that Maimway earned $5 per share and Spudco earned fifty cents per share, you'd probably conclude that Maimway was a better buy.

The price to earnings ratio, also called the P/E ratio, or just P/E, is

the relationship between the amount of money a company earns per share and the price of its stock. A company that makes a lot of money, and has a low stock price, will have a low price to earnings ratio. All other things being equal, a low P/E is better than a high P/E.

Unfortunately, all other things are rarely equal. A P/E is based on the current price of a stock and the earnings per share of the company over the most recent four quarters of operations. So, it is a short-term reflection.

For example: Maimway Industries trades at about $50 per share, based on earnings of about $5 per share. That means it has a P/E of 10 (the stock price of $50 divided by the EPS of $5). At the same time, you could buy Spudco for about the same $50 per share, based on earnings of about $.50 per share. That means that Spudco has a P/E of about 100 ($50 divided by $.50).

If you knew that Maimway had historically traded at a P/E ratio of 20, and it had slid down to 10 without any bad news, you might conclude that it was cheap at this price, and consider buying. The historical trend suggests that if the EPS stays at $5, Maimway shares should rise to near $100. If Spudco historically traded at a P/E of 20, and it had traded up to 100 without any particularly good developments, that might indicate that the stock was overpriced—and you should avoid buying it or consider selling any stock you own.

But Maimway could be making itself look profitable by not spending any money this year on developing new products or selling to new markets. By freezing those expenditures, it can generate some short-term profits—but it may suffer down the road, when it needs new things to sell and places to sell them.

On the other hand, Spudco could be showing weak earnings because it's pouring all of its money into new products and expensive new ad campaigns. It's taking a hit this year, so that it will generate big sales—and earnings—next year.

So Maimway's lower P/E doesn't necessarily mean that it's a better investment than Spudco. The number just helps you understand how

a company's stock is performing in relation to its earnings. The P/E ratio is most valuable when used with other information.

Most companies that have earnings will have a P/E of at least 12, and usually only the best companies have P/E ratios of over 25 or 30. Companies that don't have any earnings will have no P/E (remember, your math teacher taught you that any number divided by zero is not a real number).

Because P/E is such a popular measurement tool, this number is reported in the financial section of most major newspapers, along with the current price of each stock, and other important information we will see below. In the next section, I will tell you where to find this and other information.

Growth

Along with P/E, the growth of a company is the most important indicator of its prospects. A company that is growing rapidly is likely to have a stock price that is also growing. To illustrate the relationship between P/E ratio and growth, let's assume that you have the opportunity to invest in two different companies that had P/Es of 15.

Kramden Bus Lines is a bus company that has historically grown at 10 percent per year, while Norton Environmental is an environmental service company that's going to the moon—with a growth rate of 50 percent per year. Look at how the stocks of the two companies might perform, if the P/E ratios remained constant.

Kramden Bus Lines			
Year	Earnings per Share	P/E Ratio	Price
1996	$1.00	15	$15.00
1997	$1.10	15	$16.50
1998	$1.21	15	$18.15

Norton Environmental			
Year	Earnings per Share	P/E Ratio	Price
1996	$1.00	15	$15.00
1997	$1.50	15	$22.50
1998	$2.25	15	$33.75

As you can see, the stock in Norton Environmental grew with the earnings. However, most alert investors have a good idea which stocks are likely to grow the fastest, and so they tend to buy these even if they have higher P/E ratios. In the example above, it would not be surprising to see Norton Environmental trading at a P/E of over 30 times its earnings.

In fact one rule of thumb is that a company's P/E ratio is the same as its growth rate—a company growing at 50 percent would therefore have a P/E ratio of 50. This is not a very good rule, because some companies can have short spurts of high growth, while others may have sustained growth for years.

Most growth companies tend to be smaller or mid-sized companies, because it's easier to double a company with $50 million in sales than it is to double a company with $5 billion in sales.

Projected Price to Earnings Ratio

The projected P/E ratio compares the current price of the stock to the projected earnings per share. By doing this, you use the basic idea of the P/E ratio, and take into account a company's anticipated growth. The problem with this ratio is that projections are not usually reliable; and, the bigger the expected growth, the less reliable they tend to be.

When the stock analysts at brokerage firms write research reports, they usually provide both projections of a company's earnings, and

the projected P/E. They divide the current price of the company's stock by the future earnings per share. For instance, if you assume that everyone who read this book bought Norton Environmental and drove the stock price to $25 per share, the research analyst from Merrill Lynch might include the following information in the research report:

Norton Environmental
Price $20.00

Projected	Earnings Per Share	Projected P/E
1996	$1.00	25.0
1997	$1.50	16.7
1998	$2.25	11.1

By comparing the projected P/E ratio to other companies, you might conclude that Norton was a good investment, assuming that it achieves projections.

As I put the finishing touches on this chapter, Netscape—a popular provider of software for the Internet—is trading at about $55 per share, and it doesn't make any money. The only way to justify buying that stock is based on its projected P/E ratio.

Track Record and Management Skill

As you can see, a company's ability to grow and achieve its projections is key to its success. One of Wall Street's favorite sayings is "bet the jockey, not the horse." That means that the skill of the management is sometimes even more important than the company or its products.

Wayne Huizenga is a good example of this rule. After making himself and his investors millions of dollars by building a small trash hauling company into one of the largest companies in the country, he decided to try his hand at video stores. In a few years, he built Blockbuster video into the largest video chain in the country. He was renting the same movies that every other video store was renting, in nearly the same locations, but he and his management team were able to surpass their competitors in no time flat.

If you find a company that has a management team that has consistently performed, even if that performance was at another company, you have a significantly better chance that they will continue to beat their competitors, and increase their stock price.

Proven Companies

Although these are usually not quite as exciting as growth companies, there is a lot to be said about investing in an industry leader. Royal Crown Cola was the first major company to introduce a diet cola, and the first major company to introduce a caffeine free cola. Still, Coke and Pepsi continue to outsell RC by a mile. Being the biggest in your industry is a big advantage, as long as the management team is strong.

Products or Services

If you like a company's products or services, odds are that other people will as well. That may be one of the best tests of whether a company is doing a good job.

Several years ago Chrysler was coming out of some trouble. It was replacing its aging K-Car with the Dodge Intrepid/Eagle Vision/ Chrysler LHS. The stock was trading somewhere around $10, and I swore that the new products were going to be big hits. I decided to buy some Chrysler stock, but never got around to it. By the end of the year, the stock traded up to about $40.

How to Get Information on Stocks

There are a lot of places to get investment information. I use a few of the most common—which I'll describe.

Newspapers

The first place to look is the *Wall Street Journal*, *Investor's Business Daily* or the financial section of a large local newspaper. They will report the movements of the markets and have articles about specific companies and industries. These should also contain limited key

information about every major and most minor companies every day the stock markets are open. Here's a typical format you might see:

52 weeks					Yield		Vol				Net
Hi	Lo	Stock	Sym	Div	percent	P/E	100s	Hi	Lo	Close	Chg
10 5/8	6 1/2	JennyCraig	JC		...	18	101	9 3/4	9 7/8	9 7/8	...
100 3/8	56 3/8	JohnsJohns	JNJ	1.32	1.4	25	15700	94 7/8	93 1/8	93 1/2	-1/4
* 43 1/2	22 5/8	JonesApprel	JNY		...	18	1211	43 1/2	42 3/8	42 7/8	+1/2

Almost every newspaper that prints this information includes a table to explain what it means.

- **First Column.** The first column is blank for all but Jones Apparel, which has an asterisk. This space is usually reserved for special notes. In this case, the asterisk is to point out that on that day, the stock of Jones Apparel reached the highest price it had seen in the last 52 weeks of trading—43 1/2. Other special notes might indicate that a dividend was started (or canceled) or that the company was bankrupt, or a variety of other special events.

- **52 Week Hi and Lo.** This shows you the highest and lowest price of the stock during the past year, and will give you an idea of how the stock has performed during the past year.

- **Stock and Symbol.** This is the name of the stock and the stock symbol that brokers use to refer to that stock.

- **Dividend.** This is the assumed annual dividend based on what was given in the last dividend distribution. That means they take the last quarterly dividend and multiply by four to get the dividend they expect for the full year. This isn't always precise, as companies sometimes change their dividend, but it should give a basic idea of how much the company will pay. If you look at the three stocks above, only Johnson and Johnson, the largest of the three companies, pays a dividend. They pay a dividend of $1.32 per year per share of stock.

- **Yield.** The dividend yield is the dividends paid by the company during the past year divided by the price of the stock.

In the case of Johnson and Johnson, the yield is 1.4 (the dividend of $1.32 divided by the price of 93 1/2).

- **P/E.** This is the price to earnings ratio based on the earnings for the last four quarters and the closing price of the stock.

- **Sales Figures.** This is the number of shares that were sold during the day. Because these are normally big numbers, they drop off the last two zeros, and report the sales in hundreds. That means that if they say 101 shares of Jenny Craig were sold, you have to add two zeros to get the real trading number of 10,100 shares.

- **Hi, Lo, Close and Net Chg.** These are the highest price, in dollars, and the lowest price paid for the stock during the day. The closing price is the price of the last trade of the day. The net change is the difference between the closing price of the prior day and the closing price of the day reported. The three dots under Jenny Craig means that stock closed at the same price on the prior day, so there was no change.

When you are talking about stocks, a *point* is $1. When you say that Johnson and Johnson closed down a quarter of a point, or down a quarter, you mean that their closing price was 25 cents lower than yesterday's closing price.

Value Line

Value Line is a periodical that ranks and recommends about 1,500 stocks, and provides you with in-depth reports on about 100 stocks every week. It costs a lot (about $5 per week) but you can usually find it in your public library.

I like Value Line because it provides a great deal of factual information, like financial performance, that is usually hard to get in such a compact readable format. That doesn't mean it's easy to understand, but with a little work, you can get a lot out of this information.

Magazines

Barron's, Forbes, Fortune and *Business Week*, as well as a variety of

local newspapers and magazines, will provide you with more of the soft information—articles on the management teams and hot industries—that rely less on numbers and more on the experience of the editors. They are also a bit easier to read, as they include interesting personal information about the people and companies they cover.

Barron's also includes a fair amount of analytical information, and quotes for stock bonds and other securities.

Newsletters

I think of these as the "psychic hotlines" of the stock world. Most of them are mediocre, and some are just plain terrible. They can be a decent source of information, as long as you don't have to pay too much. Some of these can cost as much as $5,000 per year.

Before you subscribe, ask for a performance record to see whether a newsletter can justify its price to an investor with the amount of money and experience that you have.

Analyst Reports

These are one of the best sources of information on a company. Brokerage firms generally have research analysts that write research reports that describe a company, its performance, its competitive position, and other facts about the stock. These analysts are typically experts in their field, having written about it for a long time, and perhaps even worked in the area.

For instance, my friend Paul Marsh is the media and entertainment analyst at Cowen & Company—a brokerage in New York. Before he became an analyst, Paul worked at a large bank, where he learned about finance, and then for HBO during its infancy, where he learned about the entertainment industry.

The difficulty is that these research reports may be hard to get. Most firms only provide this information to their customers. If the report is favorable, you can often get a copy of the report from the company featured in the report. (If the report is not favorable, they probably

won't send it to you.) Some on-line services—Dow Jones News Retrieval is one—will provide copies of reports from big brokerage firms. So will certain discount brokers.

Analyst reports typically recommend that you buy, hold or sell the stock. They may also include other information, such as buy only if you are looking for a speculative stock or accumulate—which means buy when the price dips.

Analysts usually don't work in a vacuum—they have bosses that they have to report to, and they have to be able to talk to the management of companies in the industry they cover. This means some reports may not be as critical as they should be. For instance, in the early 1990s, the airline analyst from a major brokerage firm that had raised millions of dollars for America West Airlines put out a report that recommended that people buy the stock of that airline. Within two months, the airline went bankrupt.

Although most analysts are completely objective, I like to make sure that an independent brokerage firm is also recommending the stock.

Buying and Selling Stocks

To get into the stock market, you have to open an account at a brokerage firm. This is much like a checking account at a bank. In fact, most brokerage accounts have checks, ATM cards, and other similar services.

When you want to buy a stock, you just call your broker and ask him or her to buy the number of shares that you want. If you have money in your account, they will deduct this amount of money, plus their fees. If you don't have enough money in your account, you will have to get them a check within a few days. If you don't, they'll cancel your trade.

If you already own the stock and want to sell, you call your broker and place a sell order for the number of shares you want to sell.

The broker will send you a confirmation—called a *confirm* for short—

that will report the amount of stock you bought or sold, the price and the commission.

Most brokerage firms don't make mistakes, but you will see one from time to time. If there is a mistake on the confirm, you must call your broker immediately and follow the instructions on your account paperwork to clear up the problem.

Buy and Sell Orders

There are several different types of buy and sell orders, but the two most important are:

- **Market order.** This means that you want the brokerage firm to complete your order at the current market price. If the price moves up or down between the time that you place the order, and several minutes or hours later when it actually gets completed, you get the benefit (or detriment) from a change in the price. For instance, if you call your broker with a buy order for 10 shares of Coke when the stock is $80, and the stock price moves to $78 before your broker gets the trade completed, you bought the stock at $78. However, if it moves to $82, you paid $2 more than you expected.

- **Limit order.** This means that you are only willing to buy or sell stock at a designated price. The problem with this kind of order is that the stock may move away from the price you chose, and your order may not be executed. Don't use a limit order if you need to complete a trade.

In the old days, when you bought stock you would get a stock certificate representing your shares. These were big pieces of fancy paper with pictures of railroads and mermaids on them. The problem is that they were easy to lose or steal. Today, your stock is held in a *street name*—that is, the name of your brokerage firm—and credited electronically to your account. This means you don't have to worry about storing certificates.

However, if you want the actual certificate, your broker can usually get you one for an extra fee.

I have a friend who used to give several shares of Disney or Toys R Us as birthday or Christmas gifts for children. He would always order the certificate so that the kids could actually see what they had.

Buying on the Margin

Buying on margin means borrowing money from your broker to pay for a portion of the purchase price for your stock. Most brokers will lend you up to 50 percent of the price of a stock, provided that the stock is trading at over $5 and is listed on a major exchange. The broker will charge you interest at the broker loan rate, which is usually less than the interest you would pay on a bank loan.

If you want to buy 200 shares of Screaming Lemon Motors for $10 per share, you would have to pay $2,000 plus commission. If you buy that stock on margin, you pay $1,000 plus commission and your broker lends you the remaining $1,000.

This is another example of leverage—by borrowing half of the purchase price, you are able to magnify your profit (or loss). Assume that you have $1,000 to buy stock. If you bought 100 shares of Screaming Lemon Motors for $10, and the stock traded up to $15 per share, you would make a profit of $5 on each of your 100 shares—for a total of $500. However, if you bought 200 shares on margin, and the stock traded up to $15, you would have a profit of $5 on 200 shares—or $1,000. You would have to deduct from your profit the amount of interest you had to pay the broker, but you would still be way ahead.

However, like most uses of leverage, you also increase your risk. If the stock goes down $5 and you bought it with cash, you lose $500. If you bought it on margin, you would lose $1,000, or your whole investment, and still owe interest on your margin loan.

Margin calls are another downside of buying on margin. If the value of a stock you own goes down, you may want to hold the stock until it comes back up. If you've bought the stock on margin and the value goes down a certain amount, your broker will ask you to put more money into your account to insure that you can repay your margin loan. If you can't meet this margin call, the broker will sell your stock

in order to repay your loan, and you wind up taking a loss.

Selling Short

If·you think the value of a stock is going to decrease, you could make money by selling the stock today and buying it back at a lower price tomorrow. It's buying low and selling high, but in reverse order. The way you do this is to *sell short*.

First, you borrow stock from your broker and sell it. When the stock price goes down, you *cover your short* by buying the stock and returning it to your broker to replace the stock you borrowed.

Let's assume you believe that Planet Hollywood stock is overvalued at $70 per share. If you sold 100 shares short at that price, and it traded down to $60, you would have a profit of $10 per share on your hundred shares, or $1,000. However, if the stock price increases to $75, and you decide to cover your short position, you would lose $5 per share, or $500.

The risk for shorting is greater than the risk of buying stock. When you buy a stock for $10, the most you can lose is $10. There is no limit to how high the stock can go, so your potential profit is unlimited.

When you short a stock, you are betting it will go down. If you short a stock that is trading at $10, the best thing that could happen is that the stock becomes worthless or *goes to zero*. Because it can't go any lower than zero, your potential profit is limited to the price of the stock you short—in this case $10 per share. However, if you short a stock and the price goes up, there is no limit to the amount of money you could lose.

I recommend that you save short selling for very special circumstances—or avoid it altogether.

Stock Splits

Sometimes the price of a stock goes so high that it becomes hard for people to buy a single share. For instance, the stock of Berkshire

Hathaway, a large insurance company controlled by Warren Buffet, is currently trading at about $35,000 per share. Most companies don't like their stock to trade at over $100 per share, so when they get over that number, the company will declare a *stock split*.

A stock split is just like getting two nickels for a dime. If Coke were trading at $80 and declared a 2-for-1 stock split, every shareholder of Coke would get two new shares of stock for every old share they owned, and the stock price would be cut in half. Instead of owning one share of stock worth $80, you would own two shares of stock worth $40 each. Stock splits can be 2-for-1, 3-for-1 or just about anything the company wants.

If the stock price goes too low, some companies will call for a *reverse stock split*, say 1-for-10. That means if you had 10 shares worth $.50 each, you now have one share worth $5.

I recommend staying away from companies that are about to do a reverse stock split. That usually means they have been doing poorly, and the stock price often falls after the split.

Automatic Buying with Dividend Reinvestment Plans

Some companies will allow you to elect to reinvest your dividends in that company's stock. Instead of sending you a dividend check, they use the money to buy you additional shares of stock.

The benefit is that you usually don't have to pay a commission, and it happens automatically, without having to lift a finger. You may be charged a service fee, so this may offset the commission savings. Even if you reinvest your dividend through a plan, you still have to pay tax on the dividend as if you received it.

I recommend that you use this kind of plan whenever you can. It accelerates compounding—and it keeps you in a long-term frame of mind as an investor.

Options

Options are rights to buy (or sell) stock at a certain price. A call

option gives you the right to buy a share of stock for a fixed price. You can use options as an inexpensive way to invest in a company.

Let's say that a company just came out with a line of great new computers, and you thought the stock would go up. At $55 per share, you probably couldn't buy too much stock. Options are a less expensive (and more risky) way to invest in a stock.

For about $1, you could buy a call option which would give you the right to buy a share of Dweebyte Computer for $55 for a period of three months. This price ($55) is the amount you would have to pay to exercise the option and buy the stock. This price is called the *exercise price* or the *strike price*. After three months, the option expires and becomes worthless.

If the price of Dweebyte goes over $55 before your option expires, (for example, it goes to $60), your option is *in the money*. That means if you exercise the option for $55, you would receive stock that you could then sell for $60—the option is in the money by $5. You would make a profit of $5, less the $1 you spent on the option and any commissions. The difficulty is often being able to come up with the $55 to exercise that option, particularly if you have a lot of options.

Usually, the value of the option increases right alongside the value of the stock—so you could sell the option to someone else, and make about the same profit. This is what most investors do. They're not buying options to convert. They're buying them for leverage.

If you buy one share of Dweebyte for $55 and it goes up $5, you make $5. For the same $55 investment you could buy about 55 call options. When the value of the stock increases by $5, the value of each of those options increases by about $5, and you make $4,275 (55 options times $3 each).

But stocks don't always go up just because you want them to. This is where options can be trouble. If you buy a share of stock for $55 and it goes to $54, you still have a stock worth $54. However, if you're buying options, they've probably gone down to $.50 or lower—meaning you have lost half of your investment.

The following chart compares two investors—Judy and Elroy—who each invest $100 in the same two companies. One buys stock and one buys options. One of the stocks goes up, and the other goes down. Being an optimistic type, let's look at the upside case first.

Cogswell Cogs	
Initial Stock Price	$20
Initial Option Price	$1
Option Terms—exercisable at $20 for 30 days	
Stock Price in 3 weeks	$26
Option Price in 3 weeks	$7

Judy used her $100 to buy 5 shares of stock for $20. She sold them 3 weeks later for $130 (5 times $26) and made a profit of $30, for a return of 30 percent.

Elroy used his $100 to buy 100 options of stock for $1. Three weeks later he either (i) spent $2,000 to exercise his options to buy 100 shares, and then sold his stock for $2,700, or (ii) sold the options for $700 (100 options times $7). Either way, he made a profit of $600 for a return of 600 percent of his money.

Of course, not all investors are as sharp as Judy and Elroy. In the case of Jane and George, the investment plan did not go quite as well.

Spacely Sprockets	
Initial Stock Price	$20
Initial Option Price	$1
Option Terms—exercisable at $20 for 30 days	
Stock Price in 4 weeks	$19
Option Price in 4 weeks	$0

Jane used her $100 to buy 5 shares of stock for $20. She sold them 3 weeks later for $95 (5 times $19) and lost $5, or 5 percent of her investment.

George used his $100 to buy 100 options of stock for $1. They expired worthless because the stock price was less than the strike price. He lost $100 or 100 percent of his money.

Options are another example of leverage—using less money to control the same opportunity. The option costs much less than the stock but also carries far greater inherent risk. If the stock goes up, you can make much more money per dollar invested. If it goes down, however, you can lose all the money you invested. As usual, leverage provides greater risk and greater reward.

Put Options

The option to sell a stock is referred to as a *put*. A put gives you the right to force someone else to buy a stock at a fixed price. If you think stock you own may decrease in value, a put is a form of insurance. If the stock goes up, you let the put expire. If the stock goes down, you force the put writer to buy your stock at the fixed price. Usually you will buy a put, even if you don't own a stock, if you think the stock is going to decrease in value.

For instance, assume you buy a put that allows you to force someone to buy a share of Spacely Sprockets from you at $20. If Spacely Sprockets goes to $15, you could buy it for $15 and then force the put writer to buy it from you for $20, providing you with a $5 profit. This is much safer than shorting a stock because your risk if the stock price increases is limited to the amount you paid for the put.

You can also write a put, which means that you are giving someone else the ability to force you to buy their stock at a fixed price. You could do this if you think the value of the stock is going up. If it goes up, the other party will keep his stock, and you keep the money you got when you wrote the put. If the stock goes down, you can be forced to buy their stock at a higher price. Your potential loss is the strike price of the put, because this is the price you will have to pay, even if the stock becomes worthless.

Option Information

Options are only available on a small number of some of the larger and more popular stocks. You can find out which stocks have options and the essential information about those options in several newspapers, including the *Wall Street Journal*. The options pages usually provide information in the following format.

		- Call -		- Put -	
Option/Strike	Exp.	Vol.	Last	Vol.	Last
Micsft 75	Jan	11	17 7/8	118	1/2
88 3/4 75	Apr	17	17 1/2	62	2 1/4
88 3/4 80	Jan	1475	1 1/4
88 3/4 85	Dec	813	3 7/8	253	1/8
88 3/4 85	Jan	147	7	430	2 5/8
88 3/4 85	Apr	75	11 1/8	28	4 7/8
88 3/4 90	Dec	2221	3/8	1684	1 1/2
88 3/4 90	Jan	1373	4	641	4 3/4
88 3/4 90	Apr	71	7 5/8	16	7
88 3/4 90	Jul	50	10 1/2	27	8
88 3/4 95	Dec	1758	1/16	299	6 1/2
88 3/4 95	Jan	836	2 1/4	849	7 7/8
88 3/4 95	Apr	89	6	13	10 1/4
88 3/4 100	Jan	1068	1 3/16	58	11 3/4
88 3/4 100	Apr	324	4 1/4	2	13 1/4
88 3/4 100	Jan	186	1/2
88 3/4 110	Jan	92	1/4	5	18 3/8
88 3/4 110	Apr	125	2

These are the options quotes for Microsoft. Some companies will only have one or two options being traded at a time, while large popular companies tend to have many. The stock price is at the left, 88 3/4 or $88.75. The second column is the strike or exercise price of the option. The Exp. is the month in which the options expire. Last is the closing price of those options in dollars, and the volume repre-

sents how many thousands of options were traded. The dots mean that none of those options were traded on a particular day.

Microsoft can be a volatile stock, so its options tend to be more expensive. You can judge this by looking at its premium. If you wanted to buy Microsoft, it would cost you $88.75. If you bought the April option to buy the stock at $85, you would pay 11-1/8 or $11.13. If you then exercised the option by paying $85, you would have paid a total of $96.13 (the cost of the option at $11.13 plus the $85 to exercise the option). That is a premium of $7.38 over the current price of $88.75 . Volatile stocks demand a greater premium because they are more likely to get "into the money" during the course of price swings. You can see that the higher the strike price, the lower the option price—for instance, the option to buy the stock up until April at $95 will cost you $6, but the option to buy the stock at $110 is only $2. Also, with options at the same strike price, the longer the life of the option, the more it costs. For instance, the option to buy the stock for $95 in December costs 1/16 of a dollar, or about 6 cents, but the April option for $95 costs $6.

Expiration

If you don't exercise your option or sell it before it expires, it ceases to exist and you lose your money, even if you are in the money. Therefore, you have to know when your options expire. Most options have short lives, usually no more than 4 months, and are named for the month in which they expire: the June 40's are options to purchase shares of a company at $40 that expire in June. It is important to note that the June options don't expire on the last day of the month of June, as you might expect, but rather on the fourth Friday of the month. Make sure to mark your calendar to avoid letting your options expire.

Rules for Buying Options

Keep several things in mind when buying options.

- Options are high risk, high reward investments. You should only use a very small portion of your total available investment dollars for playing options.

- When you buy a put or call, you risk losing only the money you invested. Writing options, either puts or calls, is extremely dangerous, because you can lose many times the amount of your investment. Also, when you write options, you don't control the investment decision. In general...Don't do it! An exception is writing "covered" calls—selling options on stock you already own—which reduces your upside in exchange for the money you earned selling the option.

- If you are just starting on options, you may want to consider buying a small number of options for a stock that you know well and intend to buy. In addition, it may make sense to buy options that are already trading in the money. If the stock goes up, you will be able to save a little on your purchase price. If it goes down, you will pay about $1-3 a share more than if you bought the stock in the first place.

- Longer term options cost a little more, but generally increase the likelihood that the underlying stock will have time to move the way you hope before the option expires. You may want to start out by buying less options with longer durations.

Warrants

Warrants are the same as call options in most ways. They give you the ability to buy stock for a period of time at a fixed price. There are several important differences between options and warrants.

Warrants usually have a longer life. Many warrants can last as long as five years. Most warrants are redeemable, which means that if they are in the money for a certain amount of time, the company can force you to sell them back for a very low price.

For instance, if you have a five-year warrant to buy Bedrock Slate and Gravel for $10 a share, the warrant may say that if the market price of Bedrock's stock reaches $15 and stays there for at least 30 days, and you don't exercise your warrant, Bedrock can make you sell the warrant back to them for 1 cent. They usually have to give you another 30 days to exercise your warrant.

What this all means is that you have the choice of: buying the stock for $10, which is $5 cheaper than the market value; selling the warrant in the market, which should give you a comparable profit; or selling the warrant to the company for 1 cent. Clearly, you don't want to give up your valuable opportunity for 1 cent, so you are forced to take one of the first two actions. For obvious reasons, this is called *forcing the exercise*.

Warrants are issued by the company. Options are "written" by other investors. When you exercise an option to buy IBM, you are paying another investor for that stock. When you exercise a warrant to buy Bedrock Slate & Gravel, the money you pay goes to Bedrock Slate & Gravel.

Warrants are usually issued by small speculative companies, as opposed to options which are traded on larger established companies, I don't recommend warrants as a safe investment. The reason is that there are too many incentives for people to manipulate the market.

Futures

Futures are similar to options, except that you are buying (or selling) rights—called *contracts*—to purchase certain commodities. Other futures contracts allow you to bet on movements of things like interest rates, the value of foreign currencies or the stock market as measured by certain indexes.

Commodities include grains (like corn, oats, soybeans) metals and petroleum (like silver, crude oil, gasoline) foods and fiber (like coffee, sugar, cotton) and livestock and meat (like cattle, hogs, pork bellies). These investments are bets on the direction of the price of these items because they are highly leveraged. That means that a small movement in the price can make you rich or take your entire investment.

The futures market is dominated by industry insiders who are usually hedging companies' exposures to market volatility. It's not a place for an investor who's just starting out.

An exception to this advice applies if you're the ambitious wife of the attorney general for the state of Arkansas. If your husband is destined for higher office—like governor or, eventually, President—you might be able to get some good advice from the insiders working the futures market. These insiders might even be able to...encourage...a local brokerage firm to make sure all of your investments were money makers.

If you can't call on connections like that, you probably want to stay away from commodities. In fact, you should stay away from the commodities markets because some people do have connections like that.

Bonds

Bonds, notes, treasury bills, and savings bonds are all examples of debt. Each of these investments works like a loan, with you as the lender. You loan a company or government agency your money; the company or government agency promises to give it back and to pay you interest on your money in the meantime.

Debt is typically a safer investment than stocks for a number of reasons, although it has some tricky aspects that we will talk about later. If you buy stock in a company, the stock is only likely to increase in value if the company is growing and prospering. However, even if the company is not growing and prospering, the lenders still get paid back before the stockholders. If there is not enough money to pay all of the debt, the debt holders get less than they are owed, and the stockholders get nothing.

Because debt is typically less risky than investing in stock, it also has less potential for profit. If you invest in stock, the stock can increase in value, with no real limit on how valuable it can become. Debt has limited upside—the best you can hope for is to get your money back plus the interest.

Although they are fundamentally the same, the various names applied to corporate debt are generally used to indicate the duration of a particular investment.

Bills are usually debt that will be repaid in one year or less. *Notes* are usually longer than one year, but no more than five years. The term *bond* is usually reserved for debt that will be repaid after more than five years. Keep in mind that these are not hard and fast rules, and you can have ten-year notes or four-year bonds.

There are other terms that are important to understand when looking at debt. For now, it helps to think of debt as a fancy term for an I.O.U. For reference, you can look at the following form of a bond.

Amount	Coupon
$1,000	7.1%

Microsoft Inc.

For value received, Microsoft Inc., promised to pay the holder of this certificate the face amount of this bond at maturity on December 31, 2004, and interest, payable quarterly at March 31, June 30, September 30, and December 31, at the coupon rate, until maturity. Prior to maturity, Microsoft may elect to redeem the bond at a price of 101% of face amount.

- **Issuer.** This is a person who borrows the money, and "issues" the I.O.U.—in this case, Microsoft.

- **Face Amount.** The amount borrowed: here the amount is $1,000. Most bonds are issued in multiples of $1,000.

- **Coupon or Interest Rate.** This is the amount of interest that the issuer has to pay until the loan is paid back. This is usually stated as a percentage—for instance, 7.1 percent interest per year. Interest on most bonds is paid every three months, or "quarterly."

- **Term.** This is the length of the loan. If you invest $1,000 in a 30-year bond, the issuer must repay your money at the end of 30 years.

- **Maturity.** This is the date when the I.O.U. is due—in this case, December 31, 2004.

- **Redemption.** Many issuers reserve the right to repay their bonds early. This is called "redemption."

- **Redemption Premium.** Many companies will pay you a bonus if they redeem your bonds before maturity. In this case, Microsoft has agreed to pay 101 percent, or a premium of one percent of the face amount, if they redeem the bond early.

You can either buy newly issued bonds or previously issued bonds. Both are readily available through stockbrokers. If you buy newly issued bonds and hold them to maturity, you will never have to worry about the value of your bond increasing or decreasing—you will simply collect your interest during the term of the bond and then receive your original investment back at maturity.

However, during the time that you own that bond, its value is usually increasing or decreasing. This increase or decrease in value will only affect you if you decide to sell your bonds before they mature—if the value of your bond has increased, you have made a capital gain, and must pay taxes on that gain. If the value of your bond has decreased, you have a capital loss.

Why Bond Values Increase and Decrease

"When interest rates go up, the value of bonds goes down, and when interest rates go down, the value of bonds goes up." This seems to be one of the biggest riddles in the world of investing, but it makes sense if you think it through.

Assume that in 1995, the interest rate for bonds was eight percent. At that time, you bought a 30-year bond from Spudco. You paid Spudco $1,000 for the bond and the company agreed to pay you eight percent interest—or $80—each year for thirty years. Then they would repay your $1,000.

Assume that in 1996, interest rates had gone down to six percent. Spudco was issuing more bonds, and these bonds were paying the new rate of six percent, and cost $1,000. Spudco agreed to pay $60

per year for 30 years, and at the end of that time, it would give you your $1,000 back.

If the new six percent bonds are selling for $1,000, you could reasonably expect to be able to sell your 1995 bond, which is paying eight percent interest, for more money. In fact, if you tried to sell your 1995 bond at that time, you would find that it was worth about $1,250. This is an example of interest rates going down, and the value of an old bond (which pays a better interest rate) going up.

Yield

In bonds, yield is used to compare one bond to another. As we have previously discussed, yield is the amount of your profit divided by the amount of your investment. If you buy your bond at the face amount, your yield is equal to the coupon or interest rate the bond pays. But if you buy a bond in the market, and pay more or less than the face amount of the bond, then you have to calculate the yield.

Let's assume that you bought a bond which carried a coupon of eight percent and a face amount of $1,000, and that you paid $1,200 for that bond. Because the bond has a coupon of eight percent, it pays interest of $80 per year. When you pay more than the face amount for a bond, you are buying the bond at a premium.

Because you paid $1,200, you have to calculate your yield by dividing your annual profit of $80 by your investment of $1,200, and you get an annual yield of about 6.6 percent. However, keep in mind that the bond will only pay $1,000 at maturity, or $200 less than you paid to purchase the bond. That means that you will lose $200 when the bond matures, so your yield will be a bit lower than 6.6 percent, depending on the length of the bond.

You will find the *yield to maturity* formula in many advanced financial textbooks. But you'd need to be Albert Einstein or Michael Milken to understand it. What's important—to use the example from above— is that the $200 you lose is not as important for a bond that has 25 years left as it is for a bond that matures next year.

Minimizing Increases and Decreases in Value

The only way to avoid large changes in the value of your bonds is to buy shorter term bonds. That's because shorter term bonds are not as sensitive to changes in interest rates. Here's why: If interest rates increase by one percent, that means that a one-year bond bearing the new rate will only earn about $10 more than a one-year bond bearing the old rate.

However, a 30-year bond bearing the new rate will pay $10 more for 30 years, or $300 more than a comparable bond bearing the old rate. This means that a 30-year bond bearing the old rate is significantly less attractive, and therefore its value will decline accordingly.

Because shorter term bonds react less to changes in interest rates, they are somewhat less risky. They typically pay somewhat lower interest rates. Intermediate term bonds, generally between five and ten years, typically pay a slightly greater interest. Long-term bonds, generally lasting between 10 and 30 years, typically pay even greater interest—but they fluctuate the most with changes in interest rates.

This relationship between term and interest rates is sometimes referred to as the *yield curve*.

Every once in a while, the market gets out of whack, and certain shorter term bonds are paying greater interest than longer term bonds. This is referred to as an *inverted yield curve*. It means that you have an even greater incentive to buy shorter term bonds.

Ratings and Return

Bonds are rated by several independent agencies which attempt to judge the likelihood that you will get paid back. These ratings go from AAA down. Typically, issuers with lower ratings have to pay greater interest to attract investors. Everything under B in both major ratings services are called *junk bonds*. Here's an example of the relationship between ratings and interest rates:

Moody's	S & P	Recent Interest Rate
AAA	Aaa	7.20%
AA	Aa	7.46
A	A	8.05
BBB	Baa	8.32
BB	Ba	8.96
B	B	10.30

Junk Bonds (also called *high yield bonds* when your broker is trying to sell them to you) are bonds that have a rating that is so low that many insurance companies, banks and other large institutional investors are prohibited from investing in them. Because these are more risky, they usually pay higher interest.

If you want to invest in junk bonds, make sure to spread your investments among several different issuers, to minimize the chance that any one default could seriously hurt your portfolio. Also, count your junk bond holdings as *speculative investments* when planning your investment strategy.

Zero Coupon Bonds are bonds that have no stated interest rate, and they pay no current interest. You buy the bond at a significant discount to its face amount, and when it matures, it pays you the full face amount. Although you receive no interest while you own the bonds, the interest accrues every year.

Unfortunately, although you don't receive this accrued interest, you have to pay taxes on it. Usually the value of these bonds increases over time, so you can sell them for an amount close to the original investment plus the accrued interest. Zero coupon bonds are popular as investment tools for college education expenses—although I've never been able to figure out why. There's no specific reason that they should be.

Convertible Bonds are bonds that can be converted into stock at a specific conversion price.

Assume that the stock price for Maimway Industries is $10 per share—it's fallen significantly since the last time we used this outfit as an example—and the current market interest rate is six percent. Maimway might sell a convertible bond that pays interest of five percent and can be converted into Maimway stock at the cost of $12.50 per share. A $1,000 bond could buy 80 shares of stock.

By offering this conversion feature, Maimway is able to pay an interest rate that is lower than the going rate. Investors are willing to buy the bonds, even with the lower interest rate, because they have an opportunity to make even more money if the stock price goes over the conversion price of $12.50.

My recommendation is to treat "converts" as an alternative way to buy stocks. Although you usually wind up buying the stock for a higher price (in the example we just used, $12.50 versus the actual price of $10) you receive interest on your bond prior to conversion that can offset the higher price. If you like a company and would consider buying its stock, this may be an attractive alternative way to buy the stock and earn some interest. As a debt investment, you're better off with a straight bond that pays a higher return.

Investing Strategies

Bond investors should follow several important strategies:

- **Buy Quality.** The vast majority of your portfolio should be in investments that are rated A or better, because the extra interest you can get for riskier bonds is rarely worth the headache. The exception is junk bonds, bonds which should be counted toward your speculative investment allowance.

- **Laddering or Staggering Maturities.** Because shorter term bonds are less risky, you should buy bonds with a variety of maturities between two and ten years. When interest rates seem low, you should have most of your investment in bonds that mature in under five years. Compared to investing in long-term bonds, laddering your investments into bonds with differing maturities reduces your risk—but also reduces your overall interest income.

- **Diversify.** Try not to invest too much of your portfolio in any one company or industry.

Ultimately, bonds are really a pretty boring investment, based on lots of technical analysis. Rather than wasting your time trying to learn or care about them, you will probably do just as well investing in a decent mid- or long-term bond fund.

Cash Equivalents

Savings accounts, certificates of deposit, money market accounts and money market funds are all cash investments that you can get at most banks.

A money market account is a special kind of savings account, that requires you to keep a certain balance in the account. In exchange for keeping a greater balance, you receive a higher interest rate on your account. You may also be able to access the account with your ATM and write up to three checks a month on this account. Because these are a considered deposits, they are guaranteed by the federal government for up to $100,000.

However, be careful not to confuse these accounts with money market funds, which are not insured. Some banks provide both. Money market funds are a type of mutual fund that invest in cash equivalent investments.

When you buy a certificate of deposit from a bank, you agree to leave your money with the bank for a certain period of time. In exchange for leaving your money in a CD for a longer period of time, the bank agrees to pay you a higher interest rate than you would get from a savings account. CDs usually require a minimum investment of $500, and mature in as short as one month or as long as five years. When the CD matures, you receive your initial investment plus the interest you earned.

You can buy CDs from your broker, who is usually able to shop around the country for the best interest rates. However, unlike banks which do not charge fees, your broker will probably charge you a commission.

If you need your money before the CD matures, you are able to withdraw early, but you have to pay penalties that usually take away all of the interest you have earned. Therefore, try to choose CDs that will mature before you are likely to need your money. If you don't know, then choose shorter CDs, because the interest paid by shorter CDs is nearly as good as longer ones.

Like most accounts at banks, CDs are insured by the federal government for amounts up to $100,000 that you have in any single bank, and are very low risk.

U. S. Savings Bonds are available at most banks and you can invest as little as $25. They are usually sold for half of the amount written on the bond, or its face amount.

For instance, a $100 bond costs $50. If you keep the bond for its entire 30-year term, you can receive the face amount of the bond at maturity. If you redeem the bond before its maturity, but after five years, you will get the benefit of a guaranteed minimum interest rate. If you keep the bond for less than five years, you are paid a lower rate depending on when you cash them, and depending on the market rates of other investments.

There are no sales commissions for U.S. Savings Bonds, and the interest is not subject to state or local taxes. Also, until you redeem the bonds, you don't have to pay federal tax on the interest. You may be able to avoid paying any taxes on the interest by using the bonds to pay for the costs of your children's education.

This makes more sense to me as a college investment—though it's very conservative—than the zero interest bonds we talked about earlier.

For comparison, here is a list of cash investments and some information about the interest paid on each on the day I collected this information.

Investment	Yield
Checking Interest	1.5 percent
Savings Account	2.8
Money Market Account	5.0
6-month CD	4.75
12-month CD	4.9
30-month CD	5.0
5-year CD	5.25
US Savings Bonds	
Short-term	4.75
Long-term (5 years or longer)	5.16

Mutual Funds

A mutual fund is a professionally managed investment pool that takes advantage of its size and the experience of its managers to make the best possible investments. Each mutual fund is a separate pool of investments, and is managed according to a set of goals and rules set by the mutual fund manager and overseen by the Securities and Exchange Commission. These funds may invest in stocks, bonds, and alternative investments, such as futures, options, and the like. The value of a share in the mutual fund usually goes up or down with the value of the investments owned by the fund.

Some of the advantages of investing a mutual funds include:

- **Small Minimum Investments.** Some mutual funds will allow you to invest as little as $500, or even $50 per month.

- **Ranges of Choices.** With over 5,000 mutual funds, there are bound to be several that suit your investment goals.

- **Convenience.** Unlike many investments, you need not closely monitor your mutual fund investments.

- **Liquidity.** Most mutual funds can be sold over the phone, twenty-four hours a day, giving you immediate access to your money.

- **Professional Management.** Most mutual fund managers have been investing millions or even billions of dollars for years.

Mutual funds provide a way for the small investor to diversify risk and take advantage of opportunities that are only available to larger investors. There are over 5,000 mutual funds to choose from, and choosing among them is often the hardest investment choice you will have to make.

Mutual funds come in a variety of flavors, and they each have their own appeal. Most mutual fund companies use certain key words to indicate what type of fund they have—some don't and you have to read their material to find their investment style.

Aggressive Growth or Small Company Funds

These funds tend to invest in stocks—and usually stocks of smaller companies. They tend to be the most risky of the mutual funds, but also the ones that will make you the most money. Risky means that they tend to beat other funds when the stock market performs well, but they don't fair as well in flat or down markets.

Long-term Growth Funds

These funds also invest predominantly in stocks, but tend to stick to larger companies. Their goals are to invest in stocks that will appreciate in value, and don't especially focus on stocks paying dividends. That means that they typically don't perform as well as aggressive growth funds in hot markets, but they hold their value better when markets head south.

Growth and Income Funds or Equity Income Funds

These funds invest predominantly in stocks which pay dividends, as well as some bonds, and focus on safety and current income. These

are usually more conservative than funds that focus on growth. They tend to hold more stocks than balanced funds.

Index Funds

Index funds are mutual funds that invest in a particular index, or list, of stocks. Actively managed mutual funds rely on professional money managers to choose what securities to buy, sell, and hold, and when. These managers have to get paid to do their job, and they usually are paid quite well. Because these funds are constantly buying and selling stocks, they tend to generate high amounts of trading fees, as well as capital gains that are taxable to investors in those mutual funds.

Index funds avoid all of these problems. Because they invest all of their money in a fixed list of stocks, in accordance with the size of each of the companies represented, there are no investment decisions to make. Because they hold stocks as investments and don't trade in and out of stocks, these funds generate relatively low fees—and very little capital gains. This allows your money to grow faster.

How do they stack up against actively managed funds, in terms of performance? Extremely well. In any given year, only 20 to 25 percent of managed funds are able to beat the overall performance of the stock market (in 1995, when the market was up substantially, only about 16 percent of the stock funds beat the S&P 500 Index). In down years, funds have an easier time beating the market because they take their cash out of stock and put it in bonds. Even so, the market still beats more than half of all actively managed mutual funds over time. So, for long-term investing, the index funds are odds-on favorites to beat actively managed funds.

The main reason that index funds work well is that they recognize that no one has ever consistently beaten the market, and so they just try to duplicate the market. So-called "enhanced index funds" try to beat the market—and index funds—by shifting funds between cash and stock, or by using other devices. Although they may be good mutual funds, they are not index funds and shouldn't be treated as such.

Balanced Funds

As the name implies, these funds are balanced between investments in stocks and bonds—typically a balanced fund will contain at least 25 percent stock and 25 percent bonds, with the rest in one or the other (or cash) as the manager sees fit. These are usually pretty conservative, favoring blue chip stocks and highly rated corporate bonds. As you might expect, they tend to have returns somewhere between a good bond fund and a conservative stock fund. Funds also tend to be a bit lower, as managing bonds usually costs less than managing stocks, so you get a bit of a savings there.

I don't like balanced funds because the allocation between bonds and stocks is a personal matter that should reflect your age and the length of your investment goals. However, if you don't like worrying about allocation, these could be okay for you.

High Yield Bond Funds

These are the most risky, and can be the most rewarding of the bond funds. High yield debt, also known as "junk" debt, are bonds issued by companies that do not have a credit rating. That doesn't necessarily mean that they are a bad risk, but it does mean that they have to pay a lot of interest.

Most high yield bond funds pay a high yield, and spread the risk of default by purchasing many different bonds. If you intend to buy high yield bonds, this is a safer method than buying individual bonds.

Income Funds

These are normally bond funds, that seek current income, and to a lesser degree, capital appreciation on their bond investments. They tend to invest in companies that have good bond ratings, or U.S. government securities.

As with direct investments in bonds, the shorter the maturity of their bond investments, the less risk you have when interest rates move.

These funds—like most bond funds—typically report the average maturity of their inventory.

Municipal Bond Funds

Like municipal bonds, these pay less interest than comparable corporate bond funds, but the interest is free from federal taxes. If you choose a double or triple tax free fund designed for your state, you can also avoid state and local taxes. However, because these bonds tend to invest in only one of the fifty states, you are increasing your risk.

For instance, if you live in California and invest in a California Municipal Bond Fund, you will be investing almost exclusively in bonds issued in California, and therefore avoiding California state taxes. However, if the California economy has a downturn you could be taking more of a risk than you wanted.

If you don't live in a particular state, you shouldn't be buying a bond fund that invests exclusively in that state.

Money Market Funds

A money market fund is a special type of mutual fund that invests money in a variety of cash equivalent investments. Essentially, the money market fund puts together a pool of investors to take advantage of higher interest rates offered for larger investments and longer terms. You only have modest minimum investments, often as low as $250, and you can remove your money at any time. Although you may be able to invest in a money market fund through your bank, these funds are not bank accounts and so they can not be insured by federal bank insurance.

This would seem to indicate that these funds are more risky, but they really aren't. Although many savings and loans went out of business in the 1980s and 1990s, there have been no major money market funds that have gone bankrupt or into receivership.

Some money market funds invest in only tax exempt investments, and the interest you receive is tax free. You can also get access to

money market funds through checking and ATM, although access fees can cost up to $3 to $5 per check.

Low Budget Investor Tips

Most mutual funds require minimums of at least $1,000 to $5,000 to start an account. However, don't let the cover charge stop you at the door, as there are several ways to get in on the cheap:

- **Minimum Investment.** Even if you only have $250 to $500 to open a regular mutual fund account, there are people who want your business, including:

Berger 101	800-333-1001
Strong Total Return Fund	800-368-1030
General Securities	800-331-4923

- **$50 per Month Investment Plans.** If you target putting $50 per month into a mutual fund, you can get in cheap by agreeing to put in as little as $50 per month. Some funds require you start out with $1,000, but others, like T. Rowe Price or Strong Discovery, allow you to start with $0, provided you set up direct monthly deposit from your checking or savings account:

Invesco Dynamics Fund	800-525-8085
T. Rowe Price Equity Income	800-638-5660
Strong Discovery Fund	800-368-1030

- **IRA Minimum.** Even funds that normally require thousands of dollars to open a regular account will let you in for as little as $500 if you open an IRA, because they know that you are less likely to move your money, and more likely to increase your savings:

Fidelity Funds	800-544-8888
Janus Funds (all)	800-525-8983

Beating the Wrap—Avoid Wrap Accounts

Whether they're called Portfolio Allocation Services or Strategic Asset Allocators, or any number of seemingly conservative names, wrap accounts don't give you what you pay for. Mutual fund wrap accounts allow you to put money into a single brokerage fund or mutual fund account, and then they pick several mutual funds for you. For this service, they usually charge anywhere from one to over two percent of your assets per year. That's like a car dealer charging you a fee to help you choose a car on his lot (and continuing to charge you every year that you own your car).

On top of the management fee, you have to pay sales charges, load and management fees to the mutual fund managers. Your broker generally doesn't know any more about how a mutual fund will perform than you could learn reading one article on mutual funds. If your broker is too lazy to suggest a mutual fund that will satisfy your goals and make him a modest fee—without an extra two percent per year—find another broker.

The same holds true for mutual fund companies. The chart below compares $500 invested per year at an eight percent return in the same mutual fund directly and through a wrap account that charges two percent.

	Direct Investment	Wrap Account @ 2 percent
5 Years	$2,960	$2,837
10 Years	7,283	6,615
20 Years	22,967	18,438

Mutual Fund Fees—Cut Your Costs

There are several ways that your mutual fund, or the person that sells it to you, can make money. Remember that every dollar that goes to them is a dollar less that goes to you today, and a whole lot more down the road.

I'm not saying that your broker and your mutual fund manager should not get paid for the valuable service they provide, but you have to know the ropes to see where your money is going. Keep in mind that because bond funds generally have lower returns, keeping an eye on fees becomes even more important.

Load is the fee that you pay up front to join a mutual fund, and the most obvious fee you can see. If you put $1,000 into a mutual fund with a five percent load, on day two you only have $950 in your account. It may take as much as half of year for you to be back to your original $1,000. Low load or no load funds are more attractive, as you get to keep more of your money. Also, if you tend to stay in funds for several years, you may want to choose a fund that charges a no load, but an exit fee if you leave in three years or less.

Expenses are the charges for the ongoing management of your funds, and these can be steep, as much a two or three percent per year. Because these are ongoing charges, they can be even more harmful over time than a large load. Try to choose a fund that has fees below one-and-a-half percent, or look at index funds, which tend to have expenses below one percent.

Trading Costs are the fees that your mutual fund pays to its brokers when it buys and sells stocks. Funds that tend to trade in and out of stocks have higher transaction fees, index funds that buy and hold stocks tend to have the lowest trading costs.

Minimum Account Fees and other administrative fees charged by your broker or your mutual fund can seem small, but can add up quickly. If you pay a fee of $10 on a mutual fund investment of $1,000, that's 1 percent per year.

No Fee Supermarkets like Charles Schwab that sell you a number of funds without load or transaction fees tend to be heavy in mutual funds that have high fees, so make sure to look before you leap.

Terms of the Mutual Fund World

Net Asset Value or NAV is the market value of a single share of a mutual fund. This is calculated by taking the value of all of the mutual fund stocks, bonds and other investments, and dividing that value by the total number of shares outstanding in the mutual fund. If a mutual fund has investments worth $10 million and the fund has 1 million shares outstanding, the NAV is $10.

Annual Operating Expense Ratio is the amount that the mutual fund managers and employees get paid and the 12b-1 fees, which is the cost to advertise and distribute the funds. Keep in mind that the 12b-1 fees include fees paid to your broker.

Total Return is how well the fund performs based on increases in the Net Asset Value and income that the fund pays, or "yield." This also deducts expenses and assumes that any dividends and distributions were reinvested in the fund, so that funds that purposely pay out high income aren't at a disadvantage.

Expense Waivers are the mutual fund equivalent of a head start. If the fund doesn't perform as well as they would have liked, they waive some of their fees to improve their results.

For instance, a recent advertisement for one popular fund that said that it was in the Top Ten for performance measured over one year, five years and since it had started. The managers claimed to have made returns of about 24 percent for one year, 15 percent for 5 years and 13 percent since they started operating.

But, if you looked at the fine print, you saw that the fund only made 21 percent, 11 percent and 10 percent without waiving expenses. (And the current managers had only managed the fund for one year, after they bought it from some other company.)

Make sure to read the fine print.

Tax Issues on Mutual Funds

When a mutual fund receives a dividend from one of the stocks it holds, or if it sells a stock and makes money, you have to pay the taxes. At the end of the year, you will receive a statement from your mutual fund indicating your portion of the fund's profits from dividends and from capital gains. You have to pay taxes on that amount.

Because they buy stocks and hold them, index funds tend to have lower profits from capital gains. However, they will have a certain number of stocks that pay dividends. Other types of mutual funds, such as growth funds, tend to buy and sell stocks more frequently.

These high turnover type funds tend to have more capital gains, due to their constant buying and selling. However, they tend to invest in stocks that do not pay high dividends.

Some ratings provide information on the tax efficiency of mutual funds. Although this should be a factor in your decision, overall performance is still the most important measure of any mutual fund.

Chapter Twenty-three

Choosing a Broker

Introduction

Now that we've survived the review of all the investments you can make, it helps to understand where you can go to invest your money. The rule of thumb when you're making this kind of decision: Take your time. Financial decisions made in haste are usually repented—and repaid—slowly.

It seems like an inescapable fact of life that once you get to the point that you've saved a little bit of money, salespeople, wacky promoters and friends with big ideas start coming out of the woodwork. Resist the temptation—however strong—to get excited about investments. A good investor doesn't respect an urgent buck or short-term profit—only a greedhead thinks like that.

A good investor respects reliable compounding interest and financial security—in close order.

Old Aesop might not have had a 401(k) but he knew the right lesson: Slow and steady wins the financial planning race.

Banks

Banks usually offer a wide variety of investments, most of which resemble savings accounts. These include:

- Savings Accounts
- Certificates of Deposit
- Christmas or Holiday Accounts
- Money Market Mutual Accounts
- Tax-Free Money Market Accounts

Most banks offer similar interest rates, but you should call around to get the best rates and terms available. Some banks will also provide you with the full services of a brokerage firm, although this is less common.

Brokerage Firms

There are two types of brokerage firms: full service and discount. They both sell a full range of investments including:

- Stocks and Options
- Corporate Bonds, Municipal Bonds and Treasury Bonds
- Futures
- Mutual Funds of all types
- Money Market Mutual Funds

They can also set up IRAs, Keogh Plans and SEPs, which are discussed below.

Full-Service Brokerage Firms

Full-service brokerage firms sell investments and provide investment advice, and have two important features: stockbrokers and research departments. The following is a list of some of the larger brokerage firms, although there are numerous other quality brokerage firms:

- Merrill Lynch

- Paine Webber

- Shearson

- Prudential Securites

- Alex. Brown

- Smith Barney

Stockbrokers

At every full service broker, you will deal with your own stockbroker, sometimes called an account executive or a financial adviser. Your broker needs only minimal financial training to do what he or she does, but many firms provide additional extensive training and support. It is extremely difficult to tell a good broker from one with little or no training.

The best way to find a good broker is the same way you find any other professional or service-provider—by asking your friends, family and acquaintances for recommendations. Even then, you have to judge your broker for yourself. Provided that you are armed with the information contained in this book, or other financial guides, you should be able to protect yourself and judge whether your broker is doing a good job for you.

If your broker isn't making you happy, simply ask to be moved to another broker at the company—or move your account to another firm. Keep in mind that most brokers are paid on commission, based on the investments that you buy. For this reason, they often have conflicted interests—yours and their own.

A good broker will understand that his or her career is best served by keeping lots of happy clients. One who's not that good—or who fell into the business because nothing better materialized—may be more interested in selling you the Gangrene Pharmaceuticals warrants his brokerage is trying to get rid of.

If you have any doubts, remember the old European saying: The servant of two masters satisfies neither.

Rating Your Broker

It would be nice if your broker was making you thousands of dollars every week with his amazing stock picks. You have a better chance of getting good advice on your love life from the Psychic Friends Network. A good broker will help you make sense of the endless variety of potential investments and protect you from making big mistakes. If your broker also comes up with some good stock picks every once in a while, that's a plus. The checklist below will help you evaluate whether your broker is any good or not.

Things your broker should do:

- Speak with you initially and periodically to discuss your financial goals;
- Ask you what you know about investing, to establish what investments you understand and feel comfortable with;
- Ask if you have funds invested in other places, and what your other investments are, in order to give you advice based on all of your assets and investments;
- Help you invest money predominantly in low and moderate risk investments;
- Help you learn about other investment opportunities;
- Talk with you about investment strategies that will help you minimize taxes;
- Make sure that you spread your risk over several investments, or put your money into mutual funds that will spread your risk for you;

- Encourage you to invest in your employer's 401(k) plan, if available;

- Explain what fees you will have to pay.

Things your broker should not do:

- Recommend that more than 10 percent of your money go into high risk investments, such as options, futures, speculative stocks, and stocks under $5, and initial public offerings of stock;

- Recommend limited partnerships of any kind;

- Put you in investments based predominantly on the fees you will pay;

- Change investments frequently, also called "churning" your account (so they can generate more fees from your account);

- Advise you to invest in mutual funds that pay large commissions and fees.

Research

Full service brokerage firms have a group of people that provide research on specific industries and companies. They write research reports telling you what companies to invest in, and which ones to avoid. Although these reports can be useful, keep in mind that many brokerage firms also provide services to some of the companies that they write about, and receive millions of dollars of annual fees. The brokerage firm may be writing a positive report in order to curry favor with their corporate clients. Also, the quality of research varies widely from one firm to the next, and even among the individual research analysts at each firm.

If your broker provides you with a research report recommending a certain stock or bond, read the report and see if it makes sense. Then ask your broker to give you the performance record of other stocks covered by the same analyst. Also, ask your broker if his or her brokerage firm has recently completed a transaction for the company

they are recommending. If so, the report may be "pay back" and is probably suspect. If all of these things check out, you are probably safe making a small investment to see how it works. Never jump in with both feet.

Warning: Keep in mind that even the experts don't know for certain what's going to happen in the market. The *Wall Street Journal*, one of the most important publications covering the world of investments, runs a regular column testing the talents of a group of professional investment advisers. The investors choose their best stock picks, and they compete against a group of investments chosen at random by throwing darts into a dart board. The darts often beat the pros.

Discount Brokerage Firms

Discount brokerage firms do not have research departments and their brokers do not give advice. They exist solely to sell investments to people who know what they want to buy. The attractive thing about discount brokerage firms is that their transaction fees tend to be much lower than those of full service brokerage firms, and many have low or no set-up fees and maintenance fees. They sell the same investments that you can buy elsewhere. Many offer good service, on-line trading and programs for tracking your investments.

Deep discount brokerage firms offer even lower commissions, but may not offer the same level of customer service, such as 24-hour service, and on-line trading and stock quote capabilities. Also, you can set up your IRA at a discount broker, even if it's small, for minimal or no annual fees. I usually avoid these super-cheap brokers—their service sometimes isn't up to snuff.

If you plan to invest primarily in mutual funds, or are looking for a place to set up your IRA that can provide a wide variety of investment options with minimal fees, discount brokerage firms are a safe and inexpensive option.

Discount brokerage firms include:

- Quick & Reilly

- Charles Schwab
- Kennedy, Cabot

Transaction Fees			
Brokerage Firm	Number of Shares/Price		
	100/$10	500/$15	1000/$14
Full Service			
Merrill Lynch	$50	$205	$308
Smith Barney	50	212	350
Discount			
Charles Schwab	47	101	124
Fidelity	47	101	123
Quick & Reilly	38	78	94
Deep Discount			
Kennedy, Cabot	33	33	33

Mutual Fund Companies

Mutual funds are essentially pools of money that are gathered from numerous small investors and managed for the investors by professional money managers—they are described in detail below. Many mutual fund companies have several funds which an investor can choose. They can also provide some or most of the services that brokerage firms and banks can provide, including setting up retirement accounts like IRAs and SEPs.

I recommend a brokerage firm, which will usually provide you with all the benefits of a mutual fund company, and a wider selection of investments. However, you may be able to save fees through a mutual fund company.

Cold Callers

If you get a phone call from someone that wants to sell you an invest-
ment, you may be dealing with a broker at a legitimate firm that is
trying to expand its customer list. You may also be dealing with phone
fraud. If the caller is trying to get you to invest in a specific invest-
ment—such as a new and upcoming company or ownership of cable
television or wireless phone licenses—you are almost certainly deal-
ing with trouble.

You have to ask yourself, if this investment is so good, why are they
offering it to you—a perfect stranger chosen at random from a phone
list, rather than selling it to their friends and loved ones?

If the person on the other end of the line is inviting you to come to a
seminar on investing, you may be dealing with a real firm. Ask the
caller to send you a package of information on the firm. If this arrives
and seems legitimate, you might want to give the seminar a chance.

A warning: Don't make any final investment decision at a seminar.
In fact, don't even take a checkbook or financial documents. Most
investment meetings—even the legitimate ones—are designed for
maximum pressure.

In truth, I've never heard of an investment—no matter how hot—
that couldn't wait twenty-four hours while you think it over in the
quiet of your own home.

Always make sure that any investment a cold-caller offers makes sense
within the guidelines of safe investing. It is difficult to distinguish a
good brokerage firm from a fraud—so, if you have any doubts, tell
them that you don't have any money. They probably won't call again.

Infomercials

Don't ever buy an investment from a television advertisement or com-
mercial. Good investments attract plenty of knowledgeable inves-
tors; bad investments are flogged on late night television hoping to
find uninformed investors with money to burn.

I recently saw an advertisement for heating oil futures on television. The ad said that a $10,000 investment would control 420,000 gallons of heating oil. If the price of heating oil increased by only $0.10, your investment would increase by $42,000. It went on to say that with winter approaching, the cost of heating oil was likely to increase. This pitch was full of problems.

First, the price of heating oil contracts goes up and down every day with almost no relation to the time of year, severity of a particular winter or the cost of heating oil from your local heating oil distributor. More importantly, the commercial didn't say that if the price of heating oil went down by over $0.02, you would lose your entire investment. This is a classic example of leverage.

As I've mentioned elsewhere, leverage dramatically increases both the risks and the rewards in an investment.

The odds of making money on this kind of investment are low and the chances of losing all of your money are very high. Otherwise, every smart investor would be investing in heating oil futures, or silver futures, or wireless cable television, or anything else advertised on television. They aren't, and neither should you.

You've done a lot to put together some money. Don't waste your efforts.

Chapter Twenty-four

The End-Game Approach to Retirement Planning

Introduction

The essence of how retirement investment accounts work is described here because you don't have to be planning your retirement to make use of the tax advantages of these plans.

The following are types of retirement accounts.

Pension Plans

Also known as a "defined benefit plan," this is the old style retirement savings plan that few companies still provide. Exceptions are the Armed Services, which still have pension plans, and certain other government plans. Essentially, your employer agrees to provide you with a pension based on a formula. For instance, you might be entitled to receive 2 percent of your salary for each year you work at the company, payable monthly after you retire. Work for 20 years and you retire with 40 percent pay. This money is not taxed as the company puts it away for you, and they are responsible for saving, invest-

ing and distributing the money. These plans are a dream come true, as long as the company doesn't go bankrupt before they put your money aside. Unfortunately, they are also very expensive to fund and manage, and have been replaced by 401(k) plans by most employers.

401(k) Plans and 403(b) Plans

A 401(k) plan is a retirement savings account that is set up by your employer. Just in case you're curious, its name comes from the tax law that makes it work. If your employer has a 401(k) plan, this is one of the single best ways to save money. You can contribute money to the plan through direct deduction from your paycheck before you have to pay federal or state taxes on it. The money can then be invested in one or more investments permitted by your employer's plan.

Keogh Plans and SEPs are similar to 401(k) plans, but are designed for people who are self-employed. 403(b) plans are similar in many ways to 401(k) plans, but are offered by non-profit organizations such as schools and hospitals. There are some differences: one benefit is that 403(b) plans let you "catch up" by contributing extra money in later years if you didn't save the maximum amount when you were younger.

Tax Benefits

The money that contributes to your 401(k) is pre-tax money. You don't have to pay taxes on that money, or any earnings in your 401(k), until you remove the money from the account. In effect, the government is actually helping you save money. Assume that you make $2,000 a month, you probably pay taxes and other deductions of about $800, leaving you with take home pay of about $1,200. If you elect to put 3 percent of your earnings in your 401(k), your employer will deduct $60 (3 percent of $2,000) from your paycheck and deposit this amount into your 401(k) account. Because you don't have to pay taxes on that $60, you are reducing your take home pay by about $40, and you are also reducing your taxes by about $20. That means that after a year, you are giving up about $480 of take home pay, and the government is kicking in about $240 by reducing your taxes, for a total of $720. For 1996, you can contribute up to $9,500 of pre-tax money into your 401(k).

Employer Matching Contributions

Many employers will also match some of your 401(k) contribution. They may agree to put in anywhere from 10 percent to 50 percent or more of the amount that you contribute, and you don't have to pay taxes on that money until you take it out of your account. Most employers require that you continue to work for them for a period of years in order to have the money they contribute "vest," or become yours. If you leave your job for any reason before the contribution to your plan has completely vested, some or all of those funds are returned to your employer.

Investments

Although 401(k) funds can be invested in almost any type of investment, most plans provide you with a small list of mutual funds to choose from. You should choose your investments using the same criteria for choosing any investment that is provided in this chapter with two bits of advice:

- Never use 401(k) funds to buy tax-free investments, such as municipal bonds (exempt from federal and sometimes state and local taxes)—because you don't pay current taxes on your 401(k) earnings, you don't need the tax advantage of these investments, and are better using investments that will provide you with higher returns.

- If all of the investment selections for your 401(k) plan are mutual funds with high fees, encourage your employer to change the plan to include no-load or low-load mutual funds.

Borrowing from the Plan

Many plans allow you to borrow money from your 401(k) plan. Essentially, you are borrowing money from yourself, and that interest that you pay into the plan is just like any other earnings of the plan—it's tax-free. Check with your employer to find out whether your plan permits loans, and if there are any limitations. This is a great alternative to early withdrawal, as you don't have to pay penalties, and you still have the ability to use your savings. If your plan does not allow

borrowing, ask your human resources or benefits department to change your plan.

After-Tax Contributions

You can contribute after-tax earnings to a 401(k) plan, and earnings on these contributions are not taxed until you withdraw funds from the account. However, unless you are getting the main benefit of your 401(k), namely the ability to contribute pre-tax funds, I recommend using other investments that will provide you with greater flexibility and access to your money.

Financial Aid

Financial aid for college education is available based partly on the assets of the parents. Under current guidelines, money saved in a retirement plan is not considered an "asset" for purposes of calculating eligibility for financial aid. Therefore, saving in a retirement plan can provide you with an added benefit when applying for financial aid. Further, you can borrow money, if your plan permits, or withdraw money from the plan as necessary, to help foot the bill for college.

Tax Deferral

The taxes on your contributions to your 401(k) and taxes on the money earned on investments in your 401(k) are "deferred." That means that you don't pay taxes on the money when you earn it, but you do pay taxes eventually. In this case, you must pay taxes on the money when you take it out of your 401(k), usually when you retire, or under certain other permitted circumstances.

If your annual withdrawals from your 401(k) plan are less than your current earnings, you will—hopefully—pay taxes on those withdrawals at a lower rate. However, the benefit of deferring your taxes, and being able to invest them, for a long period of time is still a significant advantage over your alternatives.

Penalty for Early Withdrawal

Your 401(k) plan is a type of retirement plan, and so you are not supposed to start taking out money until you are 59 1/2 years old, or if you retire due to a permanent disability. Otherwise, not only do you have to pay taxes at your current tax rate, but you have to pay a penalty of 10 percent. Expect your plan administrator to withhold 20 percent of your distribution for taxes.

There are several "hardship" exceptions to this rule including: medical emergencies, college tuition and buying a home (but not a vacation home). In order to remove your money, you have to be able to prove that you need the money, and that it is being used for one of these reasons. Therefore, a 401(k) plan is more appropriate for long-term investing, and you should not plan on being able to access your money early unless you are buying a home, and can offset some of your tax liability with deductions, or you take a loan from your account.

Comparison of 401(k) to Municipal Bonds

The following chart compares the benefits of a 401(k) investment versus an investment in tax-free municipal bonds. The 401(k) is invested in high quality corporate bonds earning 7.2 percent, and the alternative is invested in high quality municipal bonds at 5.5 percent. (These were the going interest rates on long-term bonds on the day I looked.)

Keep in mind that you have to pay taxes when you withdraw money from your 401(k), but you can borrow money from the plan without paying taxes, as long as your employer includes this option in your plan. I have assumed that tax rates would be the same in the future, which is impossible to predict. The advantage of a 401(k) over investments other than municipal bonds is more difficult to calculate, but is generally even greater.

	401(k) Plan		Muni Bonds
Pre-Tax Earnings	$5,000		$5,000
Taxes	0		2,000
Initial Investment	5,000		3,000
	Pre-Tax	Post-Tax	
10-Year	$10,742	$6,445	5,406
20-Year	20,095	12,051	8,753
30-Year	40,255	24,153	14,952

Moving Your 401(k) Plan

If you leave your job, don't forget your 401(k). You want to make sure to consider what you should do with that little pile of money. You really have four choices: Leave the money where it is, move it to the 401(k) at your new job, put it in "storage" in an IRA account or take the cash. Each of these has its merits.

Leaving the Money

As long as you have accumulated $3,500, your old employer has to allow you to keep your money in your old 401(k) until you retire or reach 62. Although you can't put any more money into that 401(k), your money continues to grow without paying taxes. However, you may be able to get better investment options by moving your money to your new employer's plan, or to an IRA. Also, if your old employer is someone you would rather not ever think about for the rest of your life, you may just want to make a clean break by moving your money elsewhere.

Moving to Your New Employer

Most new employers will allow you to move your money from your old plan into their 401(k) immediately. If they do, the best way to move the money is through a direct transfer. Ask the 401(k) person

at your new company to help you with the paperwork, and you should be able to move the money without a hitch. Keep in mind that even if your new employer matches funds you put into your 401(k), money from your old employer is not likely to qualify for matching.

Storing Funds in an IRA

If your new employer's plan won't take your money, or won't take it right away, or if you don't have a new employer, you can always move your money to an IRA for a short time—or indefinitely. Make sure you move this money into a new IRA that is set up for this purpose, and avoid mixing it into an existing IRA. That way you can move the money into a new 401(k), or into a SEP or Keogh if you are self-employed, without any difficulty.

If you mix your old 401(k) with IRA funds, the funds can't be separated. This means you give up any benefits that 401(k) and other retirement funds have over IRAs. You can set this IRA up at most banks, brokerage firms and many mutual funds, and they are usually willing to help you transfer your money into your new accounts.

If You're Moving, Don't Take a Check

If you're moving your money to a new home, whether it's a new 401(k) or an IRA, avoid taking the money from your old 401(k) by taking a check from your old employer. Because that is considered a withdrawal, your old employer will withhold 20 percent of the amount in your account, and pay it to the IRS. In order to avoid paying taxes, you have to put all of the money into your new 401(k) within 60 days from the day you got the check, including the 20 percent withholding. If you don't put the entire amount back into a retirement account, you have to pay taxes on the shortfall at your regular tax rate, plus you have to pay a ten percent penalty.

So if you have $2,000 in your 401(k) and you ask your old employer for a check, you'll only get $1,600 (which is $2,000 less 20 percent withholding, or $400). Then you have to come up with $400 out of your pocket to put in your new plan, and you have to do it within 60 days. Even if you can scrape up the $400, you'll have to wait until

your next tax refund to get the $400 withholding back from the IRS. If you only put the $1,600 into your new plan, you have to pay taxes on $400, plus pay an additional 10 percent penalty ($40) for early withdrawal of retirement money.

The best person to help you with a direct transfer is the administrator of your new employer's 401(k) plan, or the person at your bank or brokerage firm where you set up an IRA to receive money from your old plan.

If you want or need to take the money out of your 401(k), simply ask your employer for a check. It's your money, and the rules say that if you leave your job, you can take that money, whether or not you're retiring. Keep in mind that your old employer will withhold 20 percent of the amount you take out, which goes toward taxes you have to pay. You will pay taxes at your marginal tax rate for the full amount, and unless you are 59 1/2 years or older, you will have to pay a penalty of 10 percent of the amount of the distribution (including the 20 percent withholding). You can avoid taxes and penalty on a portion of the amount by putting it into an IRA or new retirement plan within 60 days of the distribution.

Paying Off Your Loans

One potential problem with taking a loan from your 401(k) is switching jobs. If you quit or get fired, most 401(k) loans must be paid back. If you don't have enough money to pay the loan back, it is considered to be a distribution. That means you will have to pay taxes at your marginal tax rate on the amount of the loan which you can't pay, and unless you're over 59 1/2, a penalty equal to 10 percent.

As you can see, the real advantage of a 401(k) is as a long-term investment. The benefits are difficult to beat with almost any alternatives, and the ability to contribute pre-tax funds can really supercharge your retirement savings. These benefits make up for the restrictions otherwise placed on your investment. However, unless you can borrow from your 401(k), it is not currently an attractive way to save for goals of less than five years.

IRAs vs. 401(k)s

Individual retirement accounts are very similar to 401(k) plans, as they provide tax benefits for long-term investments, but on a much smaller basis. You can set up your IRA account at most banks, brokerage firms or mutual fund companies.

An IRA is not as attractive as a 401(k) in the amount of money that you can contribute, because you can't put in as much money. However, an IRA is still a wonderful way to put up to $2,000 in a tax free savings account, and slash your taxes by about $600 to $800. Also, although you have to actually earn the money you put into an IRA, a non-working spouse can put $250 into an IRA and still generate a tax deduction. That means you can shelter up to $2,250 per year in your IRA.

No matter how much you make, you can put $2,000 into an IRA if you don't have access to another retirement account, such as a 410(k), SEP or Keogh or other pension plan. If you don't know if you are covered by a retirement plan, look at your W-2—your employer is supposed to check your box if you are covered. Even if you or your spouse have another retirement plan, you can put up to $2,000 of pre-tax earnings into an IRA every year, if you make less than $25,000, if single, or $40,000, if married. If you make up to $35,000, if single, or $50,000, if married, you can still make a pre-tax IRA contribution, but only a portion is tax deductible.

This limitation may be important when you are deciding whether to join your employer's 401(k) plan. If you join the plan at the end of the year and put in as little as $1, you can be prevented from taking advantage of your IRA. Therefore, if it makes less than the IRA limits, or you (and your spouse) don't have other retirement plans, delay joining your 401(k) in the last quarter of the year, and contribute the full amount to your IRA. Then join your 401(k) in the new year to take advantage of its superior benefits.

Also, you can always put unlimited after-tax earnings into an IRA; future earnings on these amounts is tax deferred. However, unless you are getting the benefit of being able to contribute pre-tax money,

the restrictions on your access to funds in your IRA do not justify the tax deferral.

Timing of Investment

Unlike a 401(k), which takes money out of your paycheck during the year, you can put money into an IRA at any time during the year, as many times as you want, and even until April 15 of the following year, and still get the tax savings. This allows you the time to figure out your taxes and decide whether an IRA would save you money. For instance, let's say that you make $25,000 in one year and, on April 14 of the next year, you figure your total taxes for the prior year are $10,000 and your withholding was exactly correct, so you don't owe any additional state or federal taxes. If you can put $2,000 in your IRA, you can apply for a refund of taxes of about $600 to $800. That means the government is helping you to save money. Even if you can only put in $1,000, you can still get back $300 to $400.

If you want to get tricky, you can even claim a deduction before you put the money into the IRA. Let's say you file your taxes in February. You can claim an IRA deduction even if you haven't put the money into an IRA. Then you can use the money from your tax return to fund your IRA. As long as you put the money in your IRA by April 15, you are entitled to the deduction.

What to Do with IRA Investments

IRA funds can be invested in almost any type of investment, but you may have limitations depending on where you set up your IRA. For instance, setting up your IRA at a bank or mutual fund may make it more difficult to make or change investments. A brokerage firm, which is better able to access in a wider variety of investments, can usually provide better service. You should choose your investments using the same basic rules for choosing any investment, except that you should avoid tax-free investments, such as municipal bonds (exempt from federal and sometimes state and local taxes). Tax exempt investments usually pay a lower return, but make up for this lower return with tax advantages. Because your IRA provides those tax advantages for al-

most any investment, you are better selecting an investment that will provide you with higher returns.

Combining Accounts

You can combine your IRA accounts, and move them from one bank or brokerage firm to another.

Just like 401(k) plans, when you withdraw money from your IRA, you have to pay taxes on it. Also, you can't take money out of your IRA until you are 59 1/2 without paying an additional 10 percent penalty tax.

SEPs and Keoghs

Simplified Employee Pension Plans (SEPs) are essentially super-IRAs that allow self employed workers to contribute up to 13 percent of their income—but no more than $30,000—on a pre-tax basis. If you work for an employer that has a 401(k) and contribute to the 401(k), but also have a business of your own, you can still have a SEP. Your SEP contributions are limited to a portion of the earnings on your business. You can contribute to your SEP until April 15 of the following year, or even later if you get extensions for filing your tax return. Rules on withdrawals are nearly identical to IRAs.

Keogh Plans are a cross between 401(k) plans and SEPs, but require a whole lot more paperwork and hassle than SEPs. The benefit is that you can put away up to 20 percent of your self-employment earnings, with a cap of $30,000 (or possibly more in some cases).

If you have your own business and can afford to save $30,000 a year, you should consider hiring an expert to help you set up your Keogh Plan, because I can't help you within the covers of this book. These things take some work to get started.

Annuities

Annuities are an interesting combination of insurance and investment that offer limited tax advantages. Essentially, you agree to pay

a certain amount of money into an insurance company, either in a lump sue or in several payments. After that period of time, they agree to pay you a series of payments. The earnings on the annuity are not taxed until you receive your distributions.

Like other retirement alternatives, you pay a penalty of 10 percent on just the earnings of the annuity, if you withdraw earnings before you reach the age of 59 and 1/2.

With a fixed annuity, you have no choice of investments but you are guaranteed a certain return on your investment. Also, the fixed rate is usually only fixed for the initial period of the annuity and may be reset thereafter. In a variable annuity, you typically have limited investment choices.

Summary

For savings goals of over five years, a 401(k) and then a SEP—if either or both are available—are superior to an IRA. Even for shorter term investments, consider a 401(k), particularly if its allows you to borrow money from the plan. Consider an annuity carefully, as it does not have the same tax benefits as the alternative, but comes with many of the limitations, and usually high fees.

Retirement Plan Options Chart

Type of Investment	IRA	401(k)	SEP	Annuity
Annual Contribution Limit	$2,000, but limit to total income if you have a 401(k) or SEP	15% or $9,500	13% of self-employ-ment income or [$12,500]	Unlimited
Contributions	Pre-tax to limit, and unlimited after tax	Pre-tax to limit, and unlimited after tax	Pre-tax to limit, and unlimited after tax	No pre-tax and unlimited after-tax
Investments	Most securities allowed	Limited by scope of investments offered by employer	Most securities allowed	Fixed interest rate, or variable interest rate with limited investment choices
Other pluses or minuses		Pluses: Matching employer contributions; borrowing allowed by some emplo-yer plans		Minuses: Higher fees and less tax benefits than other options; fixed interest rates only last during an initial period
Contributions	Any time during year, and up to April 15 of following year	During year, deducted from paycheck	Any time during year, and if plan is established, up to filing date (with extensions) for taxes	Not applicable, because contributions are not tax deductible
Count as assets for college financial aid	no	no	no	no

Part Seven:

Plans for When You're Gone

Chapter Twenty-five

Wills—The Plain Pine Box of Estate Planning

Introduction

For most people under forty, suggesting that they might need a will is enough to give them the creeps. They typically say "I haven't gotten around to it," or "I don't need one quite yet." It's a fair guess that what they're actually thinking is: "Wills scare me."

With sentiments like these, people lose sight of the fact that the actual word—will—means exactly what it says: a way to extend your will, your intent, and your decisions about financial matters far into the future of your family—for their benefit.

So, rather than being something to avoid, a will is simply another financial planning tool and an essential one, at that. It's also a useful decision-making device. The process of making a will essentially forces you to see to it that this paper becomes a precise legal document that no one can argue with, dispute, or change.

No one but you, that is.

But, let's say that you just can't get comfortable with the idea. How bad could it be if you get on with your life with just good financial planning, but no will? This bad: If you fail to make your decisions known and die without a will, legally you will have died intestate.

The state where you lived before your death will make most of those important decisions for you as it (and not your heirs) becomes legally responsible for who gets your property, who your estate is to be distributed to, and who shall serve as guardian of any minor children or dependents that you may have. The state's "decisions" most likely won't agree with what you thought should be done and many inequities could be the result; however, since you were so careless as to die intestate, your heirs will be helpless in the face of the law.

A will not only gives you decision-making control over who gets what but also gives you control over how and when they will receive it. It will conserve and distribute your estate according to your wishes, name guardians for your minor children, and avoid the terrible, wrenching disputes that sometimes occur when both sets of elderly grandparents compete for the privilege of guardianship. Again this painful and chaotic situation would certainly not have been your choice.

Most likely, your actual wish would have been the appointment of a much younger guardian—one assured of living long enough to see your children through college, sparing them the upheaval of another turnaround in their lives, should the grandparent-guardians become disabled or die.

Convinced? Well, then, the good news is that if you've been following the advice already covered in this book, a great deal of the estate planning you need to prepare a will is completed. As an example, you:

- have your papers and records in order,
- recognize what your assets are and who owns what,
- know how much life insurance you have and/or need,
- know about your pension and social security benefits,

- know about all of your other company benefits,

- can track your investments, and

- know the value of any collectibles or family heirlooms you may own.

There are two basic ways to write a will: either with an attorney, or by yourself using a willkit (written forms and software programs are both available). Either way, you'll need this information and more to prepare your will, or have someone prepare it for you. But first, there are some related issues that you should know about.

Living Wills

A living will is really not a will in the classic sense. It is a set of instructions that you provide in the event that you are seriously injured naming the specific life support measures which you would permit.

You will also need a *healthcare power of attorney*. A power of attorney is a legal document that you can use to give someone else the power to sign documents on your behalf. It can be unlimited or limited to one or more special purposes. A healthcare power of attorney typically gives someone the power to make medical decisions on your behalf. Combined with a living will, this allows you to direct what you want to be done and gives a friend or family member the legal power to enforce your wishes with your hospital and doctor.

Probate

Probate is the legal process that oversees the working of your will. They check to see that your will is valid, and then oversee the repayment of your debts and the distribution of your assets. In order to protect your estate, probate is usually a long tedious process. Just like anything that is long, tedious and requires attorneys, probate can be very expensive.

Depending on your estate—and the complexity of your will—you can expect to pay between two percent and ten percent of your es-

tate in probate costs, attorney's fees and executor's fees. Also, it can take weeks or months to get through probate.

There are several ways to reduce or avoid the problems of probate.

You can minimize your costs of probate. Most states automatically provide fees for your executors, in some states these are as high as ten percent of your assets. Most executors will agree to waive the fee, or take a fixed fee. Your next biggest cost is usually your estate attorney. Use someone you trust, and negotiate a reasonable fee.

Finally, use a good attorney, preferably one that knows the ropes in your local probate court. Nothing can speed you through the process like a professional, and a well written will.

Beyond the Will—Assets That Your Will Doesn't Control

Property that passes under the terms of your will is called "probate property," referring to the probate process that executes the terms of your will. There are a number of assets that are not controlled by the terms of your will, but pass by the operation of law or contract. Unfortunately, your estate is still subject to taxes on almost all of these assets. Some of the most common are:

- **Life Insurance.** Proceeds from your life insurance policy go directly to the beneficiary named on the policy, without passing through your will. The person who receives the proceeds does not have to pay taxes on the proceeds. However, if you own and control the life insurance policy (having the ability to borrow on the policy or change the beneficiary is considered "control"), the proceeds of the policy are part of your estate and subject to federal estate taxes. Keep in mind that because of the unlimited marriage deduction (which we will discuss below), payments to your spouse will incur no liabilities. However, for payments to your kids or others, you will want to (i) have someone other than you buy and own the policy on your life, or (ii) irrevocably transfer the policy at least three years before you die. You can do that through a life insurance trust described in detail below. Keep in mind

that after that transfer, you can't change the beneficiary or borrow money from your policy.

- **Retirement Plans**. Proceeds from retirement plans, such as SEPs, IRAs, 401(k) plans, pension and profit-sharing plans and the like also pass to named beneficiaries. However, like insurance proceeds, these assets are subject to federal estate taxes, and federal income taxes—although you get a deduction for estate taxes paid. There's also an additional 15 percent tax if you have an huge amount of money in your plan. Currently, that limit is over $750,000.

- **Joint with Right of Survivorship**. Items owned by you and someone else, such as houses, bank accounts and brokerage accounts, can be held in joint tenancy with right of survivorship or JTWROS accounts. This means that if one of you dies, the other person has legal rights to the assets. If your spouse is the surviving person, usually half of the value of the asset is taxed in your estate. If it's someone else, such as your child, the IRS will look to who actually paid for the assets to decide who will pay the taxes. That means that owning something in a JTWROS with your children is not typically a successful way to avoid taxes.

- **Living Trust**. A living trust—also called a revocable trust—is a type of trust that allows you to control your assets during your lifetime, but pass them on to your beneficiaries without having to go through probate. The benefits are privacy—probate makes your will part of a public record—and potential savings on the cost of probate. However, living trusts can also be expensive.

Avoiding Estate Taxes

Not only does the government tax you when you're breathing, they also tax you when you die. But there are a couple of loopholes that you can use to minimize your taxes. Because you probably won't die for a long time, you have to periodically check the rules to make sure that your complex planning hasn't been foiled by some new wrinkle in the tax law.

Many states have estate or death taxes as well. A few states—Florida is one—don't have estate or death taxes. You should check with your accountant, lawyer or state tax department to get the details of your particular state.

Two basic tax rules are the basis for a lot of planning:

- **Unlimited Marriage Deduction.** You can leave as much money and other assets to your spouse as you want, without paying a dime in federal estate taxes.

- **$600,000 Tax Free.** Without going into the details of how they do it, the tax rules allow each estate to pass on up to $600,000 of assets without paying tax. After that, they start taxing the estate based on its value. Although this seems like a lot of money, if you own a house, and have some insurance or maybe a small business, and you've been saving money for retirement, you can get over $600,000 pretty easily.

Also, the IRS periodically increases the exclusion amount to keep up with inflation. One thing that's important to note: the $600,000 applies to individuals. That means that if you're married, you can shelter up to $1.2 million from taxes through a bypass trust.

Bypass Trust

This tactic lets you and your spouse take double advantage of the $600,000 rule. If you die first, you can leave all of your money to your spouse without paying estate taxes by using the unlimited marriage deduction. Then when they die, they get to exclude the first $600,000 of their total estate from taxes. If their estate is over $600,000, the estate gets hit with taxes. One way to avoid this is to use the $600,000 rule twice.

When you die, you can direct that $600,000 of your assets be placed in a bypass trust. The income from those assets (and even the assets themselves, with the trustee's approval) can go to your spouse for as long as they live. When your spouse dies, the trust is broken and the assets go directly to your kids, or whoever you name as the benefi-

ciary of the trust. Because you used your $600,000 exclusion, when your will transfers the money into the trust, no federal estate taxes are due. When you give the rest of your assets to your spouse, the marriage exclusion lets you avoid taxes on that transfer. Your spouse still gets to use the $600,000 exclusion on any assets they own when they die. By using the exclusion twice, you shelter up to $1.2 million of your estate from taxes.

Giving Your Money Away

This is one of the best ways to avoid estate taxes, as long as you keep enough to survive. Remember that because of the $600,000 rule, you can keep that much and still avoid taxes. You are legally permitted to give up to $10,000 per year to any individual as a gift, and neither you nor the person who received the gift have to pay taxes on that money. If you are married, both you and your spouse can give $10,000 to any individual, for a total of $20,000 per person per year. If you have a large family, you can give up to $20,000 per person per year, and transfer a large amount of money over time.

Keep in mind that if you give more than the limit, the recipient doesn't have to pay taxes, but you are reducing the amount of money you can shelter by the $600,000 rule. Also, I don't recommend transferring all of your money with the progress of medical science, people are living well into their eighties and nineties. It would be embarrassing to give away all of your retirement money and then have to ask for some of it back when you live another 25 years.

Worse, what if your kids spent the money you gave them and they didn't have any left to give back?

Charitable Remainder Trust

This one works best for people that have a lot of money tied up in capital investments that have appreciated over the years, such as stock, bonds, a home or a business. When you sell that asset, you will be liable for a lot of taxes. But if the asset is not providing you with a lot of dividends, interest or other income you may need to sell the asset and buy some other investment that will provide you with in-

come. If you intend to give a large gift to charity, you may want to consider a charitable remainder trust.

Once you have placed your assets in this type of trust, the trust can sell the assets without paying taxes, and then invest the assets into investments that will provide a good source of current income. You (and your spouse) are entitled to that income for as long as you live, and when you die what's left goes to the charities of your choice.

For instance, if you have a house that you bought for $100,000 and is now worth $700,000, you may put charity to practical use. If you sell the house to cover expenses you have, you can expect significant taxes. But, if you put the house in charitable trust, that trust can sell the house, invest the proceeds and pay you the interest for the rest of your life.

Generation Skipping

If you leave money to your children, that money is subject to estate taxes. If your children leave money to your grandchildren, that money may also be taxed. One technique to avoid this double tax is to leave assets directly to your grandchildren.

However, the IRS hates to miss the chance to get a piece of the pie, so if you give more than $1 million to your grandchildren, the Feds can impose a generation skipping tax. If you have that much money, you should definitely talk to a lawyer about techniques to avoid this tax.

Life Insurance Trust

Proceeds from life insurance are not taxable as income, but if the life insurance policy is owned by you when you die, the proceeds "pass through" your estate. If you have the ability to borrow money on an insurance policy, or if you have the ability to change the beneficiary on the policy, the IRS considers you the owner. That means that your estate will have to pay estate taxes on the proceeds of your life insurance policy. If the proceeds are paid to your spouse, your estate

will be able to avoid taxes through the use of the unlimited marital deduction.

However, if the proceeds are payable to someone else, your estate may be liable for estate taxes.

The simplest way to avoid this problem is to have someone else own the policy. For a new policy, you can have your child or children or other beneficiary buy the policy.

If this is not practical, or if you already have a policy that is substantially paid up or that has terms that are more favorable than you might otherwise be able to get, you may prefer keeping your existing policy, but putting it in a Life Insurance Trust. The trust then owns the policy, and the proceeds are distributed without going through your estate, thereby avoiding taxation.

My friend David Stack, a talented trusts and estates lawyer, says that this is the last, great massive loophole in estate taxes.

You can set up the trust by completing the appropriate document and naming a trustee. The trust then applies for insurance in your name, or you can transfer your existing policy into the trust. If you transfer an existing will, not the trust, you have to live for at least three years before you get the benefit of the trust.

If you die during the first three years, you are treated as if the trust was never established. During each year, you contribute enough money to the trust to pay for the insurance premiums.

Keep in mind that in order to satisfy the IRS, this is an irrevocable trust, meaning it can't be changed. Therefore, it's important that you set it up correctly, and take care of the beneficiaries you want to favor.

Living Trusts

A living trust is an alternative to using a will that allows you to avoid probate. It's called a living trust, because it is for use while you are

still alive. It's also known as an *inter vivos* trust (that's Latin for living trust—attorneys love to use Latin). Another name for this tool is a revocable trust, because you can change it after you set it up.

You usually appoint yourself as the trustee, and then have a successor trustee named who will take over when you die.

During your life, the trust will provide you with fixed payments, which you can change just about whenever you want. After you die, the assets of the trust are distributed in the same way as a will, except you don't have to pay court fees, attorney's fees or executor's fees. The successor trustee acts like an executor to make sure your wishes are carried out.

Living trusts have become very popular with younger people who are making estate-planning decisions. I'm not so keen on them, though. Many people draw up their own living trusts from do-it-yourself books—and do a bad job. A lot of assets can't pass through a living trust. If you have any amount of money in your estate, this is probably not a good idea.

Also, the IRS basically ignores the living trust. That means that during your life, you have to pay taxes on investment profits made by the trust—and, after you die, your estate still owes estate taxes.

Advantages of a Living Trust

There are three basic advantages to using a living trust:

- **Avoiding Probate.** This can save you some pretty significant money on the probate fees, executor's fees and attorney's fees. However, the cost to set up and maintain a living trust, as well as trustees fees, may reduce the amount of your savings. Whether a living trust will be economic for you is a question that only a professional can answer. More importantly in some cases, avoiding probate can save you a lot of time. Probate can take weeks, months or, in some cases, years to finish, whereas a distribution under a living trust can be accomplished in weeks in most cases.

- **Privacy.** When your will goes to probate, it becomes a public record. If you don't want that to happen, you can use a living trust to avoid making your wishes public. For most people, this doesn't seem to be an issue, particularly since you will no longer be living by the time your will is probated.

- **Management.** If you want to, you can turn over the management of your trust during your lifetime to your successor trustee. Of course, you could probably do this anyway, so I don't think this is a tremendous advantage.

Joint Living Trust

If you live in a community property state, or own many of your assets in joint tenancy with right of survivorship, it may be difficult to split your assets into two separate living trusts. In this case, you may choose to form a joint living trust. This can accomplish the same goals as a living trust, but without the difficulties of splitting up your joint assets while you are both alive.

Pour Over Will

It can be difficult to transfer some assets to a living trust, such as your bank account or your car, so most people that have a living trust also set up a *pour over will*.

This type of will controls the assets that are not in your trust, and at the time of your death, they are "poured over" into the trust. Although it may seem silly to have to have a will when that was what you were trying to avoid in the first place, you still have most of the benefits provided by the living trust, but avoid the headache of going to the DMV to transfer the title on your car.

Other Definitions

- **Executor.** An executor is the person who is charged with seeing that the terms of your will are carried out. This can be a family friend, a relative or an attorney or accountant. Keep in mind that many states provide for fees to the executor,

based on the size of your estate, that can be as much as two to four percent or more. Most family members will waive these fees, or accept a fixed fee. Many attorneys or accountants will not, as this is part of their business. Executors have the ability to make important decisions that can have significant effects on your beneficiaries. Therefore, choose someone you trust, and someone who will get the job done. It helps if that person has a good head for business, so they can understand the sometimes complicated issues they will encounter.

- **Trustee.** A trustee is the person who you choose to manage the assets of the trust, and to distribute the assets under the terms of the trust. Most banks or trust companies will act as trustees, although this will usually require you to make the directions of your trust very specific, in order to fully describe the intent of the trust.

- **Guardian.** This is the person who will take over the legal responsibilities of raising your minor children or other dependents, such as disabled adults that are your dependents. You will want to choose someone who will do the best job to raise your children, preferably someone young enough to care for them for a long time. You may also want someone good with financial affairs; although if the ideal person is not strong in this area, you can set up a trust with a separate trustee to handle the assets you are leaving to your children or dependents.

- **Beneficiary.** This is the person who is to receive assets under a trust or will.

- **Contingent beneficiary.** This is a person who will receive assets under a will or trust, but only under certain circumstances. For instance, you may want to leave your assets to your spouse, who will be raising your children. However, if your spouse dies before you, you would want your children to receive your assets. In this case, your children are contingent beneficiaries.

- **Spendthrift Clause.** If you are leaving a valuable asset to your children, and you don't want them to squander it at a

young age, you may wish to set up a trust that prevents them from receiving the asset until they are older, say 25. If they are really smart, they may try and sell their share of the asset. As a spendthrift clause prevents the trust from selling assets under these circumstances, you should have a firm commitment from this person that the responsibilities of guardianship are agreeable to him or her.

Summary

Insurance policies, investments, company benefits, your home, household furnishings and family heirlooms—all these may add up to much more of an estate than you thought—one that justifies hiring an attorney to draw up your will. A competent lawyer will pay back the cost of your will-making appointment by knowing your state's laws and avoiding the stick problems that you might inadvertently create by settling for a do-it-yourself will kit.

Chapter Twenty-six

Preparing Your Will

Introduction

Although not quite as painful as amateur home dentistry, preparing for and writing a will is something that takes a bit of getting used to. If you thought compiling the guest list for your wedding was tough, try choosing the family member or friend that both you and your spouse agree will be worthy enough to finish raising your two-year-old.

I'm going to bet that it's the most candid conversation you ever have regarding your opinions about each member of your respective families.

Whether you are preparing your first will or rewriting an existing will, you will want to prepare using the following checklist. Although much of this information will not go into your will, it is important that you keep a list of your assets and liabilities in order that your spouse, family, trustee or executor can manage your estate properly.

List Your Assets and Liabilities

The assets and liabilities that you itemize in any form of will or trust that you use should include:

- Checking Accounts
- Savings Accounts
- Safe Deposit Boxes
- Credit Cards
- Auto and Personal Loans
- Mortgage and Home Equity Loans
- Retirement and Pension Plans, SEPs, Keoghs, IRAs or 401(k)s
- Brokerage Accounts
- Insurance Policies
- Real Estate
- Other Investments
- Cars
- Household Furnishings, Jewelry and Collectibles

Other Considerations

As you're reviewing these possessions and obligations, there are a number of more general questions you should consider:

- Does your will reflect everyone you wish to cover, has it been updated to reflect births and deaths, changes in tax laws and changes in your state of residence?
- Are there specific bequests you wish to make, including bequests to charity?
- Did you remember to take into account items that will pass outside your will, such as insurance policies and retirement plans, when designing your bequests?

- Did you remember to take care of bequests involving personal property that may have significant sentimental value?

- Have you chosen an executor and a successor executor, and have you asked them to waive executors' fees?

- Have you chosen trustees and successor trustees for any trust you intend to establish?

- Will you establish trusts for some or all of your assets?

- Have you chosen guardians and successor guardians for your minor children?

- Should you establish trusts or other means to look after your children's financial assets, in addition to a guardian?

- Have you made decisions as to funeral or memorial plans?

- Will your beneficiaries have enough money to live on while your will is in probate?

The Basics of a Will

State your full name, your principal residence and the date.

State clearly that the document is a will. Then state that you revoke all previous wills.

State who should be presumed to have died first if you and your spouse die at the same time. (If you die simultaneously, a bunch of lawyers and the IRS will spend your money discussing the interesting legal problems that could result from such an unusual event.)

State where you should have your funeral, burial, cremation, etc., so your family or friends will know what to do with you.

Make specific bequests to handle specific pieces of property. For example: "To Anna Nicole, I leave my trusty bloodhound Rex."

Make general bequests that will come out of your estate. For example: "To Anna Nicole, I leave $5 million."

Designate funds to be used to pay estate taxes.

Make residuary requests. For example: "Whatever is left after satisfying my specific and general bequests, and my taxes, shall be given to my cousin Elvis."

Name guardians and successor guardians for children or disabled people in your care, who will look after these people.

Establish trusts, including naming the trustees and successor trustees who will look after these trusts.

Name the executor and substitute executor, who will make sure that your wishes, as outlined in your will, are executed.

Sign the document in the presence of at least two witnesses and attach their names to the document.

Will Kit vs. Attorney

You can buy a will kit or a will preparation manual in many stationary stores or book stores. You can also buy some excellent software to give you advice and help you write a will or set up a trust. Both Intuit's *Family Lawyer* and Nolo Press's *Willmaker* are excellent products. *Family Lawyer* includes a lot of other legal documents. As a focused product, *Willmaker* provides a more detailed look at wills and related issues—it's also more expensive.

Commercially available kits and software are fine for a variety of simple wills. They are also an excellent source of guidance for understanding how wills and trusts work, and helping you to prepare the information you need to complete a will or establish a trust. However, you are usually dealing with a great deal of money. It would be a shame to pay thousands of dollars to accountants and brokers billing your estate—and then screw up your will. Also, the more money you have, the more likely that someone will be disappointed by your will.

I have seen more family squabbles erupt over the disposition of grandma's moss-covered three-legged family credenza. And when

these things get going, you can bet that some smart lawyer will be called in to tear your will apart line by line.

Even if your family is perfect, the IRS is waiting over your shoulder, like some hideous bird of prey, waiting for you to make a mistake that will cost you thousands in additional taxes.

Therefore, you should only use will kits or software to prepare your will if it's relatively simple. If any of the following describe you, you should use the books and software for education, but you should choose a good attorney to prepare the documents and give you advice:

- your assets are over $500,000;

- you intend to set up a living trust, a charitable trust or most any other kind of trust;

- you own your own business;

- you own assets jointly with your spouse, or someone else, that have appreciated in value by over $50,000, and you have not yet paid taxes on that appreciation; or

- you live in a state that has significant estate or death taxes.

Choosing an Attorney

Trusts and estates work is very complicated, and a fairly arcane area of the law. Most lawyers have no idea how to set up a trust or write a will. That doesn't stop many of them from trying. In order to find a good attorney for this kind of work, you will want to find a specialist. Ask friends for recommendations, or seek out lawyers that claim this as their area of expertise. Most mid-sized or larger law firms will have lawyers that specialize in this area. I recommend using manuals or software to prepare for your meeting, so you will be better able to judge if you have chosen the right man or woman for the job. Being prepared can also save time, and therefore money.

To save both time and money, have the following paperwork with you when you trudge off to face the will-making appointment with your lawyer:

- a list of your assets (from your net worth statement);

- the choice of an executor, a friend or relative whom you have spoken to in advance and whom you would trust with your life and death. This person will be fully responsible for seeing your will through probate, when necessary, and making certain that the wishes expressed by your will are followed. Your executor should, if possible, live nearby and be accessible to your family; and

- the choice of a guardian for your minor children. Remember that a guardian must be someone who you feel will provide proper care as well as manage your children's money. You should have a firm commitment from this person that the responsibilities of guardianship are agreeable to him or her.

Part Eight:

Buying That White Picket Fence

Chapter Twenty-seven

Working the Real Estate Market

Introduction

There are two ways for a homeowner to sell his or her home: either directly, using ads in local newspapers and flyers around town, or through a real estate agent. These are the same two ways for a buyer to find a home, and the best place to start is with a local real estate agent.

A good real estate agent should be familiar with the area of town that interests you, and can provide information on schools, real estate taxes, public transportation, and a host of other information, including local peculiarities of buying a home. In the United States, the seller is responsible for the real estate agent's commission, so you won't have to pay for their expert assistance. Even if you end up buying a home directly from a seller, it's always smart to get as much advice from a real estate agent as possible. If you are considering two potential areas in a large town or city, it is not uncommon to speak with two real estate agents, although it is not a good idea to use more than one agent in a small town or in a single neighborhood.

Listings and Multiple Listings

Typically, sellers will "list" their house through a particular real estate agency, which means that they agree to pay that agency a commission when their house is sold. Some homes will be listed "exclusively" with one agency, which means that only that real estate agency is allowed to show the home and negotiate the sale. Exclusive listings are common for very expensive homes, particularly where the homes are furnished, to limit access to the home.

"Multiple listing" is far more common. Most real estate agents are members of a multiple listing service. This means that they have an agreement with other agencies in that city or town that allows them to get paid for selling homes listed with other agencies. When a home is listed with an agent, the agent prepares a detailed description of the home and provides it, usually with a photo, to the multiple listing association. The association prepares a large book called the multiple listing guide, which is a comprehensive listing of all the properties being sold by all of the brokers in town. This guide is periodically updated and provided to all the real estate agents which are members of the multiple listing service. In some towns, there is also a software version which is continuously updated and available on-line.

When you first visit a real estate agent, they will use this book to help identify houses for you to see. Because the multiple listing book is organized by neighborhood, it is helpful to have an idea of one or more neighborhoods where you will concentrate your search.

The agency which listed the home is the "listing agent," and the agency which brings the buyer to the closing is called the "selling agent." These two parties usually split the commission paid by the seller.

How to Find a Real Estate Agent

Ask around among your friends or business colleagues to find if they have used a broker that was particularly good, especially if they live in a neighborhood which you are considering. Also, most real estate agents will advertise in the real estate section of your local newspaper, or in local real estate circulars. This can be a very good way to

identify an agency that has a number of listings in the neighborhoods you like.

Once you have identified a handful of agents you think may be appropriate, call them to schedule appointments. You will find that most of them are happy to meet with you and talk about your real estate needs. I would not recommend working with two different people at an agency, as this can sometimes cause problems between agents, and eventually for you.

Once you meet one or two agents with whom you feel comfortable, concentrate your efforts with those people. An agent who feels confident that you are likely to buy a house through them, and help them earn a commission, is going to be more willing to work harder and help you find the house that's right for you.

How Much Is the Commission for a Real Estate Agent?

In most parts of the country, the commission which goes to the real estate agent is 6 percent. Half of that fee goes to the agency that listed the house, and the other half goes to the broker that represented the buyer, but all of the fee is deducted from the amount of the purchase price that is paid to the seller. In some cases, both the seller and the buyer are represented by the same agency, in which case the agency gets paid the entire commission.

For Sale by Owner

To find houses which are being sold by the owner, I recommend reading the local newspaper—particularly the free weekly papers which may cover a particular town or neighborhood more thoroughly. This can often provide some alternatives to the houses being sold by real estate agents.

Research the Neighborhood

The best way to research a neighborhood is to talk to people that live there. Most of your potential neighbors will be happy to talk to you if you knock on their door, as long as it's not too early in the morning,

late in the evening, or during dinner. Also, you can find out from the town clerk what the price of comparable homes in the neighborhood have recently sold for.

Be Patient and Don't Spill Your Guts

Make sure that you have a good idea of the fees that you will have to pay at closing, in order to avoid coming up short.

Unless you are under extreme time pressure, and there are few houses in your target areas, the best advice is to be patient. If you are prepared to miss a few attractive houses, you are more likely to get a good price. Also, don't tell the seller or the broker the maximum amount you are willing to pay, or you are likely to wind up paying that amount. Also, if you have been pre-approved for a mortgage, don't tell them the amount of the pre-approval.

Buyer's Broker

You may want to get a buyer's broker, who will represent you in buying a house. Because the buyer's broker gets paid a part of the commission paid by the homeowner, you can get this service for free. However, you have to keep in mind that a buyer's broker only gets paid if a sale closes. Therefore, although they represent you, they have a significant financial incentive to get you to buy a house. You can often find someone who will act as a buyer's broker at your local real estate agent. Buyer's Resource is a national organization that will help you find a buyer's broker in your area. You can contact them at 800-359-4092.

Potential Pitfalls

- **Don't Buy the Oddball.** Although you may prefer a very modern-style house, try not to buy one set in a neighborhood of colonials. Keep in mind that most people don't like to be too different from their neighbors, and so your "unique" house may draw less potential buyers when you try to sell it. This means that you are likely to have to sell it for less money.

- **Ignore the Furniture and Decorations.** Just because the present owner is a Mary Kay rep who did every room in pink shouldn't scare you away. You will probably have to do at least some painting or wallpapering in even the cleanest looking homes, so look for rooms with the right size and shape, and imagine how they would look after you move in. An exception to this rule is appliances, sinks and tubs, which are difficult to paint and expensive to change.

- **High Real Estate Taxes.** Most communities require you to pay local real estate or property taxes based on the value of your home. These taxes are used to pay for schools, roads and other facilities, and may support trash removal, water and sewer and other costs. Usually, the taxes in better neighborhoods are higher. These taxes can be quite large, so you'll need an estimate of your taxes when we calculate how much house you can afford later on in this chapter. Do not assume that your taxes will be the same as the current owner. Real estate taxes are usually based on the estimated value of your house. Because the price you pay for your house is usually much more than the current owner paid, the tax rate of the current owner may be vastly different from what you will have to pay. The real estate agent should be able to help, but a call to the office of the local tax assessor is usually the best way to estimate your property taxes.

- **Best House on the Block.** Don't buy the best home in the neighborhood. Otherwise, you usually have to pay top dollar and you still don't get exactly what you want. Also, it will be harder to sell when it comes time to move. Better to buy an above-average home and use the money you saved to make exactly the changes you want or need, or to buy into a better neighborhood.

Putting in a Bid

Once you (and your spouse, kids, dog, fish, etc.) have found a house that you want to buy, it's time to put in a bid. Your first bid is not usually an indication of what you are willing to pay for the house, it is

just an indication that you are interested. Keep in mind that you can always raise your bid if it is not enough, but it is very difficult to lower your bid later on. Ideally, your first bid should be the lowest amount that will not anger the potential seller to the point that he will not accept any more bids from you. It is very hard to make a seller that angry.

Inspection

When you sign your contract to purchase, make sure that you have the right to renegotiate the price after you have had an inspection. Then, make sure that you get the inspection done on time. Most inspectors will check to make sure everything works, like the heater, air conditioner, electrical system, water heater, septic system and appliances. The inspector will also check the structural integrity of the house including the all important condition of the roof.

Two special inspections are termites and radon. Although the presence of termites is not the end of the world, you will want the inspector to make sure that the termite damage is minimal, and can be repaired. If the damage can be repaired, an adjustment in the purchase price is in order. However, if the damage is too severe, you will want to cancel your contract to purchase. Radon is a colorless odorless gas that may be seeping from the ground into your basement, and is thought to cause cancer in high concentrations. Many radon problems can be easily solved by installing a fan, but you'll want to get advice from a professional.

Make sure your contract allows you to cancel without any loss of deposit or any damages, if your inspection turns up any serious problems. Usually the best approach is to have the right to cancel if repairs will exceed some percentage of the purchase price. I like 10 percent as the cut off.

Protect Yourself with Your Contract

Make sure that your contract has clear language that will allow you to get out of the contract, without penalty, for problems beyond your control. Typical contingencies include:

- **Mortgage.** Your contract should have an escape clause if you can't get a mortgage. In order to take advantage of this clause, you usually have to show that you have applied for a mortgage and been turned down. Most of these clauses have a time limit between 30 and 60 days. If you don't have this clause, you may be forced to buy the house (or pay a large penalty) even if you can't get a mortgage.

- **Inspection.** Make sure your contract allows you to escape without penalty if various inspectors discover problems with the house, such as extensive repairs, termites, radon, etc. Usually these clauses will only allow you to get out of the contract if the damages exceed a certain dollar amount, and some allow the seller to make repairs at their expense. In any case, if the damages can't be repaired in a reasonable amount of time, you should be able to void the agreement.

- **Fire Damage.** If the house is damaged by fire after you've signed the contract to purchase, but before you close, you want to make sure that the seller pays for repairs. Also, if the damage is over a certain dollar amount, or will take a long time to fix, you probably want the ability to get out of the contract. Otherwise, you may wind up waiting for months before you can finalize the purchase.

Chapter Twenty-eight

Your Down Payment and the Really Big Loan

Introduction

Scouting out dilapidated dream houses is fun. Arranging the financing is work—but, if you approach it systematically, it doesn't have to be so bad.

For most people, the hardest part of buying a house is coming up with enough cash to qualify for a mortgage. This is the dreaded down payment. It's the amount you have to pay for your home when you buy it, as opposed to the mortgage—the part you borrow from a bank or elsewhere.

At the time of purchase, or *closing*, most banks will lend you 80 percent of the purchase price of your new house and require you to pay 20 percent of the purchase price as the down payment. Most people choose to work with these numbers—doing everything they can to get the cash for a 20 percent down.

However, many traditional lenders will also permit you to make a down payment of as little as 10 percent, if you buy *personal mortgage insurance* or PMI. They may also limit the amount of money you can borrow on a 10 percent down payment. In many markets—especially big cities—these limits will restrict where you can buy a house.

In some cases—like special-situation mortgages and owner-financed purchases—you can put even less than 10 percent down. Among the most reliable of these alternative deals:

- **Seller Financing.** Some sellers will allow you to pay almost the entire purchase price over a number of years, in effect lending you the money to buy the house. This is usually referred to as seller financing. The IOU you give to the seller is a seller note. The terms of a seller financing are often much different from loans from a bank or mortgage company, and your seller may be willing to provide you with more favorable terms, particularly if they are in a hurry to sell. You can usually find sellers in your area who may be agreeable to providing seller financing through a real estate agent or advertisements in local newspapers and circulars.

- **Developer Assistance.** When a developer has a few homes that have not sold in a development, or is not able to sell homes as fast as expected, the developer may agree to provide a portion of the down payment. This typically covers only about half of the normal 10 percent down payment, but it can enable you to buy a home before you have had the time to save enough for a down payment. Usually, these developers require that you go through one or more lenders who have agreed to work with the developer.

- **VHA/FA Approved Loans.** These government-subsidized loans usually require only a five percent down payment—but not everyone qualifies.

- **State or Regional Programs.** In many areas, these programs assist first time home buyers or buyers whose annual income falls below certain levels. These programs often allow the buyer to come up with a five percent down payment, and the

program guarantees to repay the bank a portion of your loan if you default.

- **Buying property from a bank.** If a homeowner doesn't pay off his home loan, the bank will eventually foreclose on the house. This means that the bank takes the house and sells it, using the proceeds to pay off the loan. Banks do not like to do this, because they sometimes get stuck owning dozens of empty houses. If you have a decent credit rating, and qualify for a loan, you may be able to buy a house from foreclosure with little or no down payment.

Closing Costs

In addition to the down payment, you will also be required to pay for additional costs related to the purchase, which are referred to as "closing costs." These costs are usually an additional three to five percent of the cost of the house, depending upon the area of the country and the fees and "points" you have to pay the bank.

The major closing costs include bank fees and points, several months of property taxes and insurance payments, attorney fees, title insurance, personal mortgage insurance and survey or inspection fees. Your broker or lender can help you estimate these costs. You can negotiate who pays them—buyer or seller. But the buyer usually pays.

For purposes of shopping, you're safe assuming that you will need 13 to 15 percent of the purchase price for your down payment.

Putting Together Your Down Payment

Usually your down payment comes from savings. If you have a 401(k) plan at your job, and you've put some money in the plan, you may be able to use that money for your down payment. Most 401(k) plans will allow you to borrow money from the plan, which is really just borrowing money from yourself. Usually, you can only borrow the money you actually put in the plan, but some plans will also allow you to borrow the amount that your employer contributed. Because you have to pay this money back, it may affect the amount you feel comfortable borrowing for your mortgage.

Another alternative is to get a distribution from your 401(k) or IRA, Keogh or SEP plan. Because it's a distribution and not a loan, you don't have to pay this money back. The problem with this approach is that you originally avoided paying taxes on the money you put in your 401(k) or other plan; therefore, when you take the money out, you have to pay taxes.

On top of that, you usually have to pay an additional 10 percent of the money to the IRS as a penalty for taking your "retirement" money early. Expect about 20 percent withholding on an early cash distribution.

The Family Loan

Many first time home buyers rely on loans from their family, and possibly friends, to use as a down payment. I have found that parents are the best source for at least some portion of the down payment, particularly if you threaten to move back into their house if they refuse.

Family members—especially parents—are often willing to lend or contribute toward the down payment on a house. For one thing, it's usually a pretty safe investment. For another, it's usually a civilizing influence on people. Buying a house—and the debt load that goes with it—is a fundamental part of settling down.

However, you should still be careful when you tread this financial ground. If you can, you might want to prepare a promissory note for any conversation you have with family members about borrowing money toward a down payment. This note doesn't have to get into heavy legalese—all it needs to include is:

- the amount being borrowed,
- the name or names of people borrowing,
- the name or names of people lending,
- the amount being borrowed,
- the date the loan was made,

- the term of the loan,
- interest or bonuses owed, and
- a payment schedule.

You have to be careful using this approach—most banks and loan companies don't want you to owe too much money to other people, and they may not want to lend you money if you borrowed money for the down payment.

One way to get around this is to tell the bank that the money was a gift that does not have to be paid back. The bank may ask for your family member to sign something that says the money was a gift. Many people generate this letter, even though they have an understanding with the family members lending them the money that they will return the favor—that is, repay the loan or lend to another family member—at some future time.

The Really Big Loan

The balance of a house's purchase price not covered by the down payment is usually borrowed from a bank or finance company. These loans are often called mortgage loans or mortgages, and the house serves as collateral for the loan. Some sellers are willing to provide seller financing, by allowing you to pay the purchase price over a period of years. Most sellers, however, need the proceeds from the sale of their house to pay off their own mortgage loans, so seller financing is not common. Most of what we discuss in this section does not apply to seller financing.

Banks and finance companies use the same set of rules to design and approve loans, and therefore most of the loan packages they offer are identical in many ways. The most notable exceptions are in the case of fees and interest rates. These may be quite different from one lender to another, so most home buyers shop around to get the best interest rates and fees.

How Much Is Your Mortgage Payment Going to Be?

For a rough estimate, if you use the figure of about $8.80 per thousand dollars of mortgage loan, you'll be able to calculate your monthly mortgage payment. That means that a mortgage of $200,000 will cost you about $1,760 per month.

Also, don't forget to deduct the down payment from the purchase price, before you try to calculate your monthly payment. That means that if the purchase price is $100,000, you will probably pay a down payment of 10 percent, or $10,000, and borrow the rest, or $90,000. Your monthly payment on a $90,000 mortgage would be about $792 per month (90 multiplied by $8.80). This rough estimate is based on an interest rate of 10 percent, but a small move in interest rates can significantly change your payment. For instance, at a 7 percent interest rate it only costs $6.60 per $1,000 of mortgage, so the same $90,000 loan would only require a monthly payment of about $595 (90 multiplied by $6.60).

What Can You Afford to Spend on a Mortgage Payment?

The best place to start is by looking at how much you can afford to spend on rent, and multiply by one-and-a-half. If you can pay your rent without too much trouble, this should be the amount you can afford to spend on your monthly mortgage payment and real estate taxes. This is because most of your mortgage payment and all of your real estate taxes are tax deductible.

Here's how this works: If you pay rent of about $700 a month, you must first earn $1,000. After you deduct about $300 in taxes, you end up with enough to pay the rent. But if you spend that $1,000 on a mortgage payment and real estate taxes, the government kicks in by waiving the income taxes.

You don't have to wait until the end of the year to start enjoying your tax benefit. If you intend to buy a house, just file a new W-4 form with your employer. This is the form they use to calculate how much money your employer should take out of your paycheck for taxes. By increasing the number of dependents you claim, you can reduce the

amount of taxes taken out and have enough money to cover your mortgage.

The W-4 Form—Money for Nothing

Whenever you take a new job, you fill out a W-4 form and tell your employer how many dependents you have. Your employer relies on this information to calculate how much money they have to withhold from your paycheck for federal and state taxes. Because most of your mortgage payment and all of your real estate taxes are tax deductible, buying a home dramatically decreases the amount of taxes you have to pay. But most people can't afford to pay big mortgage payments and then wait until the following year for a tax refund.

One way around this problem is to file a new W-4 form and increase the number of dependents you claim. Although you really haven't added any dependents, as long as you only claim enough additional dependents to decrease your withholding by the estimated amount of your tax savings, you shouldn't have any trouble with the IRS. This lets you receive the money when you earn it, so you can afford a bigger mortgage payment.

The following chart shows the number of additional dependents you should add based on your estimated mortgage payment (and property taxes) for your new home (or the increase in your payments if you are moving from one home to another).

Monthly Payments	Add to Dependents
$400-600	2
600-800	3
800-1,000	4
1,000-1,200	5
1,200-1,400	6
1,400-1,600	7
1,600-1,800	8
1,800-2,000	9
2,000-2,200	10
2,200-2,400	11
2,400-2,600	12

If you have had to pay a large amount of taxes, or gotten a large refund in prior years, your withholding may be wrong. Get a copy of Form W-4 from your employer and use the detailed worksheet on the back. For additional advice, get *IRS Publication 919-Is My Withholding Correct?* This is one of the more comprehensible IRS documents.

How Much Will a Bank or Mortgage Company Lend You?

Most lenders use two formulas to calculate the amount of money they are willing to loan you: the top ratio and the bottom ratio. These ratios are the upper limit of your borrowing power, and are calculated on your gross monthly income—the amount you earn before deductions for taxes, social security and all the other things that get deducted from your paycheck.

The top ratio is your total housing expenses (including monthly loan payment, real estate taxes and insurance) divided by your gross monthly income (before withholding for taxes, etc.). The bottom ratio is your total housing expenses divided by your monthly gross income, after deduction of fixed expenses such as car loans, student loans and minimum credit card payments. Most banks do not want you to exceed either a top ratio of 33 percent, or a bottom ratio of 38 percent of your gross income.

For example: If your monthly gross income is $3,000, you would qualify for monthly housing expenses of up to $990 ($3,000 multiplied by 33 percent). If you have a monthly car loan payment of $300, credit card minimum payments of $150 and a student loan of $100, your adjusted gross would be $2,450, your housing expenses—using the bottom ratio as a guide—should not exceed $931.

Because you need to know the estimated amount of your real estate taxes and homeowners' insurance to calculate these ratios, I'll discuss these in greater detail later in this chapter. However, for purposes of starting your search, you can figure that a bank will approve your loan if your monthly loan payment will be about 30 percent of your gross monthly income.

Beyond your mortgage payment, you can expect to pay real estate

taxes on your property in most states. Real estate taxes are generally based on the purchase price or value of your new home. Your real estate agent should be able to give you an idea of the likely real estate taxes for a house in a specific price range. You will also have to pay for homeowners' insurance.

Any local real estate agent should be able to give you an idea of what you can be expected to pay for insurance coverage. In certain areas, particularly gated communities, you may also have to pay fees or dues to support security services, landscaping and maintenance.

Condominiums and Co-operatives

Condos and co-ops are like apartment buildings or townhouses where you own your own unit, and you and all your neighbors jointly own the common areas, such as the hallways, elevators, building lobby, swimming pools and garages. In these situations, you can expect a substantial monthly maintenance fee to pay for maintenance of the common areas, security and improvements.

Calculating Your Mortgage Payments

To calculate your mortgage payment, you need to know the amount of the loan, the interest rate and the length of the loan. You can calculate your monthly loan payment by using the worksheet and the Key Number Table below.

First, write your mortgage amount in Space 1. Make sure to round to the nearest thousand. Then cut off the three zeros, and enter that number in space 2. Next, using your interest rate and term, pick your key number from the chart beneath the worksheet and put it in Space 3. (If your interest rate is between two in the chart, for instance, 8.2 percent, find the key numbers for 8.0 percent and 8.5 percent and you can estimate that your key number is about midway between those two key numbers.) Multiply Space 2 by Space 3 to get your mortgage payment.

Mortgage Payment Worksheet

	Your Information	Sample
1. Mortgage Amount	$ _____	$90,000
2. Mortgage in Thousands	$ _____	$ 90
3. Key Number[1]	_____	7.5
Multiply 2. by 3. to get your Monthly Mortgage Payment	$ _____	$675

[1] See the following pages for more information relating to this number

KEY NUMBER CHART

Interest Rate	Term 15 Years	Term 30 Years
4	7.40	4.77
4 1/8	7.46	4.85
4 1/4	7.52	4.92
4 3/8	7.59	4.99
4 1/2	7.65	5.07
4 5/8	7.71	5.14
4 3/4	7.78	5.22
4 7/8	7.84	5.29
5	7.91	5.37
5 1/8	7.97	5.44
5 1/4	8.04	5.52
5 3/8	8.10	5.60
5 1/2	8.17	5.68
5 5/8	8.24	5.76
5 3/4	8.30	5.84
5 7/8	8.37	5.92
6	8.44	6.00
6 1/8	8.51	6.08
6 1/4	8.57	6.16
6 3/8	8.64	6.24
6 1/2	8.71	6.32
6 5/8	8.78	6.40
6 3/4	8.85	6.48
6 7/8	8.92	6.57
7	8.99	6.65
7 1/8	9.06	6.74
7 1/4	9.13	6.82
7 3/8	9.20	6.91
7 1/2	9.27	6.99
7 5/8	9.34	7.08
7 3/4	9.41	7.16
7 7/8	9.48	7.25

KEY NUMBER CHART

Rate	15 Years	30 Years
8	9.56	7.34
8 1/8	9.63	7.42
8 1/4	9.70	7.51
8 3/8	9.77	7.60
8 1/2	9.85	7.69
8 5/8	9.92	7.78
8 3/4	9.99	7.87
8 7/8	10.07	7.96
9	10.14	8.05
9 1/8	10.22	8.14
9 1/4	10.29	8.23
9 3/8	10.37	8.32
9 1/2	10.44	8.41
9 5/8	10.52	8.50
9 3/4	10.59	8.59
9 7/8	10.67	8.68
10	10.75	8.77
10 1/8	10.82	8.87
10 1/4	10.90	8.96
10 3/8	10.98	9.05
10 1/2	11.05	9.15
10 5/8	11.13	9.24
10 3/4	11.21	9.33
10 7/8	11.29	9.43
11	11.36	9.52
11 1/8	11.44	9.62
11 1/4	11.52	9.71
11 3/8	11.60	9.81
11 1/2	11.68	9.90
11 5/8	11.76	10.00
11 3/4	11.84	10.09
11 7/8	11.92	10.19

APR—The Great Equalizer

APR is the number you'll often find in advertisements for mortgage rates, and many other types of loans. APR stands for "annual percentage rate," and is an attempt to put the cost of a loan, including the interest rate, as well as the assortment of charges, fees and points into one all encompassing number. That's why the APR is always somewhat higher than the interest rate.

Unfortunately, the APR is not a perfect way to compare the terms of one loan to another because the size of a loan has an effect on the calculation, and the bank probably didn't use your loan amount to calculate its APR. Keep in mind that although the APR is a fairly good indicator of the total cost of a loan, it may be off by as much as 0.2 percent.

Fixed Rate Loans

A fixed rate loan has the same interest rate for the life of the loan, and therefore your monthly payment remains constant. The main benefit of a fixed loan is that you have the security of knowing your monthly payment will not change. If interest rates go up, your payment will not increase.

If interest rates go down by a meaningful amount, you refinance by taking out a new loan at the lower interest rate and using the money to pay off your existing loan. In other words, you have no risk, and you may be able to benefit from a change in interest rates. You will have to pay some fees to refinance your loan, so it only makes sense to refinance if the savings on your monthly payment exceeds the refinancing fees.

Adjustable Rate Loans

An adjustable rate loan or "ARM" is subject to periodic adjustment as interest rates go up or down. Depending on the loan, adjustments may occur as frequently as once every six months or as infrequently as every five years. As interest rates increase or decrease, your monthly payment will go up or down. Usually, there is a ceiling and a floor

that prevent your payment from going too high or too low, regardless of how far interest rates move. Also, most adjustable loans also have a collar that prevents your payment from changing too much in any single adjustment.

The benefit of an ARM is that your initial payment is lower. Because your interest rate and your monthly payment are initially lower, it may be easier for you to qualify for an adjustable loan. If you are just starting out, and feel comfortable that your earning power is likely to increase, a lower initial payment may outweigh concerns about potential increases over the life of the loan. Adjustable loans are also more attractive when the general consensus is that interest rates are high. If interest rates decrease, you can then refinance with a fixed rate loan and lock in a low interest rate. However, you always run the risk that interest rates, and your payments, increase.

Graduated Payment Mortgage

Some loans are designed to have negative amortization for the early part of the loan. One of these is the graduated payment mortgage or GPM. This means that the initial monthly payment is less than the amount necessary to pay interest on the loan. The outstanding amount of the loan increases every month to cover the shortfall of the interest. After the initial period, the monthly payment is increased to the amount necessary to repay the loan over the remainder of the term. By minimizing the payment during the beginning of the loan, a buyer is able to qualify for a larger loan and borrow more money. I don't recommend this type of loan.

Jumbo Loans vs. Conforming Loans

Jumbo Loans are merely loans over a certain amount, generally around $203,000. Because these loans are larger, they carry slightly higher interest rates than regular size or "conforming" loans.

30 Years vs. 15 Years

The most common mortgage terms are for either 30 years or 15 years.

There are benefits to each. The 30-year loan is just plain cheaper—your mortgage payment will be about 22 percent less if you select a 30-year loan. However, the total interest cost for a 30-year loan is considerably more—more than double the interest cost of a 15-year mortgage.

A 15-year loan usually gets a slightly lower interest rate than a similar 30-year loan. However, because your payments are still higher, you will have to be able to qualify for a higher monthly payment. If you are buying near your spending limits, this may not be possible. By investing more money in your home, you tend to build up your equity faster. Although this may not be your best use of your investment dollars, it may provide you with a sense of comfort that an investment fund might not be able to duplicate.

Keep in mind that although it looks as if your interest savings are dramatic, you are paying 20 percent more every month. By taking a 30-year mortgage and putting that 20 percent in other investments, you may be able to completely offset your additional interest expenses.

I lean toward a 30-year mortgage, because it's easier to qualify, the stated interest rate is not much higher than the one you will get for a 15-year loan, and if you can afford to, you will get the same result by overpaying your 30-year loan by 20 percent each month. You may feel more comfortable with the whole process if you're not committed to a higher payment. You can always make additional payments if you get a bonus or after you get a raise. However, you should look at the section on Mortgage Paydowns below to see how you can calculate your benefit of paying your mortgage off early.

Comparing the Numbers

Term	30 Year	15 Year
Interest Rate	10%	10%
Amount	$100,000	$100,000
Monthly Payment	$877.57	$1,074.61
Total Interest Paid	$215,925	$93,428
Amount of Loan Outstanding		
Five Years	$96,574	$81,316
Ten Years	$90,938	$50,576
Fifteen Years	$81,664	$0

Points

In one of the Talking Heads early 1980s hits, David Byrne sang, "Some good points, some bad points, I'm checking it out, I've got it figured out." I don't know if Byrne was referring to mortgages when he penned those words—but he could have been.

Points are up-front, one-time, lump-sum interest payments you make on a mortgage. Usually, paying points is a way of decreasing the interest rate on your mortgage for the life of the mortgage. These are only good points if you hold your mortgage long enough to get the benefit of a lower interest rate.

For instance, if you pay points to reduce the interest over a thirty year term, but sell your home in five years or refinance the loan after three years, you give up most of the benefit you bought with your points.

Each point is one percent of a new loan being placed. If you borrow $100,000, one point would equal $1,000. Two points would be $2,000. The term "points" is sometimes used to mean percent points, as in "Your interest rate will be two points over the bank's prime lending rate." Usually the context will be enough to tell you which kind of points you're talking about.

Points are usually paid at the closing of your deal, but they may be paid at the time of mortgage application; in the latter case, you should find out whether points are refundable if the loan doesn't go through.

Sometimes you can pay extra points to get a special benefit from your lenders. Some lenders guarantee to provide the favorable interest rate in effect when you apply for the loan, even if interest rates go up before you close. Make sure that you will also get the benefit of a lower rate if rates go down. Your lender may also charge you points for an extension if you don't close within a certain time period.

Points are usually paid by the buyer, although the seller may sometimes agree to pay some or all of the points. Points you pay when you buy your home are deductible as interest in the year they are paid. Points you pay if you refinance your mortgage or purchase investment property must be amortized over the life of your loan. For instance, if you pay $3,000 of points on a 30-year loan, you get a deduction of $100 every year ($3,000 divided by 30).

In order to deduct points as interest on your income tax return, you must be careful how you pay them. Make sure that the lender gives you the entire loan, and that you pay the points with your own check. Don't let the lender deduct points as a discount from the loan proceeds. Points paid by the seller are not deductible at all, because you can only deduct interest that you pay. (The seller's points are merely one of the expenses of selling and, if it is one's own residence being sold, may be of little value from an income-tax point of view.)

Teaser Rate

With many ARMs, the rate during the first year, or the first adjustment period, is set artificially low to attract more borrowers. If you plan to be in a house for only a few years, this can be very attractive, particularly if you have a long adjustment period. Make sure to calculate what your initial payment would be if you weren't getting the teaser rate: this is likely to be your monthly payment after your first adjustment.

Adjustment Period

This is the length of time between interest rate adjustments. Adjustments can also be made as often as every six months or as infrequently as every three to five years, depending on your loan.

With some loans, interest rates may be adjusted although monthly payments are not. If rates go up but your payment doesn't, this could result in negative amortization. If rates go down but your payment doesn't, you may be paying your loan down faster.

Index and Margin

The interest rate on your ARM may go up or down depending on the trend for interest rates. Most lenders peg your loan rate to some national indicator of current rates, also called an "index." The "margin" is the difference between the index and your interest rate.

For instance, the index used for your ARM might be the rate on one-year United States Treasury bills, also called T-bills. Another common index is based on the average mortgage interest rate across the country as reported by various government agencies.

Adjustment Cap, Lifetime Cap and Floor

This is the maximum increase in your interest rate during any adjustment period. For instance, your loan agreement may set a 2 percent cap on any adjustment. That means that even if interest rates go up by 3 percent, your loan rate only increases by 2 percent.

When choosing an ARM, make sure you understand what happens if the rate increases beyond the cap. Some loans "save" the extra 1 percent at the next adjustment and increase you by that amount.

The ceiling, or lifetime cap, is the highest your interest rate can ever go, regardless of what happens to the index. Typically, your loan will have a five-point ceiling. This means that if your loan starts at eight percent, it can never go beyond 12 percent. (A ceiling allows you to calculate your worst case.)

You should know how much it will cost if your loan ever reaches the ceiling rate, even though it may be a bit frightening. For instance, if your loan starts out at eight percent and has a five-point lifetime cap, calculate what your monthly payment would be at 12 percent.

On the other side of the spectrum, some ARMs set a limit—or "floor"—on decreases in your rate—either for each adjustment period or over the life of the loan. This means that even if interest rates fall, your payment will not go below a certain minimum amount. Keep in mind that if interest rates fall that far, you can always refinance.

Negative Amortization

Amortization means gradually paying off the principal part of your loan. Most loans are designed so that your monthly payment will be exactly the right amount to pay your interest and repay your principal over the term of your loan. If for some reason your monthly payments aren't enough to cover even the interest due, negative amortization is a possibility.

Negative amortization means you are actually borrowing more money, and increasing the amount of your loan, in order to cover shortfalls in your monthly payment.

Negative amortization could follow a hike in interest rates that's larger than your cap. For instance, if an interest rate increase would require you to pay $1,000 per month, but your cap prevents your payment from exceeding $900, you may be borrowing the additional $100 until your next adjustment.

Fixed rate loans don't have negative amortization, but ARMs sometimes do. Before choosing a specific ARM, make sure to ask if it permits negative amortization, or "deferred interest."

Convertible Loans

If your mortgage is convertible, you can flip your adjustable-rate mortgage to a fixed-rate. You will have to pay a slightly higher interest rate to get a conversion option.

Some loans allow you to convert at any time during the life of the mortgage, while others restrict conversion to certain anniversaries of the loan. Be sure to find out what it would cost to convert. Most convertible loans will charge you fees equal to at least one point to convert. You should always check if it would be less expensive to refinance with a new loan or convert your existing loan.

Federal Housing Administration Mortgages

The Federal Housing Administration (FHA), a federal government agency, helps homeowners buy with low down payments. Local lenders will make loans of up to 97 percent of the value of property, because the FHA would insure them against loss in case of foreclosure.

If your purchase price is under $50,000, your down payment can be as low as three percent, otherwise it's usually five percent. FHA loans may be placed on one- to four-family dwellings and are intended for owner-occupants.

In exchange for the FHA's agreement to guarantee that your loan is repaid, you have to pay a mortgage insurance premium (MIP) up to 3.8 percent of the loan. Because most FHA buyers don't have extra cash at closing, the MIP can be added to the amount of the mortgage loan. If you pay off your FHA mortgage within the first ten years, you get a rebate of a portion of your MIP.

If your down payment is very small, you may also be charged one-half percent of the outstanding balance each year as additional MIP. The number of years this extra premium is charged depends on the size of your down payment.

The FHA bases its loans on the appraised value of your home as estimated by authorized FHA appraisers. Your real estate broker should be able to tell you if this and other related FHA programs are available in your community—or you can call local lenders to see if any offer FHA loans.

FHA loans were also desirable in the past because they could be as-sumed. New regulations, however, limit this advantage.

Veterans Administration Loans

There are several attractive things about VA loans, including the following:

- You may need no down payment.
- The loans are assumable (with the restrictions listed below in the discussion of assumptions).
- The government sets a fixed interest rate and prohibits you from paying more than one point (the seller must pay the rest).

As with FHA mortgages, the money comes from a local lender; the Veterans Administration guarantees that the loan will be repaid. VA loans may be made for the entire appraised value of the property up to a maximum of $184,000.

To qualify, the veteran must have:

- a discharge "other than dishonorable" and
- 180 days of active (not reserve) duty; 90 days if you were in Korea or Vietnam, or two years if you enlisted after 1980.

VA loans may be used for one- to four-family houses, owner-occu-pied only; although if you move to a new house and still have eligibil-ity, you can continue to pay your old loan and take out a new loan.

For the privilege of a VA loan, you will need to pay a funding fee to the Veterans Administration, depending on the size of your down payment: 1.875 percent for no down payment; 1.375 for at least 5 percent; and 1.125 percent for at least 10 percent down.

Assumable Mortgages

If a mortgage is assumable, a buyer can merely take over the pay-

ments from the seller. This is a great benefit, as you can reap considerable savings on closing costs and other related costs by assuming the seller's mortgage, rather than getting a new mortgage. Naturally, you will only want to assume a mortgage that has an acceptable interest rate and other repayment terms. You may also be able to avoid having to qualify for a mortgage. Because the seller retains liability for that FHA or VA mortgage if you fail to make your payments, expect the seller to look carefully into your financial background.

In most areas where the value of homes has increased, the house you are buying is usually worth more than the outstanding balance of the mortgage. In this case, you will probably have to pay the seller some additional funds, similar to the down payment you would have to pay if you obtained a new mortgage. An assumable mortgage that is close to the true value of the house will require a minimal additional down payment, and is therefore very attractive.

Even if the mortgage is not very high compared to the value of the house, you may be able to convince the seller to accept the balance of the purchase price with part cash and part loan. That loan is likely to be secured by the house, and is called a second mortgage.

Like a regular mortgage, if you don't pay your second mortgage, the lender (in this case the seller) can foreclose on your house. If your seller will agree to take the entire amount as a second mortgage, you can actually buy your new house with no down payment.

FHA loans made before December 15, 1989, and VA loans made before March 1, 1988, are completely and freely assumable—you can close as soon as you want and you don't have to get any approvals. Newer FHA loans are "assumable with approval." You can only assume these mortgages if you satisfy the lender's income ratios and credit worthiness.

With the newer VA mortgages, you need to qualify for an assumption (but you don't need to be a veteran). You can also be charged up to $500 to process the assumption and, for certain loans, you have to pay the VA a one-half percent fee.

Some adjustable rate mortgages are also assumable, but aside from saving you on closing costs, you will probably not get a much better deal than what you could otherwise get in the market. It's best to treat these loans like any other ARM when comparing them to other loans available.

Matching Your Loan to Your Plans

If you are buying a starter home, and plan to move to a larger home after four or five years, it may make sense to opt for an adjustable rate loan with a three- to five-year adjustment period. That way you lock in a low rate for the first three or five years, and sell your home before or shortly after your monthly payment is first adjusted.

If you're buying a home that you expect to keep for a long time—say, seven years or more—I strongly recommend a fixed-rate loan. If rates suck, you can refinance to the lower rate—and, if rates go up, you'll be sleeping soundly while your adjustable-rate paying neighbors are searching for their Sominex.

Mortgage Loan Application

The following is a representative list of things that you may be required to provide in your loan application:

- W-2 forms for two years and a pay stub from your most recent paycheck (if you are self-employed, you will probably need two years of tax returns and a profit and loss statement from the current year),

- the names and addresses of employers for past two years,

- the addresses of residences for past two years,

- a copy of the contract for purchase,

- your bank name, address, account numbers and latest three months of bank statements for all bank accounts,

- a list of open loans, including amounts outstanding and minimum payments,

- loan information on other real estate you own,

- any recorded copies of divorce decrees,

- your drivers license and/or social security card, and

- any fees for credit check and appraisal of the house.

Finding the Right Lender

You have already done a lot of work to choose the perfect house, so you don't want a second rate lender or mortgage broker to cause you any headaches. There are several ways to protect yourself from using the wrong lender or mortgage broker, and getting the best service and deal:

- **Recommendations.** Ask your real estate broker for three recommendations. They want you to be able to get your loan completed so that you can close the deal, so it's in their best interest to get someone who is going to perform. If you know other friends who have recently closed a purchase or refinancing, they may also be able to help you to find the right person.

- **Shop Around.** Take the time to open the local phone book and call five or six lenders or mortgage brokers. Give them the basic information about you and the house you want. Tell them you're comparing loan packages for the best terms.

- **Get a Written Estimate of Closing Costs.** Make sure that you get this up front, so you can start calculating how much time and money you will need to complete the purchase.

Web Tip

You can also shop for loans on the Internet. Mortgage Net at dirs.com.mortgage is a resource directory for many mortgage services. You'll find mortgage payment calculators, rate updates and tutorials on rates and term options. HSH Associates at www.hsh.com offers shareware called PC Mortgage Update. Then, if you send HSH a nominal fee, you'll receive data on current information including lenders in your area. Several big lenders—including Bank of America at www.bankamerica.com and Countrywide Credit at www.countrywide.com will let you prequalify via the net.

Mortgage Checklist

Use this handy checklist to record all of the pertinent information on your potential lenders in one place.

	Lender #1	Lender #2	Lender #3
Lender			
Phone number			
Contact person			
Costs			
Application cost			
Term (years)			
Points			
Interest rate			
Loan amount			
Down payment required			
Private mortgage insurance			
Prepayment penalty			
Qualifying ratio			
Monthly payment			
Maximum monthly payment (ARMs only)			
APR			
Adjustable rate info			
Index			
Margin			
Initial rate			
Adjustment period			
Adjustment cap			
Lifetime cap			
Negative amortization (yes/no)			
Convertible (yes/no)			
Conversion date			
Conversion fees			

Mortgage Paydowns

Making additional payments on your mortgage can be a great way to save money on interest, and increasing the amount of "equity" in your home, while giving you a greater sense of comfort with your mortgage loan. For instance, if you have a 30-year mortgage for $100,000 at 8 percent interest, your monthly payment is about $733. However, if you pay $800 a month, you will pay the loan off about 7 1/2 years early.

Because the additional amount you pay goes to reducing the principal amount of your loan, and isn't used to pay interest, you don't get a bigger tax deduction. But because you are repaying the loan ahead of schedule, you are saving interest charges for the last years of your loan.

Although it sounds very attractive to pay your mortgage off years earlier, sometimes the interest you save is actually costing you money. That's because the interest you pay on your house is tax deductible, and therefore relatively inexpensive. Rather than paying more than your mortgage payment, you may actually be able to do better by investing your excess cash in the stock market, or elsewhere, and continuing to pay your regular mortgage payment.

You are usually better off repaying your mortgage early if any of the following things apply to you:

- You are in a 15 percent tax bracket. This means that the tax benefit you get from paying interest on your mortgage is not very great, so you may want to consider repaying your mortgage.

- You take the standard deduction. As we discussed in the tax section, most people can elect whether to take the standard tax deduction (in 1995, $3,900 for singles and $6,550 for couples filing jointly) or to itemize all of your actual tax deductions. If you pay less taxes by taking the standard deduction, you aren't getting any tax benefit from your mortgage interest, so you may want to pay your mortgage down ahead of schedule and save money on interest.

- You invest in conservative investments, such as bonds. Because bonds tend to have a lower return than other investments, the interest you will earn is probably less than the interest you will save by paying down your mortgage loan.

You are usually better off paying your mortgage on time, without making additional payments if either of the following applies to you:

- You are in a 28 percent tax bracket or higher. Provided you itemize deductions, you are getting a significant tax benefit on the interest you pay on your mortgage, and saving interest by paying the loan off early is not as attractive as investing in most other investments, even bonds.

- Your house is worth less than your mortgage. If a decrease in the value of your house has left the house worth less than the outstanding amount on the mortgage, you probably don't want to prepay any amount of the mortgage. That's because you may want to consider negotiating with your lender to take your house back in settlement of your mortgage, and you don't want to pay more to the lender than you must.

Refinancing Your Mortgage

When interest rates go down, you may want to refinance your existing mortgage with a lower rate loan, and save some money in the process by reducing your monthly payment. If you can save more than 2 points on your interest, it probably makes sense to refinance, but you better use the chart below to make sure.

Refinancing is just like getting your first mortgage, you will need a new application, credit check, survey, title search, appraisal, etc. Plus, you may choose a mortgage that requires points. If you use the same lender, or if your mortgage is relatively new, you may be able to avoid some of these fees or negotiate a lower price. For instance, the surveyor may be willing to update your report at a discount. Even so, you will need a fairly dramatic reduction in your monthly payment to justify paying all of these expenses.

Finding and selecting the right mortgage is covered above, and most of this information is useful for finding a new mortgage.

Other Options If You Intend to Refinance

If you think you want to refinance your loan, it may also be time to consider the following:

- switching from a floating rate loan to a fixed rate loan, or vice versa, if your financial situation has changed since your original loan (if interest rates have come down, it may make sense to "lock in" that low fixed rate);

- choosing between fixed and adjustable rate mortgages;

- consolidating your mortgage and a second mortgage or home equity loan to save interest on both of these loans; and

- decreasing the term of your loan—from 30 years to 15 years— in order to save interest.

Although this last move may increase your monthly payment, it can save you a lot of interest because you pay your loan off much earlier. Interest rates on a new 15-year loan are slightly better than a new 30-year loan. You may be able to save nearly as much money by making larger payments on a 30-year mortgage. Although your interest rate will not be quite as attractive, you aren't tied to a much larger payment, and you can make extra payments as you can afford them.

Comparing Your Savings

In order to decide whether to refinance, you need to know the costs of refinancing, and the reduction in your monthly payment. The following chart will tell you how many months you will need to recover your refinancing costs. If you are considering a switch to a 15-year loan, complete the chart for a 30-year loan, anyway. If a 30-year loan makes sense, and the refinancing costs for a 15-year loan are similar, then a 15-year loan should also be acceptable, provided that you can make the monthly payments.

You can get most of the costs from the closing documents from your existing mortgage, and an estimate from the lender or broker you are considering for your refinancing.

Most of these costs are not tax deductible, but can be added to the basis in your home. Even points which are deductible for the original loan are not deductible in a refinancing, and must be divided over the term of the loan, and that amount can be deducted each year. ($3,000 of points for a 30-year loan give you a $100 deduction every year.)

You will also need to know your marginal tax rate. Remember that if you pay $100 of mortgage interest, and you're in a 28 percent tax bracket, you save $28 on taxes. If by refinancing you can decrease your monthly payment by $100, you have to pay that $28 of taxes, so you really save $72.

Costs of Refinancing
Prepayment Penalty on
 Existing Mortgage (uncommon) $ _____
Application Fees _____
Points _____
Credit Check _____
Survey _____
Title Search _____
Title Insurance _____
Appraisal _____
Inspection (if required) _____
Transfer and Filing Fees _____
Attorney (bank's) _____
Attorney (yours) _____
Other _____
Total Costs $ _____

Existing Monthly Payment $_____
less New Monthly Payment _____
Monthly Savings _____
Less Additional Taxes _____
(Monthly Savings x Tax Bracket)
Adjusted Monthly Savings _____

Months to Break Even _____
(divide Total Costs by Adjusted Monthly Savings) _____

Making the Refinancing Decision

If your months to break even is longer than you plan to live in your house, you clearly don't want to refinance. If your months to break even is more than six years, you are probably better off saving the refinancing costs and investing that money. The money that you can make by investing the costs of refinancing is likely to be greater than the money you can save by refinancing.

If you don't spend your money on refinancing costs today, you could invest that money and continue to earn interest. If your break even is short, missing that interest isn't very significant. If your break even is long, the return on that investment can become insignificant.

Home Equity Loans

Getting a home equity loan is about as easy as napping in church. Jim Palmer actually takes time from his busy (underwear) modeling career to relieve starting pitchman Phil Rizzuto for The Money Store team, so you know there is some cash in this business.

The fact is that home equity loans, which are sometimes called second mortgages, are a good way for you to get access to some of the equity you have built up in your home. With interest rates only a couple of points above your mortgage rate, home equity loans are cheaper than almost any other loan out there. With the tax deduction you get on the interest, they're even cheaper than they seem.

Line of Credit vs. Fixed Loans

One key choice is whether you want a line of credit or fixed loan. The line of credit loan is almost like your credit card. You can access the money with a check, credit card or ATM card, and typically can borrow up to your limit over a period of years, with a 10- to 12-year term being typical.

Like adjustable rate loans, you may get an initial teaser rate, and then you usually go up to a market rate adjusted monthly with a maximum cap on the interest you will have to pay. You can expect to

pay interest as you go (and maybe some principal), and the principal either due at the end of term or can be paid over a fixed time, for instance, 10 more years. These are good for things like college tuition and other bills which will require a number of large payments over time.

Fixed-rate loans are more like mortgages, where you borrow the entire sum up front, and then pay it back in fixed monthly payments over 10 to 15 years. These are better for large one-time expenditures, such as a car or boat or debt consolidation.

How Much to Borrow

Most home equity lenders let you borrow up to 80 percent of the value of your home, less the outstanding amount of your existing mortgage. However, you can borrow as much as 90 percent or even 100 percent of the value of your home, but expect to pay two or three percent more in interest than on the 80 percent home equity loan, and a maximum line of $50,000 or less from most lenders.

Costs

Costs for these loans come in a variety of ways, including some or all of the following:

- appraisal costs, for an appraisal of your property;
- closing costs, such as points or fees, attorney's fees, filing costs, etc.;
- yearly fees, maintenance fees and transaction fees every time you borrow money on your line of credit, unless you have a minimum outstanding on your line; and
- extra interest costs, if you find a bank that will waive most of the fees listed above.

Deductible Interest

You can deduct the interest on up to $100,000 of home equity debt, unless:

- you earn over $200,000, in which case you can only deduct the interest if you spend the money on home improvements;

- you spend the money on tax advantaged assets, such as municipal bonds or certain whole life insurance products;

- the value of your home is less than the total of your mortgage and your home equity loan, which is a problem if you take out a 100 percent loan and then real estate values drop.

Make sure you understand the terms of the new loan. Ask about the maximum rate on line of credit loans so you know what to expect. If your line of credit could be due at the close of the initial term, make sure you have enough to pay it off when the time comes. Also, don't borrow over 80 percent, or at most 90 percent, of the value of your house if you can possibly avoid it. The interest rates get less attractive for the higher loans, and you could lose your tax deduction if the value of your home dips. Remember, if you can't pay off this loan, you can lose your house.

Watching Your ARMS

Most of us have had checking or savings accounts for a while, and have rarely seen a mistake by the bank. That's because the numbers are pretty straightforward. This is not true with mortgages and particularly adjustable mortgages, where banks and other lenders are far more likely to make mistakes. By paying attention, you may be able to save some money.

If you ask your lender, it will usually provide you with detailed backup numbers that show how it calculated your interest rate and payments. Most of the money management software discussed earlier, such as Intuit's Quicken, Microsoft Money and Managing Your Money, are able to provide you with calculations of mortgage payments.

If you think it's boring to have to trudge through all those numbers, you can get someone to do it for you. The American Homeowners Foundation (800-489-7776) will check your adjustable rate mortgage for free—if they find a mistake, they get to keep half as a "bounty." The Mortgage Monitor, run by the American Homeowners Associa-

tion (800-283-4887) will check your fixed or adjustable rate mortgage, and your escrow account, for between $200 and $300. If you call 303-575-1548, you can talk to a voice mail system that will allow you to order information about these and related topics, such as reducing you property tax bill, which is sent to you via fax.

Conclusion

Summing up this book feels like trying to get in the last word at the end of a Russian novel. So much has gone on that I'm not sure how to give a parting nod to the process.

I guess the best thing to do is end near where I began. Organizing your finances is really just an extension of organizing your life. It can be tedious—and it requires constant tending. But, if you're willing to put in the time and pay attention to the details, you can succeed in an effort that has baffled many geniuses. You can create a comfortable, secure and enjoyable life for yourself and the people closest to you.

Measuring your financial condition and your money-management skills is really a common-sense process. The most important measure of an investment strategy is how it handles the volatile shifts between good markets and bad ones.

In fact, the best planning is colored with a healthy dose of pessimism. The gurus on TV and in newspapers may talk relentlessly about their optimism. But the wisest investor asks to see a mutual fund's performance in its worst years—so that there aren't any surprises when the market goes against you.

Saving and investing from an early point does encourage certain consistent behaviors. Both activities value historical performance. And both emphasize long-term returns (five years and more). Sure there are a lot of one hit wonders in the financial world—but consistency rules.

One of the best things about developing financial discipline at a relatively young age is that it saves you the nervous anxiety of trying to make a bunch of money when you hit middle-age. If you set good habits in your twenties and thirties, you can ride the power of compounding to a later life that's not stressed out about money.

Understanding how things work is important in making good decisions—but you don't have to do everything yourself. In some cases, the do-it-yourself movement has gone to counterproductive extremes. Sure, you can trade your own stock at a deep discount brokerage and draw up your own living trust from a $10 kit. But are these always the best ways to go? If you use them wisely, a stockbroker or a lawyer don't to cost a ridiculous amount—and their experienced insight can be worth their fee.

The key is to avoid coming to these service-providers in a panicky rush. They can sense a lack of control. An informed client always gets the best service.

Here is one last example of two different approaches to investing—one haphazard and the other well-considered.

I knew a guy who bought a house on a quiet street in my home town. It was a small house in a neighborhood of small houses, all on small pieces of property. He gutted his small house and put up a six bedroom monstrosity that almost covered the entire lot. He filled his entire back yard with an immense pool. He also put statues on the front lawn, and a circular driveway.

By the time he was done, he had the most expensive house on the street. But when he tried to sell it, no one wanted to buy a large house that dwarfed everything else in the neighborhood.

Overimproving is like putting a $5 shine on a $10 pair of boots. If you buy a house for $20,000 less than the average price for that neighborhood but have to put $60,000 into it, you may wind up with a house that is more expensive than comparable houses in the neighborhood, and have a tough time selling it.

On the other hand, a couple I know recently bought a wonderful house in an older, established neighborhood. Although everything was in impeccable condition, the style of the carpeting and appliances and fixtures in the kitchen and bathrooms were all quite dated. As a result, they were able to buy the house for much less than comparable homes in the neighborhood.

Over the last few years, they have redone one room at a time, updating the kitchen and bathrooms as they go. When they are finished, they will have one of the nicest homes in the neighborhood, with a modern kitchen and bathrooms done to their taste. More importantly, their total investment will be significantly less than the average home in their area, providing them with a tidy profit, should they decide to sell.

Just so that I don't sound too philosophical as we wind things down here, let me reiterate an important conclusion of this book: Proper planning and a consistent savings program are the basis of financial stability. It should be the foundation of your investment strategy. This will provide you with peace of mind and a ready reserve of cash. Cash doesn't mean a bag of twenties stuffed in your mattress—but rather a low-risk, highly liquid place to invest your money. Having money—and access to it—will always be the central definition of financial well-being.

We've reviewed the tools. We've considered the strategies. The execution is up to you. Good luck.

Index

accountants 78-79, 204, 334, 341

accrued interest 128, 282

adjusted gross income 64

amortization 128, 366, 370-371, 378

annual renewable term 197

annuities 245, 317

asset management accounts 98

auto insurance 168, 193, 211-212, 216

 collision coverage 212

 deductible 205, 208, 212, 215-216

 gap insurance 177

 uninsured motorists coverage 216

bad financial habits 7-8

bank cards 117

bank checks 108

bank records 71, 95

banking software 105

banks 72, 86, 93-99, 101, 103, 106, 108-109, 112, 117, 121-123, 130, 157, 160, 193, 282, 284-285, 298, 303, 313, 315, 334, 353, 357, 360, 385

bonds 58, 62-64, 71, 82-83, 86, 131, 221, 228-229, 237, 240-249, 264, 277-290, 294, 309, 311, 316, 329, 379, 384

 convertible bonds 282

 index funds 239, 288-289, 293, 295

 junk bonds 281-283

 mortgage backed bonds 244-245

 municipal bonds 58, 62, 71, 82, 131, 221, 228, 290, 309, 311, 316, 384

 mutual funds 74, 82, 86, 108, 224, 239, 242-243, 249, 286-289, 291-292, 294-295, 300-302, 309, 313

 U.S. savings bonds 83, 243, 246, 285

 zero coupon bonds 282

brokerage firms 70, 83, 86, 222, 252, 259, 264-266, 277, 298-299, 301-304, 313, 314-317

 discount brokerage firms 302

 full-service brokerage firms 299

bypass trust 328

capital gain 63-64, 74-75, 86-87, 236, 250, 279, 288, 295

capital loss 86, 279

car, buying 2, 153, 157, 179
 auto insurance 168, 193, 211-212, 216
 auto loan key numbers 168
 black book 160
 Blue Book 159-160, 165
 borrowing the money 18, 128, 167
 buying a new car 153, 156, 171, 181
 buying a used car 160, 179
 dealer's invoice 159, 161
 down payments 164
 extended warranty 157-158
 extra sticker 154
 repair costs 162
 36-Month Rule 169
 trade-in 160, 164-165, 169, 180, 182
 used car strategies 181
car, leasing 173, 177
 capital reduction 176
 closed-end lease 177
 fees 177-178
 implied interest cost 176
 leasing 153, 173-178
 mileage limits 177
 open-end lease 177
 payments 175, 177-178
 residual value 176-177
 taxes 177-178,
 term 175, 177
cafeteria plan 85
cash crunch 20, 145
certificate of deposit (CD) 284
charitable donations 88-89
 balancing your checkbook 102, 105
 buying checks 101
 cashiers checks 108
 certified checks 100, 107-108
 check storage 99
 checking accounts 11, 93, 95-98, 101-103, 106, 108-109, 113, 121, 240, 265
 investments 89-90
 property 88-89
 third party check 107
COBRA 206
college 19, 27-28, 82-83, 127, 168, 203, 239, 240, 242-245, 282, 285, 310-311, 324, 383
condominiums 361
consumer credit counseling service (CCCS) 148

co-operatives 361

"credit doctor" 143

credit card loss protection 188

credit card 11, 16, 18-20, 23-24, 33, 48-49, 90, 97, 109, 111-124, 127, 130, 137, 139, 142-143, 145-146, 163, 188-189, 360, 383

 billing errors 123-124

 charge cards 117, 120, 137

 debit cards 121

 disputed charges 124

 fees 115-117, 120, 166, 177-178

 interest 114-123

 lost or stolen cards 124

 secured credit cards 121-122

 "teaser" rate 118, 369, 383

credit report 31, 113, 137-139, 142-143, 146-147

credit unions 94, 136, 156-157, 161

debit cards 121

debt 18-22, 28, 33, 35, 111, 125, 127-128, 130, 132, 141, 143, 145, 146-149, 163, 189, 202, 221-222, 241, 277-278, 283, 289, 356, 384

 debt insurance 189

 interest rate (coupon) 278

 issuer 109, 113-114, 278

 maturity 278-280, 285, 290

 redemption 279

 secured debt 18, 130, 146

 unsecured debt 18, 130, 146

depreciation 18, 64-65, 175

dining cards 47-48

direct deposit 79, 99, 199

discount brokerage firms 302

dividends 64, 70-71, 73, 75, 250-252, 254, 256, 262, 269, 287-288, 294-295, 329

dollar cost averaging 232-233

education 18, 56, 75, 82-83, 168, 203, 243-245, 282, 285, 310, 341

employee pension plans 317

estate taxes 89, 326-332, 340, 345, 350, 358-361

extended warranty 157-158, 188

Fee For Services 301

financial aid 244-245, 247, 310

flexible spending account 84

foreclosure 355, 372

401(k) Plans 132, 308, 315, 327, 355

full-service brokerage firms 299

futures 224, 227, 249, 276-277, 286, 301, 305

grace period 114, 119, 132

groceries 13, 44, 201-202

health clubs 51

health insurance premiums 85
HMOs (health maintenance organizations) 190, 204-206
home equity loan 33, 90, 125, 131, 245, 380, 383-385
house, buying 153, 242, 349, 353, 356
 auto insurance 168, 193, 211-212, 216
 beneficiary 190, 201, 326, 328, 330-331, 334
 bottom ratio 360
 claim 358-359
 co-pay 85
 credit card loss protection 188
 credit card or mortgage debt insurance 189
 deductible 315, 358-359, 369, 379, 381
 dental insurance 189
 disability insurance 72, 84, 166, 191-192, 207, 208
 down payment 235, 239, 353-358, 372-374
 exclusion 190, 328-329
 401(k) 132, 308, 315, 327, 355
 floater 190
 health or medical insurance 84-85, 190, 192, 204-206, 209, 211
 homeowner's insurance 360-361
 inspection 165, 182-183, 348, 351, 382
 insurance 187-193, 354, 360-361, 372, 378, 384
 level premium term 197
 life insurance 3, 132, 166, 189-192, 195, 197-198, 200-202, 208, 232, 324,
 326, 330, 384
 pre-existing condition 190
 premium 35, 39, 47, 84, 109, 115, 188-189, 195-201, 206-208, 215, 274, 279-
 280, 372
 renter's insurance 193
 rating 19, 147, 160, 190-191, 200, 282, 289, 355
 rider 189
 seller financing 354, 357
 survey 380
 top ratio 360
 umbrella insurance 193
interest 8-9, 18-20, 23-24, 32-33, 58, 62-64, 68, 70-71, 73, 75-76, 82-83, 90, 95-
 96, 98-99, 102-103, 108, 112, 114-122, 128-131, 133-135, 146-147, 156-158,
 161, 164, 166, 169-171, 174, 176, 188, 220-223, 228-229, 242, 245-246, 250,
 267, 276-285, 289-291, 297-298, 309, 311, 329, 357-358, 361, 365-371, 373-
 374, 376, 378-385
 calculating interest 96
 interest on savings accounts 95-96
investing, rules of 220
IRA (individual retirement account) 73, 75, 83-85, 200, 291, 302, 312-317, 320, 356
 Keogh plans 298, 308, 317
leverage 31, 227, 267, 270, 272, 305

life insurance 3, 132, 166, 189-192, 195, 197-198, 200-202, 208, 232, 324, 326, 330, 384
 term life insurance 195, 198, 200
 universal life 43, 198
 whole life 198-199, 384
liquidity 8, 21, 222, 287
money market accounts 98, 240, 284, 286, 298
money market funds 99, 222-223, 240, 284, 290-291
money orders 108-109
mortgage 32, 33, 58, 75-76, 89, 125, 130-131, 147, 189, 200, 202, 204, 244-245, 348, 353-361, 365-385
 adjustable rate loans 365-366, 375, 383
 conforming loans 367
 fixed rate loans 365-366, 371, 380
 graduated enhanced mortgage 366
 jumbo loans 367
 mortgage loans 125, 130, 357
 mortgage payment 58, 75, 359, 361, 385
 points 1, 34, 90, 355, 365, 368-369, 380-381, 383-384
multiple listing 346
municipal bonds 58, 62, 71, 82, 131, 221, 228, 290, 309, 311, 316, 384
NOW accounts 98
overdraft 97, 101, 103, 114
 overdraft protection 96-97, 103, 114
passbook savings 95
payroll deductions 11-12
pension plans 83, 307, 315, 338
phone 11, 27, 36, 40, 42-43, 69, 73, 101, 112, 123-124, 139, 148, 162, 180, 182, 188-189, 191, 214-215, 253, 287, 304, 376
PPOs (preferred provider organizations) 204-206
principal 128-129, 133, 339, 371, 378, 383
property taxes 12, 33-34, 350, 359, 385
public transportation 34, 345
real estate 2, 64, 74, 89, 116, 120-221, 345-347, 349-350, 354-355, 358-361, 372, 376, 385
 buyer's broker 349
 fire damage 349
 inspection 165, 182-183, 348, 351, 382
 listings 346-347
 mortgage 32, 33, 58, 75-76, 89, 125, 130-131, 147, 189, 200, 202, 204, 244-245, 348, 353-361, 365-385
 multiple listing 346
real estate agents 345-347, 349-350, 354, 361
rent 26-31, 43, 45, 145, 358
retirement 2, 64, 71, 93, 202-204, 208, 235, 240, 242, 245, 303, 307-308, 310-311, 313-315, 318, 327-329, 338, 356

risk and reward 223
rule of 100 241-242
savings accounts 23, 28, 93, 95-96, 98, 103, 106, 108, 121-123, 157, 188, 198, 220, 222, 228, 240, 284, 291, 298, 308, 315, 385
savings and loans 290
scholarships 59, 244, 247
secured credit cards 121-122
secured debt 18, 130, 146
 cash value life insurance loans 132
 401(k) loans 131, 314
 home equity loans 33, 90, 125, 131, 245, 380, 383-385
 margin loans 131, 267
SEPs 85-86, 298, 303, 308, 313, 315, 317, 320, 327, 338, 356
social security 3, 70, 75, 87, 113, 138, 324, 360, 376
statement savings accounts 95
stocks 63-64, 83, 86, 223, 236-237, 239-243, 246, 249, 250-253, 255, 258-259, 262-263, 270-271, 273-274, 277, 283, 286-289, 293-295, 301
 blue chips 251-252
 common stock 237, 253-254
 growth stocks 253
 options 25, 28, 43, 86, 94, 149, 154, 159, 161, 163-165, 192, 195, 249, 270-276, 286, 301-302, 312, 377
 calls 267, 275
 hedge 197
 lock 197
 put 272, 273
 penny stocks 252-253
 preferred stock 221, 253-254
 warrants 275-276, 300
stockbrokers 279, 299, 302
store credit cards 120, 146
student loans 13, 16, 20, 46, 125, 127-128, 132-135, 137, 146, 149, 360
 accrued interest 128
 amortization 128
 compounding 8-9, 227, 269, 297, 388
 consolidation 135-136
 deferment 133, 146
 extended payments 134
 forbearance 133
 grace period 132
 graduated payments 134
 interest 128-131, 133-135
 principal 128-129, 133
sublets 27

taxes 10-12, 15-16, 25, 33-34, 56-59, 62-84, 86, 88-90, 94, 99, 132, 149, 166, 177-178, 201-202, 220, 228-230, 239, 244-246, 279, 282, 285, 290, 295, 300, 308-317, 326-332, 340-341, 345, 350, 356, 358-361, 379, 381
 adjustments 57, 59-60, 64, 136, 159, 242, 365, 370
 alternative minimum tax 59
 credits 57, 59, 75
 deductions 57-60, 89, 175, 315, 378-379, 383, 385
 electronic tax assistance 77
 exemptions 57-59
 extensions 147, 317
 federal income tax 56, 70, 246, 327
 FICA 12
 filing taxes 61, 66-69, 74, 246, 317
 flat tax 59-60
 graduated tax 56-57, 59
 income not reported 71
 itemizing 74-76, 88
 marginal tax rate 62, 82, 314, 381
 non-taxable income 72
 property taxes 12, 33, 34, 350, 359, 385
 reports of income 70-71
 schedules 75, 78
 state income tax 76, 88
 tax-free municipal bond 82, 311
 tax advantages 58, 83-84, 175, 307, 316-317
 tax preparers 78
travel 11, 49-51, 90, 115, 120
 travel agents 49-51
traveler's checks 109
umbrella insurance 193
United States savings bonds 83, 243, 246, 285
unsecured debt 18, 130, 146
used cars 159-160, 168, 180-182
 diesel or turbo-charged cars 181
 flood damaged car 181
 payment without a title 181
 rental or fleet cars 180
 salvage cars 181
 service records 180, 182
 warranty 36, 157-158, 174, 182-183, 188
utility services 44
wills 323, 325, 339-340
 joint with right of survivorship 327
 living wills 325
 probate 325-327, 331-333, 339, 342
yield 50, 224-225, 246, 262, 280-282, 289, 294